P9-DNS-023

More Marine Paintings and Drawings in the Peabody Museum

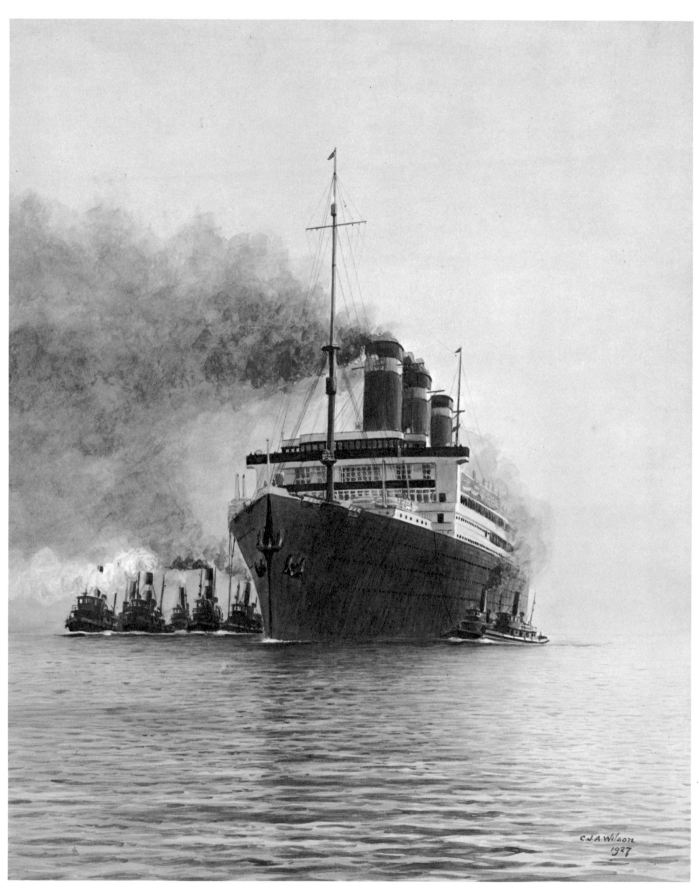

2337. S.S. *LEVIATHAN* BEING NUDGED INTO PORT BY TUGS

More Marine
Paintings and Drawings

IN THE

PEABODY MUSEUM

BY

Philip Chadwick Foster Smith

Peabody Museum

SALEM · MASSACHUSETTS

1979

OTHER BOOKS BY PHILIP C. F. SMITH

A History of the Marine Society at Salem in New-England, 1766–1966
(1966)

Portraits of the Marine Society at Salem in New-England
(1972)

The Journals of Ashley Bowen (1728–1813) of Marblehead
(1973)

The Frigate Essex *Papers: Building the Salem Frigate, 1798–1799*
(1974)

Captain Samuel Tucker (1747–1833), Continental Navy
(1976)

Fired by Manley Zeal: A Naval Fiasco of the American Revolution
(1977)

The Artful Roux, Marine Painters of Marseille
(1978)

TABLE OF CONTENTS

LIST OF COLOR ILLUSTRATIONS

INTRODUCTION

IN 1968, Marion and Dorothy Brewington's *Marine Paintings and Drawings in the Peabody Museum* was published by the museum. It catalogued all the original marine art—mechanically reproduced prints were not included—received by the institution from its founding in the year 1799 through the year 1966. The result of almost ten years' labor and research, "The Brewington Book," as it has been styled by some, was a pioneering effort in the field. Consisting of xvii+530 pages, weighing in at six and a half pounds, and containing 1,961 entries— 1,500 of which were illustrated in black and white with sixty others in full color—it has since become a "Bible" to connoisseurs of ship portraits and collectors of marine art around the globe. Nearly 450 identified marine artists are represented in it, as well as a host of unidentified practitioners—withal, an impressive testament to one of the most important collections of its kind in the world. It is now out of print and a collector's item.

In the decade which followed publication, the museum's collection was further enriched by an astounding succession of interesting and important original ship portraits, shore views, and other subjects of maritime interest. As the numbers rose into the many hundreds, the decision was made to publish a supplementary volume before the logistical and financial burdens of such a project made it impossible to accomplish. This book is the result.

The first of the three sections it contains catalogues all relevant accessions received by the Peabody Museum between January 1, 1967 and December 31, 1977. Subjects predominantly ethnological in character have been omitted unless in some way they shed light on maritime enterprise or trade. So, too, have the numerous Chinese pith paper paintings of birds, butterflies, bugs, and boats. These latter essentially

duplicate comparable material presented in the original volume. The numbering of entries begins at 1,962, where the Brewington work left off. Although the basic format remains the same, an attempt has been made to simplify the arrangement of individual entries.

Because users of the book have been found to be not only the student of marine art and the collector of it but also the picture researcher desirous of knowing whether or not a picture of a certain vessel, episode, or view exists, it has been deemed fitting to include a second section cataloguing the illustrated logbooks in the museum's collection. It is hoped that by this addition, the usefulness of the joint volumes will be enhanced.

The third, and final, section contains the principal corrections, amendments, or reattributable material discovered in the Brewington catalogue after many years of intensive use.

A great many individuals have made this project possible. The following have in large measure made it possible financially: Anonymous, Jack R. Aron, Lee R. Ashmun, M.D., Frederick Bense, Richard H. Boehning Antiques, Bursaw Oil Company, the Alfred E. Chase Charity Foundation, Charles D. Childs, Donald Cleveland, Major General Richard Collins, USA (ret.), Robert A. Cushman, Bayard Ewing, Alfred Gold, J. Welles Henderson, Harold D. Hodgkinson, Frank T. Howard, Crosby M. Kelly, Samuel L. Lowe, Jr., Marine Arts Gallery, J. William Middendorf II, Charles S. Morgan, Robert R. Newell, Walter W. Patten, Jr., Mr. and Mrs. R. Forbes Perkins, Ralph K. Reed, the Salem Marine Society, Samuel Sokobin, Stern Hall Spirt & Associates, Robert G. Stone, the Lucy and Eugene Sydnor Foundation, Edward B. Thomas, Alexander O. Vietor, S. Morton Vose II, Robert J. Wetmore, M.D., Nathaniel Whittier, Wright Chemical Corporation, and last, but by no means least, a generous grant from the National Endowment for the Arts, a Federal Agency, without which the endeavor could not have been brought to fruition.

I am grateful to Dorothy Brewington for making available certain artists' dates from hers and her late husband's unpublished research notes and to Virginia L. Close for her meticulous indexing.

At the museum, many others worked with me assiduously. Among

them I should like to single out A. Paul Winfisky, my former assistant and currently Keeper of Pictures and Prints; Kathy M. Flynn, Photographic Assistant; Markham W. Sexton, Staff Photographer; Geraldine M. Ayers, Staff Secretary; and Grace Vanner Fairfield, who assisted me part time doing yeoman service with the fund raising, cataloguing, and generally keeping track of the work at hand.

<div align="right">

PHILIP CHADWICK FOSTER SMITH

Former Curator of Maritime History
Peabody Museum of Salem

</div>

PART I

More Marine Paintings and Drawings
in the Peabody Museum

A., F.

1962. "Marblehead." Gas House Beach, Marblehead, Massachusetts. Pencil sketch. $4^3/_4$ × $7^7/_8$ in. (13.2 × 20 cm.). Signed, lower center, "F.A [illegible] 96." Bequest, Stephen Phillips, 1975. M16230

1963. "Marblehead." Behind Graves' Boatyard, Marblehead, Massachusetts. Pencil sketch. $4^3/_4$ × $7^7/_8$ in. (12.2 × 20 cm.). Signed, l.r., "F. A. [illegible] 96." Bequest, Stephen Phillips, 1975. M16231

Agate, A. T. British [1812–1846]

1964. Disappointment Island. Pencil. $4^1/_4$ × $6^3/_4$ in. (10.5 × 17.3 cm.). Inscription at l.r., "Disappointment Island Aug. 25, 1839". Unsigned, attributed to A. T. Agate. Gift, F.B.L., 1976. M16275

1965. Otaheite Harbor. Pencil and ink. $8^1/_2$ × $13^1/_4$ in. (21.7 × 33.6 cm.). Signed, l.l., "A T Agate del". Gift, F.B.L., 1976. M16274

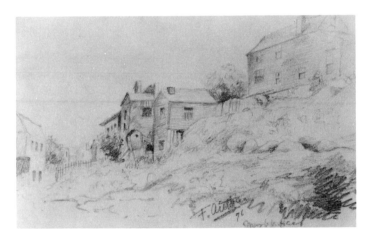

1962

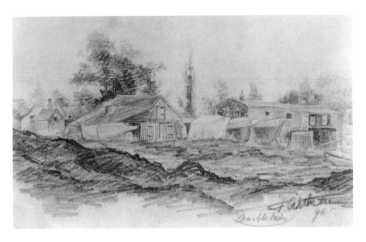

1963

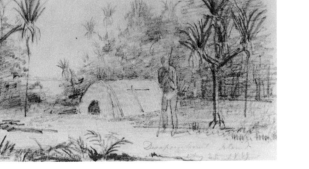

1964

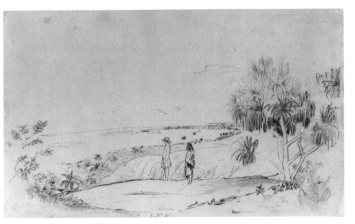

1965

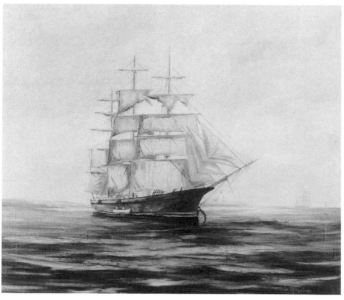

1966

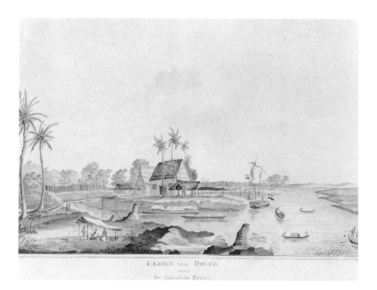

1967

1968

Albertson, Oliver E. American

1966. Unidentified ship. Oil. 20^1/8 × 24^1/4 in. (51 × 61.5 cm.). Signed, l.r., "Oliver Albertson." Pencil inscriptions on stretcher: (1) "Ship with Salt cargo, for curing fish, at anchor inside Gloucester, Mass." and (2) "Oliver E. Albertson 6 Sylvan Street Gloucester Mass." Gift, Mr. and Mrs. Howard LeVan, Jr., 1974. M15685

Arends, Jacob Dutch

1967. "Gezigt Van Douko Aan De Solosche Rivier." Watercolor. 11 × 14^7/8 in. (28 × 37.7 cm.). Signed, l.l., "J. Arends." Dated, l.r., "A° 1799." Inscriptions on reverse: "Jan niegelaar" and "on the strait side of Pupua separating Prince Frederic Henry Island from the mainland Dutch New Guinea." Gift, Frances Damon Holt, 1972. M15356

1968. "Land Gezigt-Buiten Grisse." Watercolor. 11 × 14^7/8 in. (28 × 37.7 cm.). Signed, l.l., "Jacob:Arends." Dated, l.r., "6 Februarii A° 1799." Inscription on reverse: "Yonge Heer Jantje" and "Janziegelaar." Gift, Frances Damon Holt, 1972.

M15357

B., R.

1969. DIRIGO. "Dirigo – Baltimore" [American bark]. Pen and ink. 6^1/4 × 8^1/2 in. (16 × 21.5 cm.). Signed, l.r., "R.B. 1916." Gift, William J. Baybatt, date unknown. M14203

Bailey, C. (?) American

1970. "Salem Wharf." Watercolor. 10 × 15 in. (25.4 × 38.1 cm.). Signed, l.l., "C. (?) Bailey." Dated circa 1890. Purchase, 1975. M16216

Baptiste, M. A. [w. 1845]

1971. Canton factories. Watercolor. 14^3/8 × 24^7/8 in. (36.5 × 63.1 cm.). Unsigned, attributed to M. A. Baptiste. Dated post 1848. Gift, F.B.L., 1972. M15324

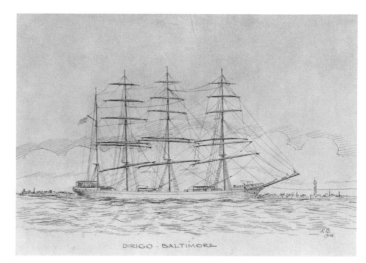

1969

2

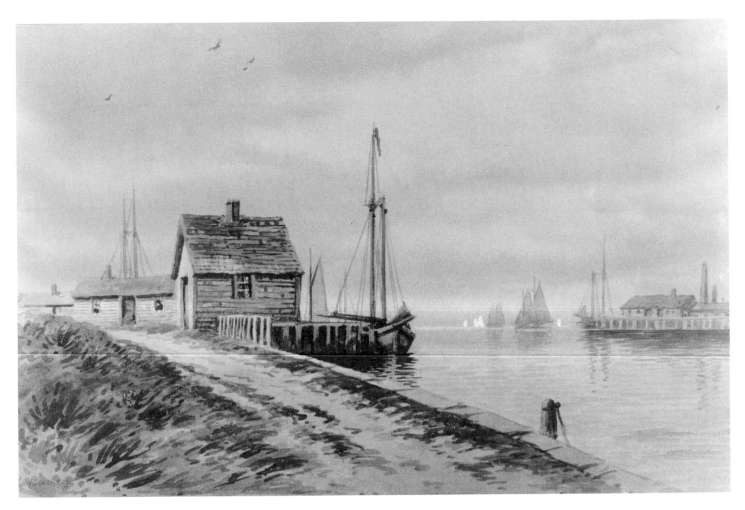

1970

1971

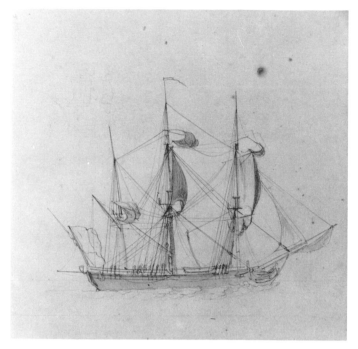

1972

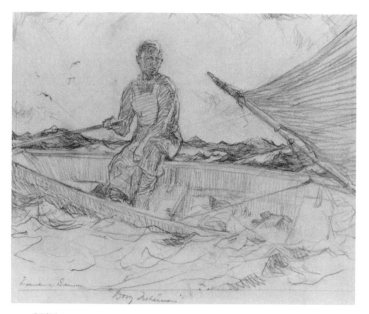
1974

Baugean, Jean-Jerome French [1764–1819?]

1972. Unidentified ship. Pen and wash. 8¹/₄ × 8¹/₂ in. (21 × 21.5 cm.). Unsigned, attributed to Baugean and presumably a leaf from a sketchbook. On reverse: pencil sketch of another unidentified ship. Gift, Augustus P. Loring, 1968. M13439

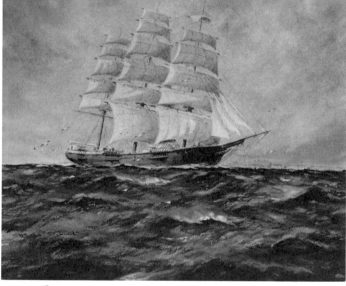
1976

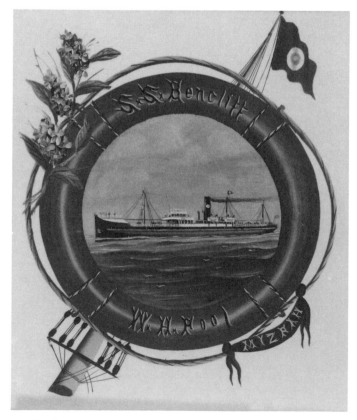

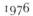
1973

Bell, J. British ?

1973. BENCLIFF [British steamer]. Oil on china. 12 × 10¹/₈ in. (30.5 × 25.7 cm.). Signed, "J. Bell." Built, 1894, Sunderland, England, 1,977 tons. Encircled by ornamented life-ring with name "S.S. Bencliff" at top and "W. H. Pool" at bottom. No accession information. M14555

Benson, Frank Weston American [1862–1951]

1974. "Dory Fisherman." Pencil. 9¹/₄ × 10³/₄ in. (23.5 × 27.3 cm.). Signed, l.l., "Frank W. Benson." Gift, Stephen Wheatland, 1977. M17040

Benson, John Prentiss American [1865–1947]

1975. "The Beach at Salcomb." Oil. 30 × 25¹/₄ in. (76.2 × 64.1 cm.). Signed, l.l., "John P. Benson." Gift, Mrs. William Bentinck-Smith, 1968. M13389

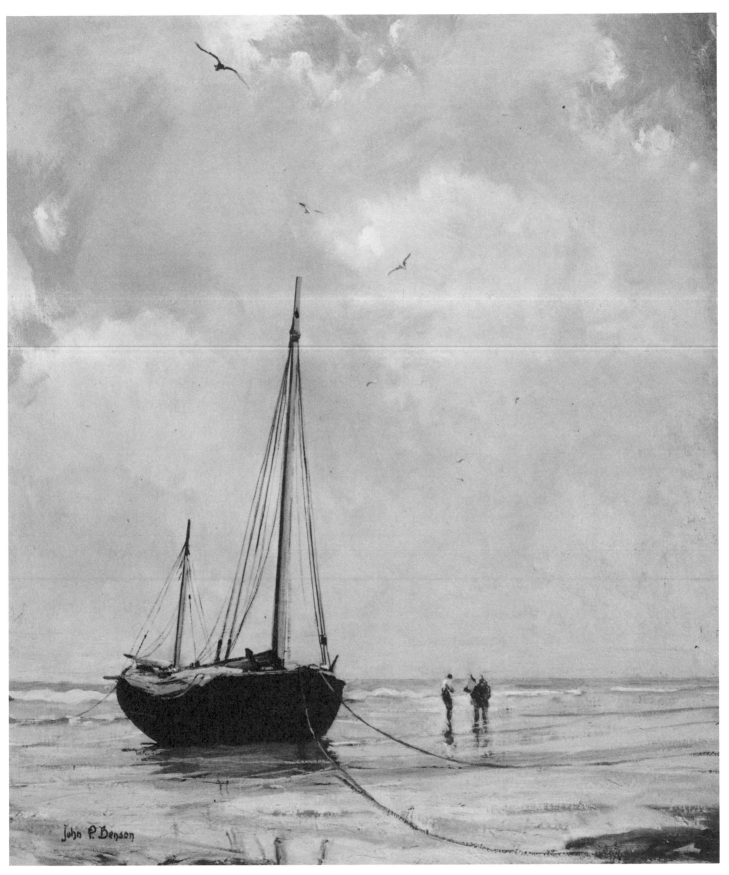

John P. Benson

1975

Birchall, William Minishall British [1884 – ?]

1976. ST. DAVID. [U.S. Ship] Watercolor. 9¹/₈ × 11¹/₈ in.
(23.2 × 28.3 cm.). Signed, l.l., "W. M. Birchall." Gift, F.B.L.,
1975. M16190

5

Bridges, Fidelia American [1835–1924]

1977. Sketchbook containing mostly drawings of birds but including three pages of schooner drawings. Pencil. 6^1/$_2$ × 4^1/$_8$ in. (16.5 × 10.5 cm.). Gift, Alice S. Bourgoin, 1976. Not illustrated.
 M16271

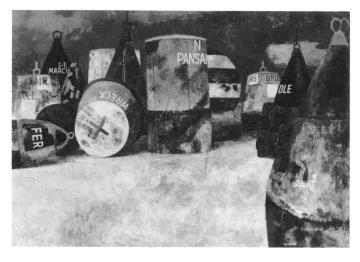

1978

Brill, Reginali

1978. Buoys and British navigation markers. Oil. 24^1/$_2$ × 34^1/$_2$ in. (62.2 × 87.6 cm.). Signed, l.r., "Reginali Brill". Deposit, Francis Lee Higginson. FLH 271

Buhler, Augustus W. American [1853–1920]

1979. "The Beachcomber," formerly called "The Ancient Mariner." Oil. 40^1/$_8$ × 26 in. (101.9 × 66 cm.). Unsigned, attributed to Augustus W. Buhler, 1918. Model for the subject was George Marble Wonson of Gloucester, Mass. Gift, Miss Dorothy Buhler, 1971. M14500

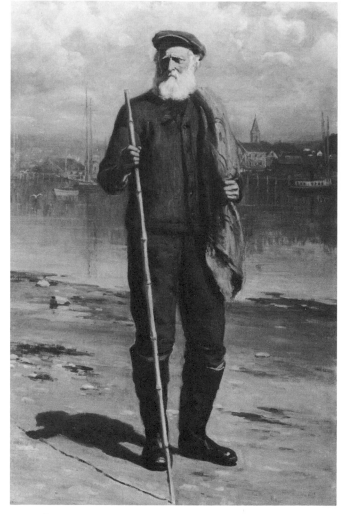

1979

1980. Smith's Cove, East Gloucester, Massachusetts, with pinky. Pen and ink. 11 × 14^3/$_4$ in. (28 × 37.4 cm.). Unsigned, attributed to A. W. Buhler. Gift, Stephen Wheatland, 1969.
 M13526

1980A. Gloucester Harbor, Massachusetts. Watercolor. 20 × 28 in. (51 × 71 cm.). Signed, l.l., "A. W. Buhler 1919." Deposit, Francis Lee Higginson. FLH 267

1980

1981

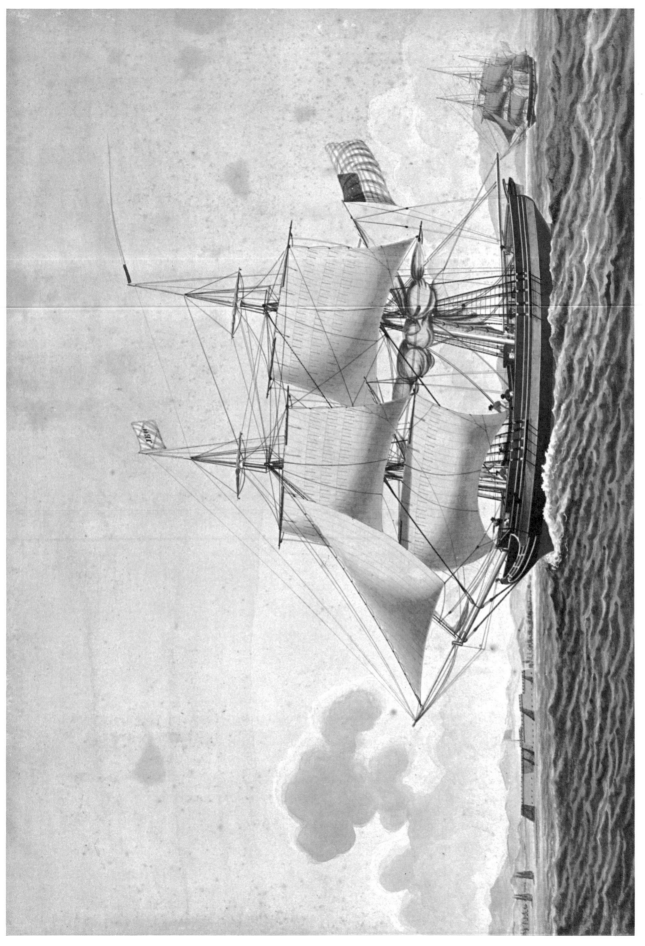

1991. THE SNOW *JEW* OF BOSTON PUTTING TO SEA

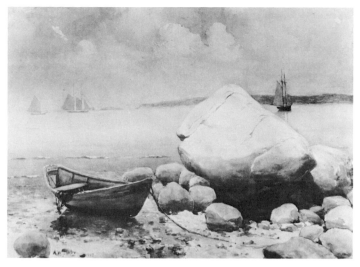

1980A

Burgesi, A. J.

1981. Unidentified British steamer. Oil on panel. 6³/₄ × 10⁵/₈ in. (17.2 × 27 cm.). Signed, l.r., "A. J. Burgesi 1891 'Bombay'." Deposit, Francis Lee Higginson. FLH 259

Buttersworth, James E. American [1817–1894]

1982. Yacht Race off Boston Light. Oil. 15¹/₈ × 20¹/₈ in. (38.3 × 51.1 cm.). Signed, l.r., "J. E. Buttersworth." Gift, J. Welles Henderson, 1975. M16242

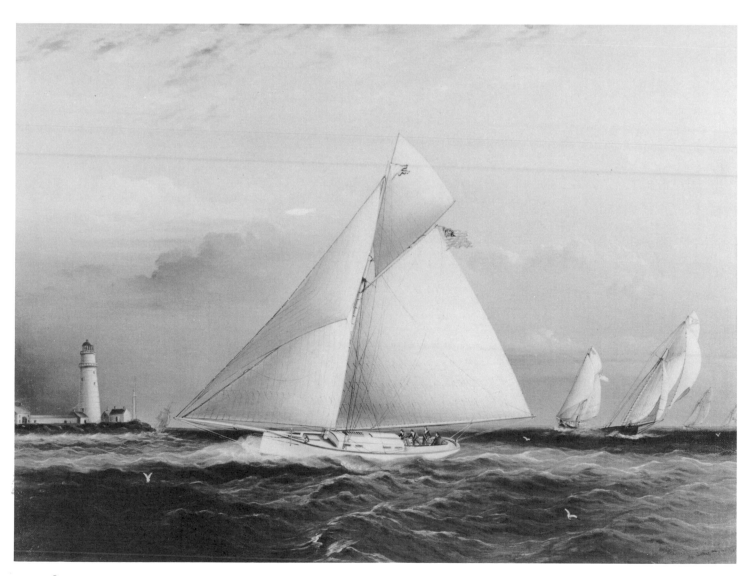

1982

7

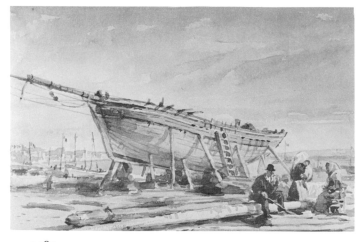

1983

1985

1984

1986

Cairilli, M. R.

1983. French vessel under construction. Watercolor. 8 × 12 in. (20 × 30.5 cm.). Signed, l.l., "M. R. Cairilli." Deposit, Francis Lee Higginson. FLH 268

Caldwell, James Thomas British [c. 1815–1849]

1984. Whampoa Island, Canton [Pearl] River. Watercolor. 6½ × 10½ in. (16.6 × 26.7 cm.). Unsigned, attributed to James Thomas Caldwell, Commander, R.N. Dated circa 1842–1849. Gift, F.B.L., 1972. M15279

1985. Islet in Kowloon Bay near Hong Kong. Watercolor. 5⅞ × 10¼ in. (15 × 26 cm.). Unsigned, attributed to James Thomas Caldwell, Commander, R.N. Dated circa 1842–1849. Gift, F.B.L., 1972. M15280

1986. Opposite Hong Kong. Watercolor. 7½ × 11 in. (19.1 × 28 cm.). Unsigned, attributed to James Thomas Caldwell, Commander, R.N. Dated circa 1842–1849. Gift, F.B.L., 1972.
M15281

1987

1987. "From the Side of the Gaer [Guia] Hill, Macao, looking to the road to Camoen's Cave." Pencil. 6½ × 10½ in. (16.5 × 26.6 cm.). Unsigned, attributed to James Thomas Caldwell. Gift, F.B.L., 1968. M13454

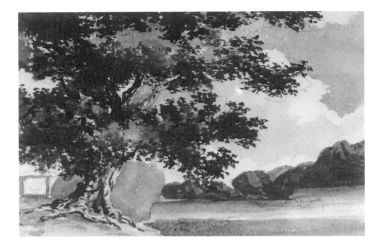

1988

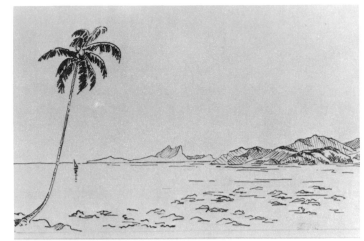

1992

1989

1993

1990

1990. The Bogue Rock near Hong Kong, circa 1850. Pencil. 7^1/$_8$ × 10 in. (18.1 × 25.4 cm.). Unsigned, attributed to James Thomas Caldwell. Gift, F.B.L., 1968. M13457

Camelote Italian

1991. JEW [American snow]. "Jew of Boston." Watercolor. 17 × 23 in. (43 × 58.4 cm.). Signed, l.l., "Camelote." Built Quincy, Massachusetts, 1831, 59 tons. Gift, J. Welles Henderson, 1975. See color plate facing page 6. M16243

Cheesman, ?

1992. "Tahaa Is. across the coral reef from Raiatea, with the silhouette of Bora Bora on the horizon." Pen and ink. 5^1/$_2$ × 7^3/$_8$ in. (14 × 18.7 cm.). Unsigned, attributed to Cheesman.
 M13960

1993. "River mouth with shore flat protected by coral reef." Pen and ink. 5^1/$_4$ × 7^5/$_8$ in. (13.3 × 19.3 cm.). Unsigned, attributed to Cheesman. Gift, Stephen Phillips, 1970. M13961

1988. Kowloon Bay near Hong Kong circa 1850. Watercolor. 6^1/$_8$ × 9^1/$_2$ in. (15.6 × 24.2 cm.). Unsigned, attributed to James Thomas Caldwell. Gift, F.B.L., 1968. M13455

1989. "On the Passage From Macao to Deans Island." Pencil. 6^3/$_4$ × 10^7/$_8$ in. (17.1 × 27.6 cm.). Unsigned, attributed to James Thomas Caldwell. Gift, F.B.L., 1968. M13456

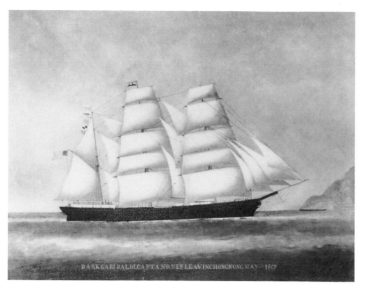

1994

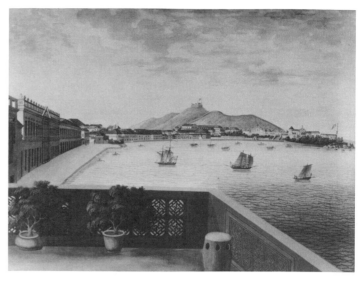

1999

1997

1998

Chinese Artists, Unidentified

1994. GARIBALDI. "Bark Garibaldi Capt A. Noyes leaving Hong Kong May 1869" [American bark]. Oil. 27⅞ × 35⅞ in. (70.7 × 91.2 cm.). Built 1860, Stockton, Me., 598 tons. Gift, Edward A. Taft, 1972. M14892

1995. Entry out of sequence. See item number 1981.

1996. Chinese Court of Inquiry, 1807, depicting the *Neptune* incident. Oil. 28½ × 40¼ in. (72.5 × 102.1 cm.). Unsigned. A companion picture is at the Winterthur Museum, Winterthur, Delaware, and another pair at the National Maritime Museum, Greenwich, England. Purchase, 1970. See color plate facing page 14. M14311

1997. Camoen's Grotto. Oil. 22⅞ × 29½ in. (57.8 × 75 cm.). Gift, Mrs. Jon Wiig, 1972. M15274

1998. "Corner of New China St – Close beside the Spanish hong." Gouache. 13¾ × 17¾ in. (34.8 × 45 cm.). Dated circa 1830. Purchase, 1974. M15707

1999. Macao, Praya Grande from the South. Gouache. 14⅛ × 18⅝ in. (35.8 × 47.3 cm.). Unsigned. Gift, Stephen Wheatland, 1967. M13146

2000

2001

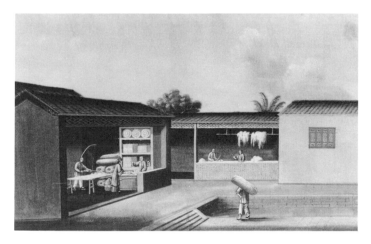

2002

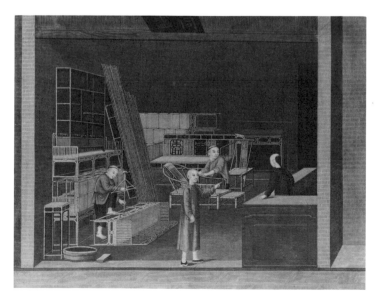

2003

2000. Shanghai. Pen and ink. 9 × 12 in. (22.9 × 30.5 cm.). Unsigned, circa 1860. Gift, Samuel Sokobin, 1969. M13586

2001. Chinese fur trader. Gouache. 11¼ × 13⅞ in. (28.5 × 35.2 cm.). The number "59" appears in the upper left corner. Purchase, John Robinson Fund, 1969. M13827

2002. Cotton textile manufacture in a series of 12 depicting the cultivation of cotton in China to the sales of printed and dyed textiles. Watercolor on pith paper. 7⅜ × 10¾ in. (18.7 × 27.3 cm.). Gift, Henry S. Streeter, 1972. M15297

2003. Chinese Bamboo Furniture Shop. Gouache. 10⅝ × 13⅞ in. (27 × 35.2 cm.). Purchase, Anna Phillips Fund, 1972. M15123

2004

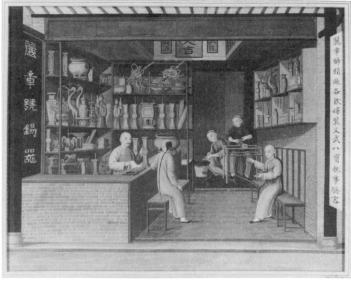

2005

2004. "Medicine shop – or as the man calls [?] it 'large Phee-shack – shop.'" Gouache. 13³⁄₈ × 17⁵⁄₈ in. (34 × 44.8 cm.). Dated circa 1830. View along Thirteen Factory Street, Canton. Purchase, 1974. M15705

2005. Chinese Pewter Shop. Gouache. 10³⁄₄ × 13³⁄₄ in. (27.2 × 34.9 cm.). Purchase, Anna Phillips Fund, 1972. M15122

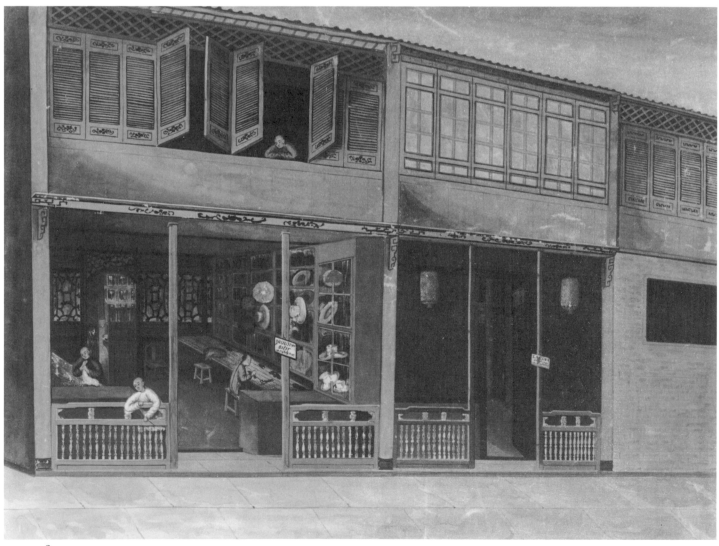

2006

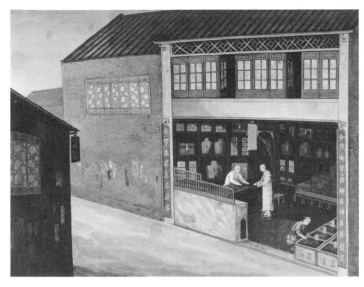

2007

2008. Manufacture of porcelain. Gouache. $17^{7}/8 \times 21^{3}/4$ in. (45.4×55.2 cm.). Dated at circa 1820. Inscribed at top of sheet: "No 16" and at l.r. "N5." Chinese characters at l.l. and l.r. Purchase from the John Robinson Fund, 1968. M13411

2007. "Tea shop" along Thirteen Factory Street, Canton. Gouache. $14 \times 18^{1}/4$ in. (35.5×46.3 cm.). Dated circa 1830. Purchase, 1974. M15706

2008. Manufacture of porcelain. Gouache. $17^{7}/8 \times 21^{3}/4$ in. (45.4×55.2 cm.). Dated at circa 1820. Inscribed at top of sheet: "No 16" and at l.r. "N5." Chinese characters at l.l. and l.r. Purchase from the John Robinson Fund, 1968. M13411

2009. Porcelain manufacture. Gouache. $8^{3}/4 \times 14$ in. (22.2×35.5 cm.). Dated circa 1820. Illustrates the mining and transportation of clay. Purchase, Fellows and Friends Funds, 1969.
 M13649

2010. Porcelain manufacture. Gouache. $8^{3}/4 \times 14$ in. (22.2×35.5 cm.). Dated circa 1820. Illustrates transportation of the clay to the preparation area. Purchase, Fellows and Friends Funds, 1969. M13650

2011. Porcelain manufacture. Gouache. $8^{3}/4 \times 14$ in. (22.2×35.5 cm.). Dated circa 1820. Illustrates men beating the clay mixture. Purchase, Fellows and Friends Funds, 1969.
 M13651

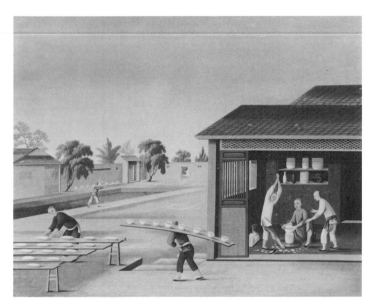

2008

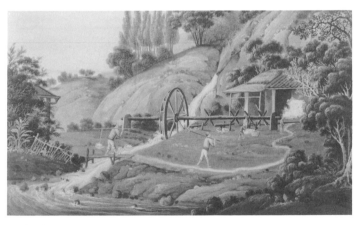

2010

2009

2006. "Polly the Tailor's shop – China St. new – close beside the Spanish Hong" and "Lamqua the painters shop." Gouache. $13^{3}/4 \times 17^{5}/8$ in. (35×44.8 cm.). Dated circa 1830. Purchase, 1974. M15704

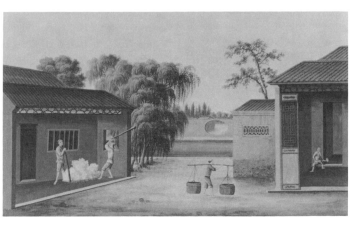

2011

13

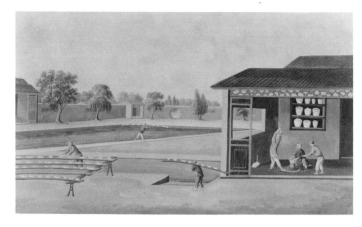

2012

2013

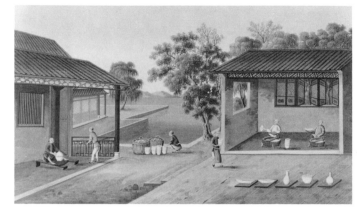

2014

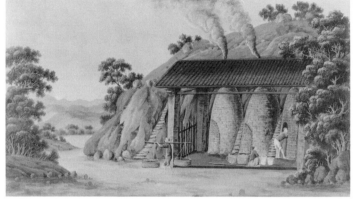

2015

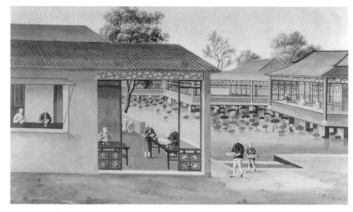

2016

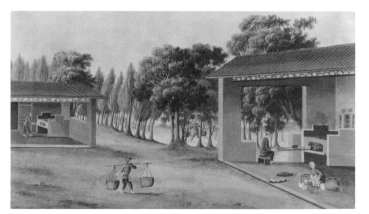

2017

2012. Porcelain manufacture. Gouache. 8³/₄ × 14 in. (22.2 × 35.5 cm.). Dated circa 1820. Illustrates the forming of the clay and being laid out to dry. Purchase, Fellows and Friends Funds, 1969. M13652

2013. Porcelain manufacture. Gouache. 8³/₄ × 14 in. (22.2 × 35.5 cm.). Dated circa 1820. Illustrates decorative pieces being hand formed. Purchase, Fellows and Friends Funds, 1969. M13653

2014. Porcelain manufacture. Gouache. 8³/₄ × 14 in. (22.2 × 35.5 cm.). Dated circa 1820. Illustrates loading into wicker tubs. Purchase, Fellows and Friends Funds, 1969. M13654

2015. Porcelain manufacture. Gouache. 8³/₄ × 14 in. (22.2 × 35.5 cm.). Dated circa 1820. Illustrates the kilns firing the porcelain. Purchase, Fellows and Friends Funds, 1969. M13655

2016. Porcelain manufacture. Gouache. 8³/₄ × 14 in. (22.2 × 35.5 cm.). Dated circa 1820. Illustrates the porcelain being decorated. Purchase, Fellows and Friends Funds, 1969. M13656

2017. Porcelain manufacture. Gouache. 8³/₄ × 14 in. (22.2 × 35.5 cm.). Dated circa 1820. Illustrates the final firing of decorated porcelain. Purchase, Fellows and Friends Funds, 1969. M13657

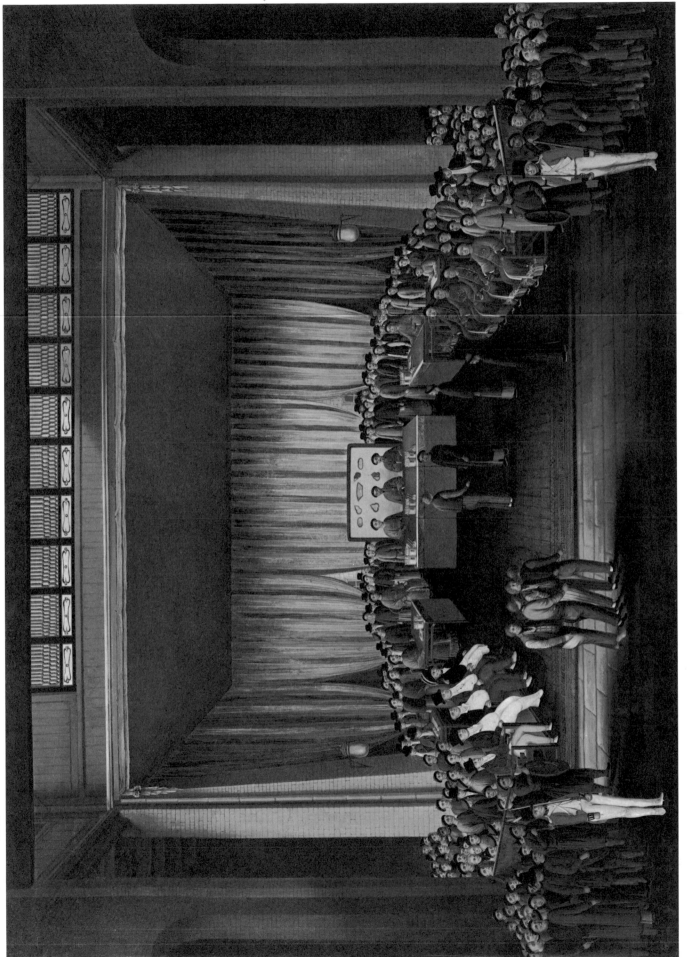

1996. CHINESE COURT OF INQUIRY, 1807, INTO THE *NEPTUNE* INCIDENT

2018

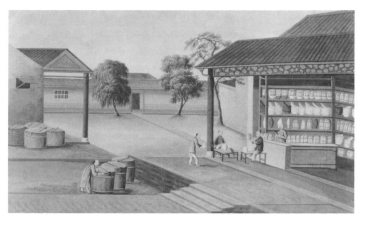

2019

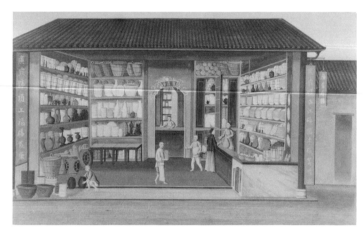

2020

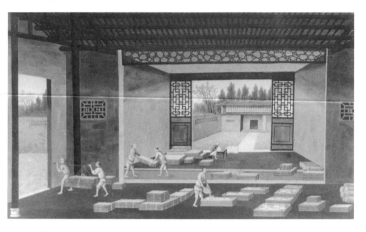

2021

2018. Porcelain manufacture. Gouache. 8³/4 × 14 in. (22.2 × 35.5 cm.). Dated circa 1820. Illustrates the finished wares in tubs from the rural factory to the market. Purchase, Fellows and Friends Funds, 1969. M13658

2019. Porcelain manufacture. Gouache. 8³/4 × 14 in. (22.2 × 35.5 cm.). Dated circa 1820. Illustrates the tubs at a distribution center. Purchase, Fellows and Friends Funds, 1969. M13659

2020. Porcelain manufacture. Gouache. 8³/4 × 14 in. (22.2 × 35.5 cm.). Dated circa 1820. Illustrates a porcelain shop. Purchase, Fellows and Friends Funds, 1969. M13660

2021. Porcelain manufacture. Gouache. 8³/4 × 14 in. (22.2 × 35.5 cm.). Dated circa 1820. Illustrates porcelain being packed for shipment. Purchase, Fellows and Friends Funds, 1969. M13661

2022. Porcelain manufacture. Gouache. 14¹/2 × 19¹/2 in. (36.9 × 49.5 cm.). Unsigned. Illustrates the gathering and sprinkling of water on the raw earth in the kaolin or petuntse mine. First of a set of five. Purchase, 1968. M13470

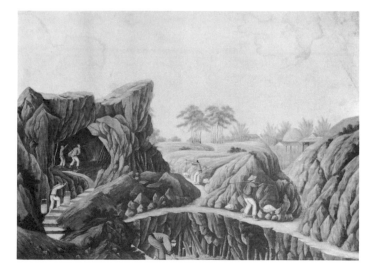

2022

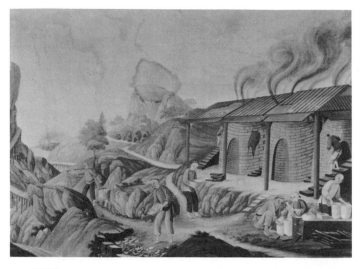

2023

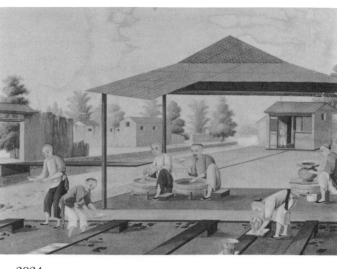

2024

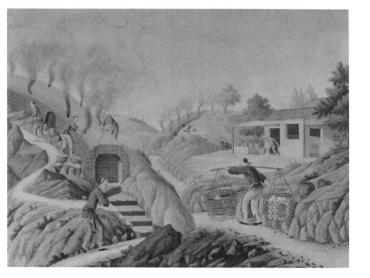

2025

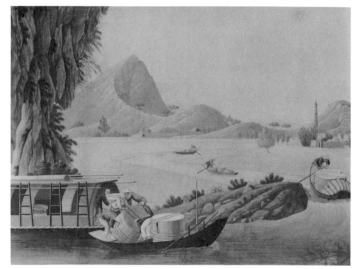

2026

2023. Porcelain manufacture. Gouache. 14¹/₂ × 19³/₄ in. (36.9 × 50.2 cm.). Unsigned. Illustrates the removal of the china from the fires and the discarding of broken pieces. Second of a set of five. Purchase, 1968. M13471

2024. Porcelain manufacture. Gouache. 14¹/₂ × 19⁵/₈ in. (36.9 × 49.7 cm.). Unsigned. Illustrates the china being colored and dried in the sun and ornate pieces being hand-formed. Third of a set of five. Purchase, 1968. M13472

2025. Porcelain manufacture. Gouache. 14³/₈ × 19⁵/₈ in. (36.6 × 49.8 cm.). Unsigned. Illustrates the firing of the china at the kilns. Fourth of a set of five. Purchase, 1968. M13473

2026. Porcelain manufacture. Gouache. 4¹/₂ × 19⁵/₈ in. (36.9 × 49.8 cm.). Unsigned. Illustrates the loading of small sampans and the transfer of the china tubs to a larger barge downriver. Fifth of a set of five. Purchase, 1968. M13474

Clark, William British [1804/5–1883]

2027. Greenock, Scotland, harbor scene. Oil. 21¹/₂ × 32 in. (54.6 × 81.3 cm.). Signed, l.l., "W. Clark, 1830". Deposit, Francis Lee Higginson. FLH 281

Cornè, Michele Felice Neapolitan–American [1752–1845]

2028. Allegorical representation of Salem Harbor, Massachusetts, and the Derby family fleet. Fresco, combination of media. Octagonal 111 in. (282 cm.) diameter. Unsigned, attributed to Michele Felice Cornè, circa 1800. This painting is the ceiling of a cupola which surmounted the former Pickman-Derby-Brookhouse mansion on Washington Street, Salem, designed by Samuel McIntire in 1782. Gift, The Essex Institute, Salem, 1971. M14582

Cranch, John

2029. "Tailors – Companion to the Sailors." Oil on wood panel. 5⁷/₈ × 4⁷/₈ in. (15 × 12.4 cm.). Unsigned, attributed to John Cranch. Title inscription on reverse. Companion to M16265. Gift, Sargent Bradlee, 1976. M16264

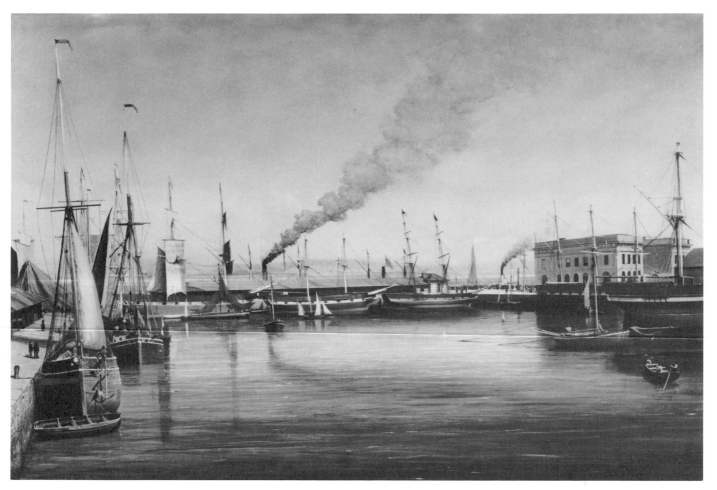

2027

2028
(Detail)

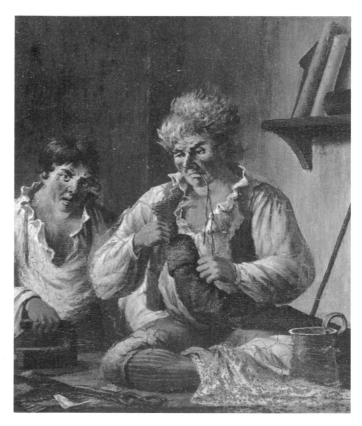

2029

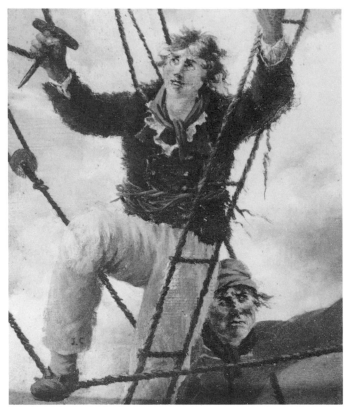

2030

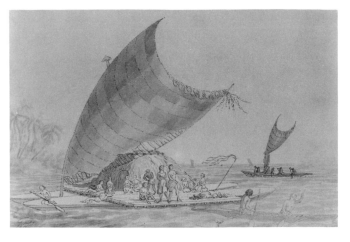

2032

2030. "Sailors – Companion to the Tailors." Oil on Wood panel. 6 × 4³/₄ in. (15.1 × 12.2 cm.). Unsigned, attributed to John Cranch. Label on reverse: "Nº 2 John Cranch." Companion to M16264. Gift, Sargent Bradlee, 1976. M16265

Cumming, R. H. Neville

2031. BALTIC [British steamer]. Watercolor. 23 × 38³/₈ in. (58.4 × 97.4 cm.). Signed, l.r., "R.H. Neville Cumming, 1904". Built 1904, Belfast, 23,884 tons. Deposit, Francis Lee Higginson. FLH 279

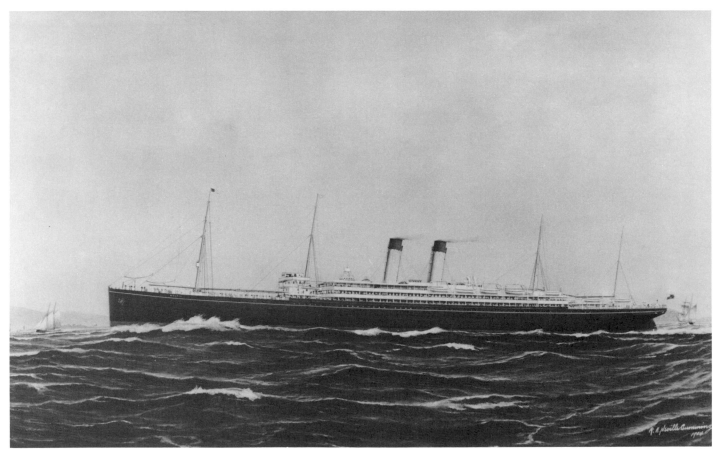

2031

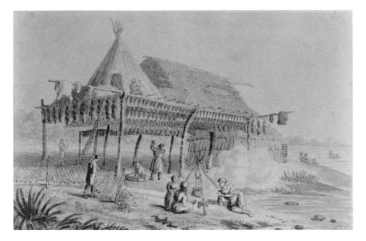

2033

2035

D., W.

2032. South Seas canoes. Pen and wash drawing. 5⁷/₈ × 8⁷/₈ in. (15 × 22.6 cm.). Signed, l.l., "W.D." Gift, Frances B. Damon, 1969. M13790

2033. Northwest Coast habitation and natives. Pen and wash drawing. 5³/₄ × 9 in. (14.6 × 22.9 cm.). Signed, l.r., "WD." Gift, Frances B. Damon, 1969. M13791

Daniell, Thomas and William British
[1749–1840] and [1769–1837]

2034. Chinese Junk. Ink Wash. 8¹/₄ × 8¹/₂ in. (21 × 21.6 cm.). Unsigned, attributed to Daniell, from one of his sketchbooks. Pencil sketch of another ship on reverse. Gift, Augustus P. Loring, 1968. Not illustrated. M13439

2035. "Whampoa" with Chinese junks. Pencil. 6¹/₄ × 9³/₄ in. (15.9 × 24.7 cm.). Unsigned, attributed to Thomas and William Daniell, circa 1790. Gift, Donald Angus, 1969. M13535

2036. Chinese junk. Pencil. 8³/₄ × 17¹/₈ in. (22.2 × 43.4 cm.). Unsigned, attributed to Thomas and William Daniell, circa 1790. Gift, Donald Angus, 1969. M13536

2037. "No. 69 Near Macao China." Pencil and wash drawing. 20³/₄ × 29¹/₂ in. (52.7 × 75 cm.). Unsigned, attributed to Thomas and William Daniell. Dated circa 1794. Gift, Frances Damon Holt, 1972. M15343

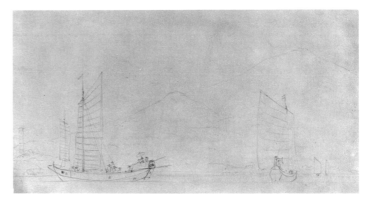

2036

2037

2041

2038

2043

2039

2039. "Stern of a Budgerow." Pencil. 3³/₄ × 5¹/₂ in. (9.5 × 13.9 cm.). Unsigned, attributed to Thomas and William Daniell. Dated circa 1790. Gift, Frances Damon Holt, 1972. M15345

2040. "Cochin Canoe." Pencil. 9 × 14⁷/₈ in. (22.8 × 37.8 cm.). Unsigned, attributed to Thomas and William Daniell. Dated circa 1790. Gift, Frances Damon Holt, 1972. Not illustrated. M15347

2038. Six sketches of Chinese and Western watercraft. Pencil. 8⁷/₈ × 5⁵/₈ in. (22.5 × 14.3 cm.). Unsigned, attributed to Thomas and William Daniell. Dated circa 1790. Gift, Frances Damon Holt, 1972. M15344

2041. "River Scene." Wash drawing. 6¹/₄ × 8⁵/₈ in. (15.8 × 21.9 cm.). Unsigned, attributed to Thomas and William Daniell. Dated circa 1790. Gift, Frances Damon Holt, 1972. M15351

2042

2044

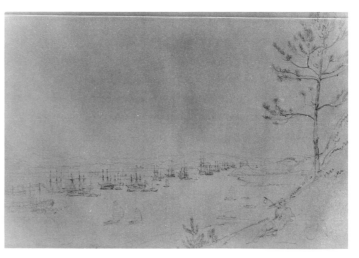

2045

2042. "Warships Long Boat." Pencil. 10¹/₄ × 8 in. (26 × 20.4 cm.). Unsigned, attributed to Thomas and William Daniell. Dated circa 1790. Gift, Frances Damon Holt, 1972. M15352

Daniell, William British [1769–1837]

2043. Unidentified Chinese junk. Pencil. 4⁵/₈ × 7⁵/₈ in. (11.8 × 19.4 cm.). Unsigned, attributed to William Daniell, circa 1790. Gift, Philip Hofer, 1967. M13154

2044. "Watering Place Rajah Bassah Dec 6 1824." Pencil. 13¹/₄ × 19¹/₈ in. (33.6 × 48.5 cm.). Signed, l.l., "Wᵐ Daniel." Gift, Donald Angus, 1970. M14472

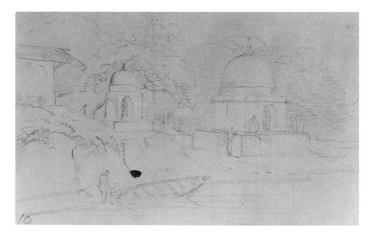

2046

2045. View of Whampoa Reach. Pencil. 14⁵/₈ × 21⁵/₈ in. (37.2 × 54.9 cm.). Unsigned, attributed to William Daniell. Gift, Frances M. Damon, 1971. M14527

2046. River scene in India: Ansence – Between Ariot and Vellue. Pencil. 5³/₄ × 9¹/₂ in. (14.5 × 24.1 cm.). Unsigned, attributed to William Daniell. Dated circa 1790. Gift, Frances D. Holt, 1972. M15409

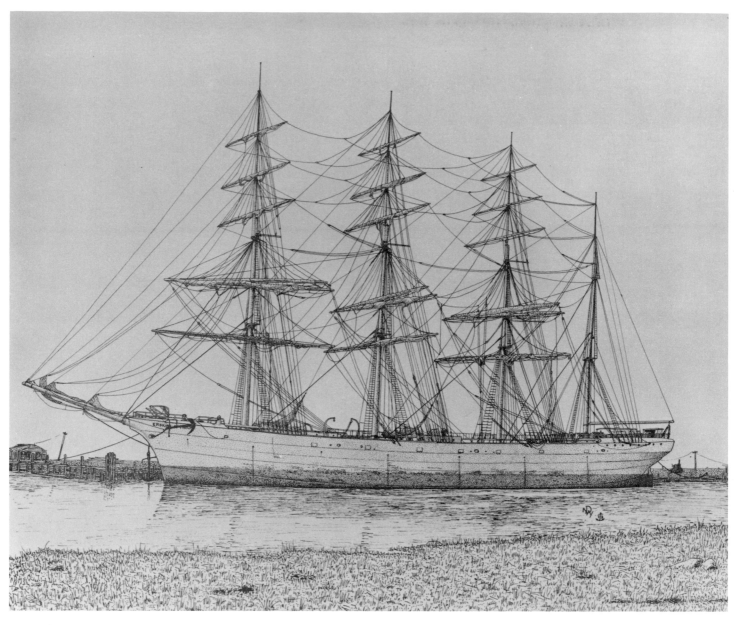

2047

Day, Noel Anglo–American [1926–]

2047. ERSKINE M. PHELPS [American bark]. Pen and ink. 14 × 16⁷/₈ in. (35.5 × 42.7 cm.). Signed, l.r., with the artist's monogram and in border "Noel Day." Built Bath, Maine, 1898, 2,715 tons. Gift, Noel Day, 1976. M16253

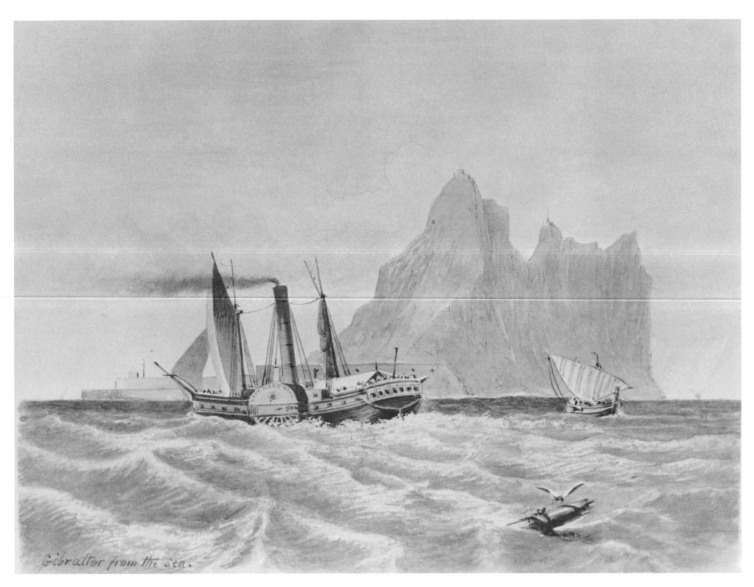

Gibraltar from the sea.

2048

Delamotte, William A. British [1775–1863]

2048. Gibraltar from the sea with P. & O. steamer *Lady Mary
Wood*. Watercolor. 9 × 11⁵⁄₈ in. (22.9 × 29.5 cm.). Signed on
mat, "W.A. Delamotte Delt". Deposit, Francis Lee Higginson.
<div align="right">FLH 263</div>

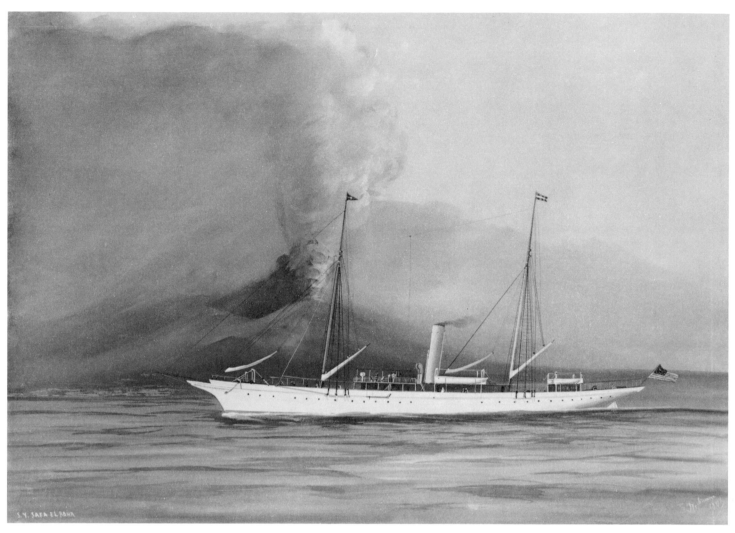

2049

De Simone, Tomaso Italian [fl. c. 1880–1910]

2049. SAFA EL BAHR [American steam yacht]. Gouache. 17⅞ × 25¼ in. (45.3 × 64.2 cm.). Signed, l.r., "De Simone 1906." Built 1894, Glasgow, 205 tons. Mt. Vesuvius in the background. Purchase, John Robinson Fund, 1970. M13909

2051

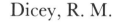

2050

2052

Dicey, R. M.

2050. H.M.S. SHANNON [British frigate]. Pencil. 11 × 7⁵/₈ in. (28 × 19.3 cm.). Signed, "R. W. Dicey," circa 1813. Accession information not known. M13917

Drew, Clement American [1806–1889]

2051. Unidentified ship. Oil. 13⁷/₈ × 20¹/₈ in. (35.7 × 51 cm.). Signed, on reverse, "No 34 / Pnxt C Drew / 18 Court St Boston / 1841." Torn trade label of Drew's on back of frame. Bequest, Miss Julia M. Fairbanks, 1969. M13665

2052. Unidentified ship. Oil. 14 × 20 in. (35.5 × 50.8 cm.). Signed, on reverse, "No 37 / Pnxt C Drew / 18 Court St Boston / 1841." Torn trade label of Drew's on back of frame. Bequest, Miss Julia M. Fairbanks, 1969. M13666

2053. Boon Island Light and shipping. Oil. 14 × 24 in. (35.6 × 61 cm.). Signed, l.r., "C. Drew." Deposit, Francis Lee Higginson. FLH 266

2053

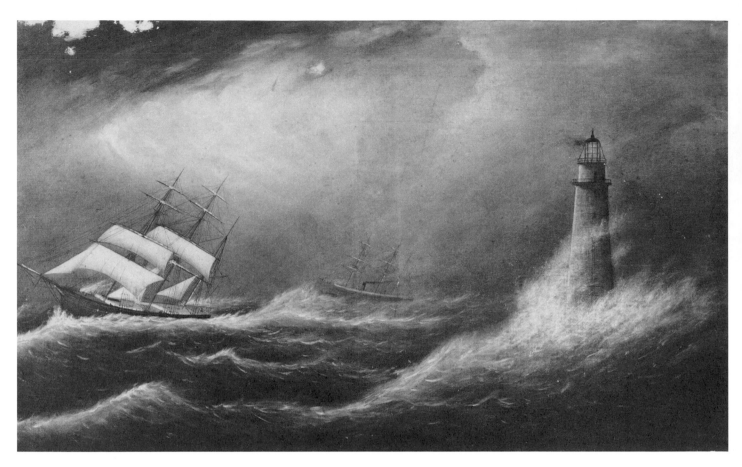

2054

2054. Minot's Light, Boston, with unidentified ship. Oil. 20 × 34¹/₄ in. (50.8 × 87 cm.). Signed, l.r., "C. Drew 1887." Inscribed on reverse: "Minot's Light by C. Drew 1887." Gift, Mr. and Mrs. Paul Colella, 1972. M14893

2055. White Island. Oil on board. 9¹/₈ × 12¹/₈ in. (23.2 × 30.8 cm.). Inscription on reverse: "Yachts off White Island Light Isle of Shoales By C. Drew 1884." Deposit, Francis Lee Higginson. FLH 262

Dutton, Thomas G. British [fl. 1845–1879]

2056. MONARCH [British steamer]. Oil. 50 × 70 in. (127 × 178 cm.). Inscription around liner: "Monarch Steam Ship, Captⁿ Bain, R.N. Passing the Bass Rock, 21ˢᵗ July 1834 Voyage from London to Edinburgh, Completed in 37 Hours. Presented by the Proprietors to James Law Jones Esqʳᵉ, Chairman of the London & Edinburgh Steam Packet Company." Deposit, Francis Lee Higginson. FLH 258

Edwards, Edward British [1738–1806]

2057. Allegorical representation of the Incorporation of The Marine Society, London, 1772. Oil. 34 × 34¹/₂ in. (86.3 × 87.6 cm.). Unsigned, attributed to Edward Edwards. Deposit, Samuel A. Bowman, 1968. D-500-11

Field, G. B.

2058. "North West View of the Town &c at Malacca." Pen and ink. 15¹/₄ × 21³/₄ in. (38.8 × 52.6 cm.). Signed, l.r., "sketched by G. B. Field N []." Dated circa 1860. Gift, Mr. and Mrs. John D. Holt, 1974. M16104

2059. "North View of BOOKET BRUIN at Malacca, the Country Residence of Major Farquhar, Governor of that Place." Pen and ink. 15³/₄ × 21 in. (40 × 53.2 cm.). Signed, l.r., "sketched by G. B. Field Novʳ 10." Dated circa 1860. Gift, Mr. and Mrs. John D. Holt, 1974. M16105

2055

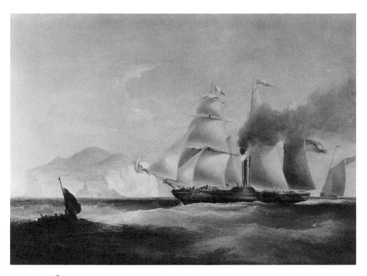

2056

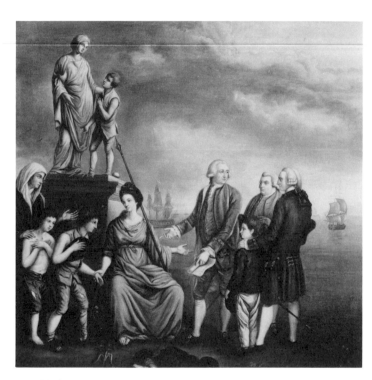

2057

2058

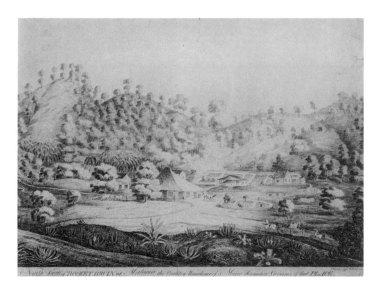

2059

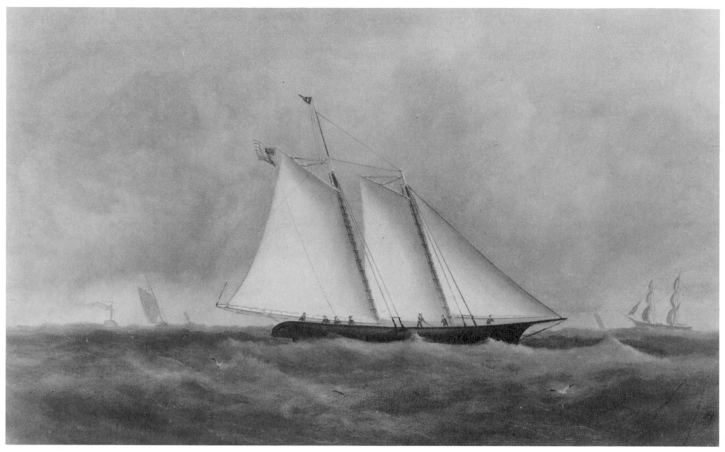

2060

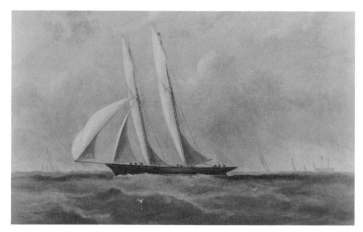

2061

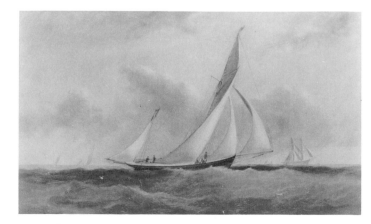

2062

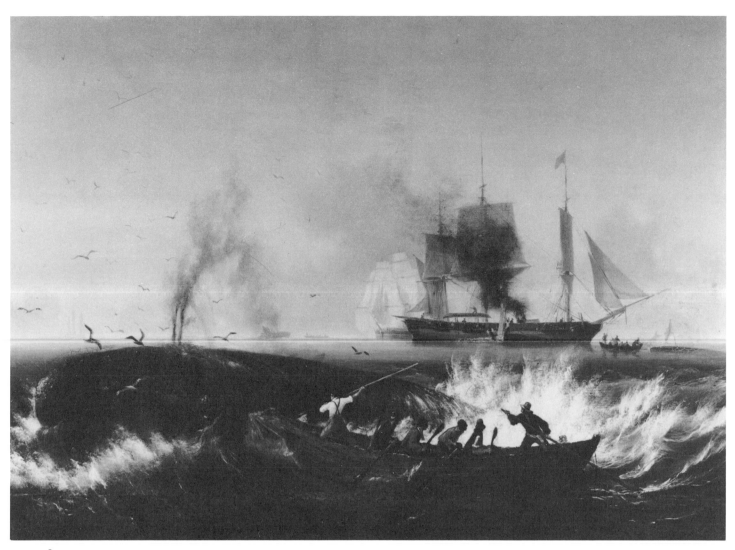

2064

Fowles, A. W. British [b. circa 1840]

2060. AMERICA [American schooner yacht]. Oil on paper. 9 × 14½ in. (22.8 × 36.9 cm.). Signed, l.l., "A.W. Fowles Ryde 1876." Built 1851, New York, N.Y., 170 tons. Purchase, 1935.
M13873

2061. CORINNE [British yacht]. Oil on paper. 8⅞ × 14¾ in. (22.5 × 37.5 cm.). Signed, l.l., "Sketch A. W. Fowles Ryde 76." Built 1874, Cowes, England, 93 tons. Purchase, 1935.
M13875

2062. FLORINDA [British yawl]. Oil on paper. 8⅞ × 14⅞ in. (22.5 × 37.7 cm.). Signed, l.l., "Sketch A. W. Fowles, Ryde, '76." Built 1873, Gosport, England, 1,879 tons. Purchase, 1935.
M13876

2063. Unidentified British cutter yacht. Oil on paper. 8⅞ × 15 in. (22.7 × 38.2 cm.). Signed, l.l., "Sketch A. W. Fowles Ryde 76." Purchase, 1935.
M13874

Garneray, Ambrose Louis French [1783–1857]

2064. Attacking the Right Whale. Oil. 23⅝ × 33 in. (60 × 83.8 cm.). Signed, l.r., "L. Garneray." Deposit, Mrs. John E. Abele, 1974.
M15688

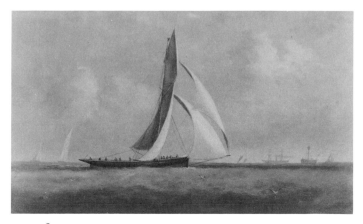

2063

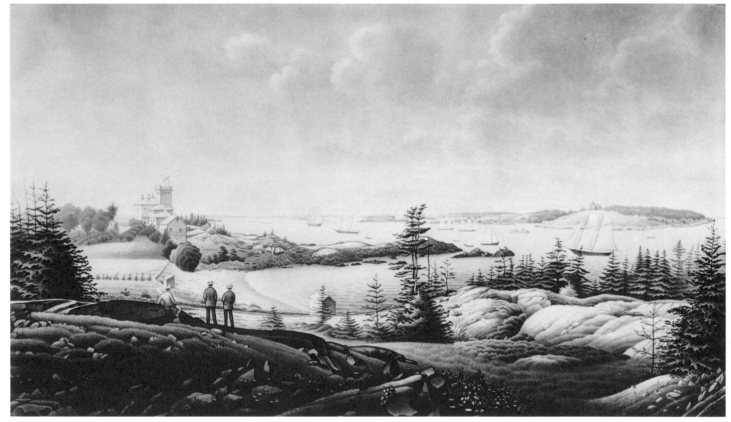

2067

2067. "Entrance to Portland Harbor, Me." Wash drawing. 19³/₄ × 31³/₄ in. (50.2 × 80.5 cm.). Signed, l.r., "Fr. Goth 1877." Gift, Ebenezer Gay, 1971. M14681

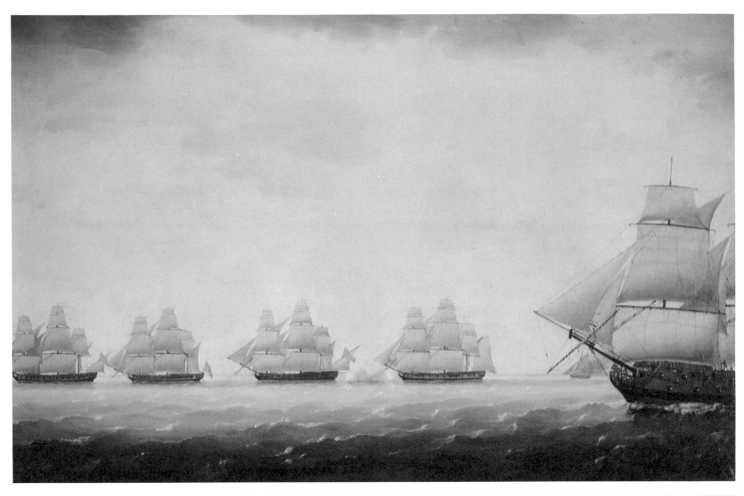

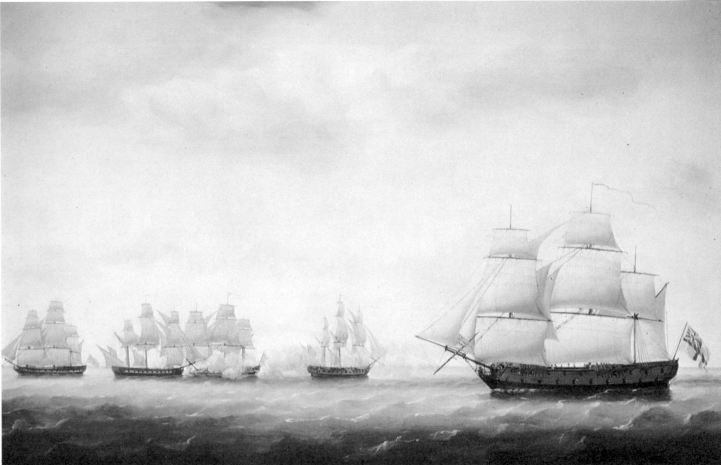

2076 and 2077. ENGAGEMENT BETWEEN THE AMERICAN CONTINENTAL FRIGATES *HANCOCK* AND *BOSTON* AND
THEIR PRIZE SHIP *FOX* AND THE BRITISH FRIGATES *FLORA* AND *RAINBOW*, 7 JULY 1777

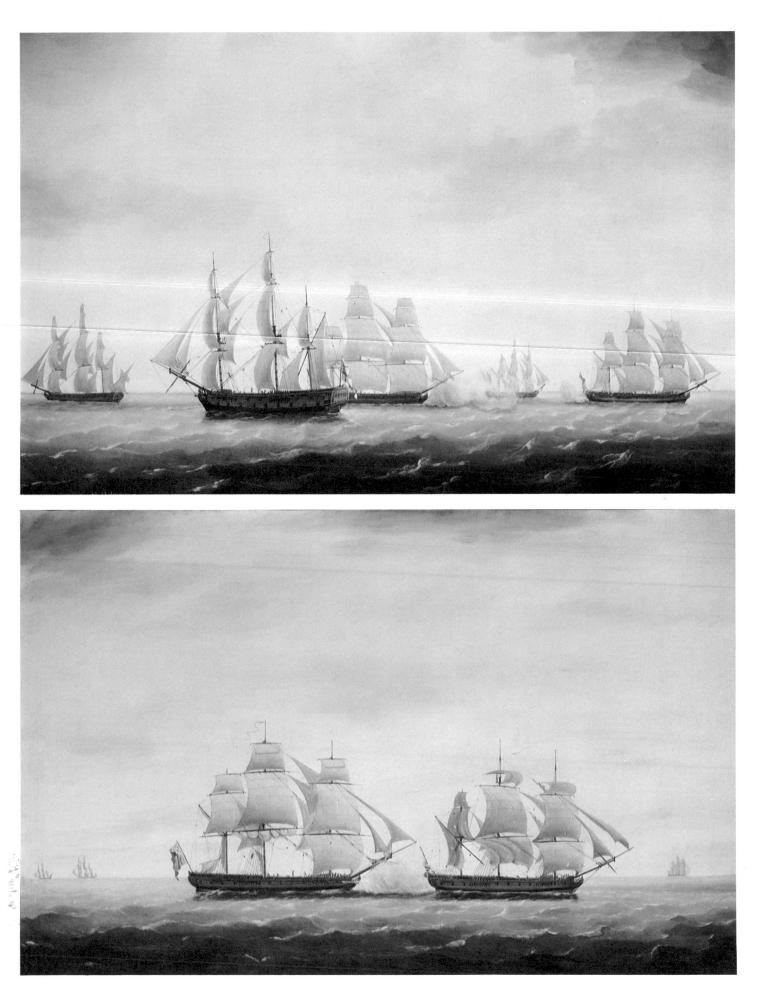

2078 and 2079. ENGAGEMENT BETWEEN THE AMERICAN CONTINENTAL FRIGATES *HANCOCK* AND *BOSTON* AND
THEIR PRIZE SHIP *FOX* AND THE BRITISH FRIGATES *FLORA* AND *RAINBOW*, 7 JULY 1777

2065

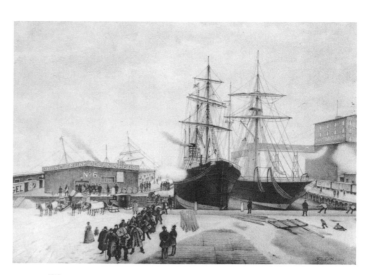

2066

2068

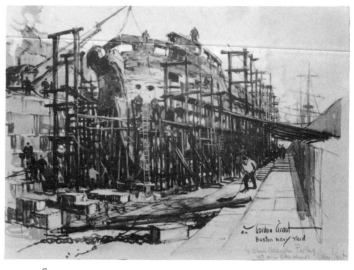

2069

Gay, Winkworth Allan American [1821–1910]

2065. Canton, China. Watercolor. 11 1/8 × 16 3/4 in. (28.2 × 42.6 cm.). Signed, l.l., "W. Allan Gay Canton, China." Deposit, Sargent Bradlee, 1975. D-500-90

Goth, Fr.

2066. OREGON [American steamer]. "Arrival of Steamship Oregon. Portland. Me. Jan. 21. 1884." Pencil. 14 1/8 × 20 1/4 in. (35.9 × 51.3 cm.). Signed, l.r., "Fr. Goth. 1884." See also M12550, a wash drawing by Goth of the same subject. Gift, Charles E. Mason, Jr., 1972. M15342

2068. "Cape Elizabeth Drydock near Portland. Me." Pencil. 14 1/8 × 18 in. (35.9 × 45.7 cm.). Signed, l.r., "Fr. Goth. 1878." See also M12551, a wash drawing by Goth of the same subject. Gift, Charles E. Mason, Jr., 1972. M15341

Grant, Gordon American [1875–1960]

2069. CONSTITUTION [United States frigate]. Watercolor. 12 × 18 in. (30.5 × 45.7 cm.). Signed, l.r., "Gordon Grant Boston Navy Yard." Built 1797, Boston, Mass. 2,200 tons. Inscribed: "to Charles Wellington Furlong with sincere Compliments Gordon Grant." Stamped: "NOV 6 1927." Gift, Mrs. Charles W. Furlong, 1968. M13303

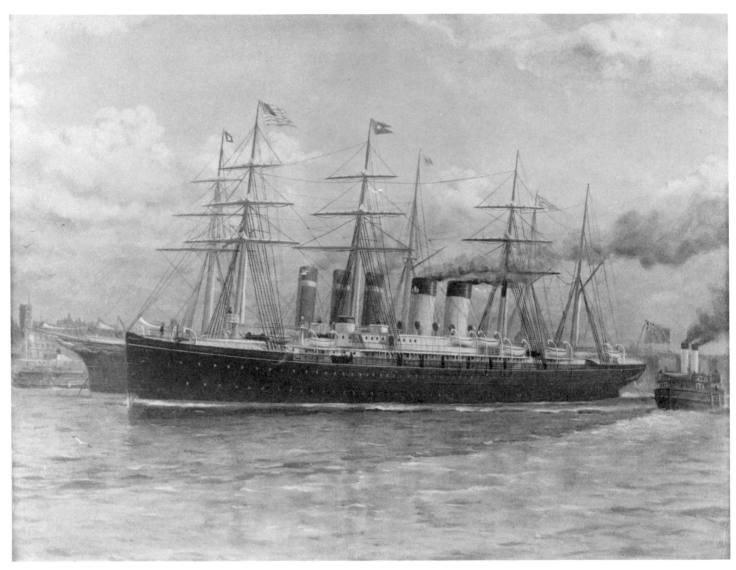

2070

Greenwood, P. (?)

2070. GERMANIC [British steamer]. Oil. $12^{1}/_{4}$ × 16 in. (31.1 × 40.6 cm.). Signed, l.r., "P.(?) Greenwood, 1888". Built 1874, Belfast, 5,008 tons. Deposit, Francis Lee Higginson.

FLH 273

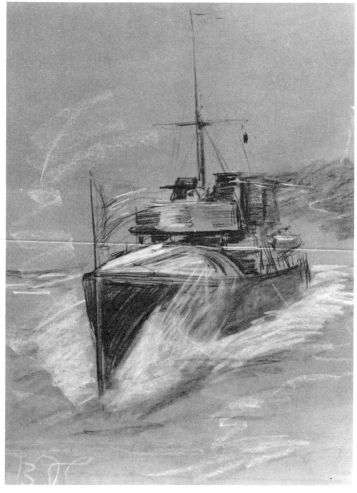

2071

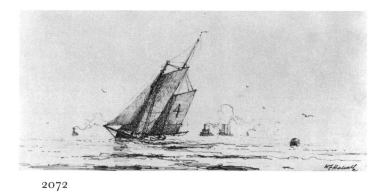

2072

Halsall, William Formby American [1841–1919]

2072. Pilot schooner No. 4. Pen and ink. 5 × 10⁷/₈ in. (12.7 ×
27.6 cm.). Signed, l.r., "W. F. Halsall." Gift, Mrs. Howard
Thayer Kingsbury, 1967. M13085

2073

Gribble, Bernard British [1873–1924]

2071. British destroyer of World War I. Pencil and chalk draw-
ing. 28¹/₄ × 20³/₈ in. (71.7 × 51.6 cm.). Unsigned, attributed to
Bernard Gribble. Gift, Giles M. S. Tod., 1974. M15657

2073. Unidentified sloops and schooners. Pencil sketch. 2¹/₂ ×
5 in. (6.3 × 12.7 cm.). Unsigned, attributed to W. F. Halsall,
circa 1880. Gift, C. K. Cobb, 1968. M13297

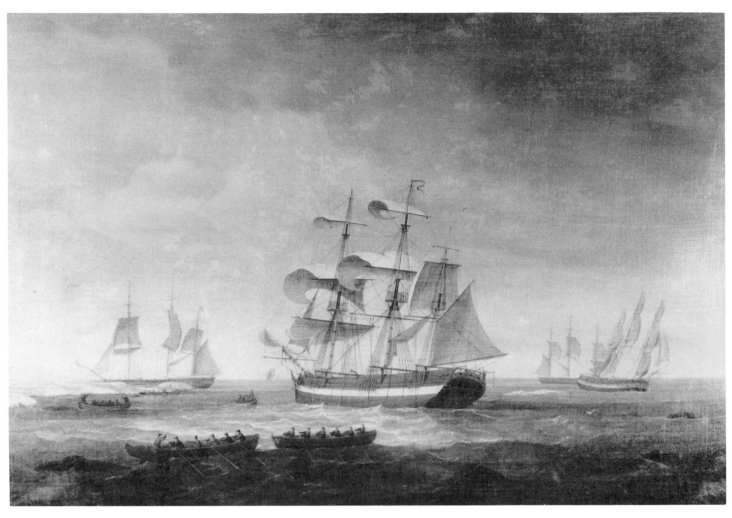

2074

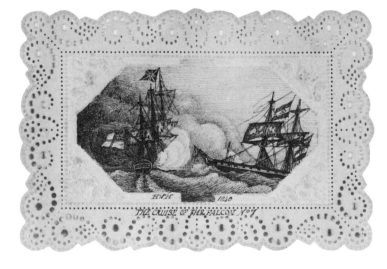

2075

Harwood, John British [fl. 1770–1825]

2074. English Whale Fleet in the Arctic. Oil. 26³/4 × 39¹/4 in. (68 × 99.6 cm.). Unsigned, attributed to John Harwood. Gift, F.B.L., 1976. M16520

Herbert, Henry William American [1807–1858]

2075. FALCON. "The cruise of the Falcon" [British warship]. Eight pen and ink sketches on doilies. 3 × 4¹/2 in. (7.5 × 11.4 cm.). Each signed and dated "H.W.H. 1840." Gift, Mrs. David P. Wheatland, 1976. M16506

Holman, Francis British [fl. 1767–1790]

2076. Naval engagement of 7 July 1777 between the American Continental frigates *Hancock* and *Boston*; their prize, H.M.S. *Fox*; and the British frigates *Flora* and *Rainbow*. Oil. 24 × 36¹/4 in. (61 × 92 cm.). Signed, l.l., "Fx Holman 1779." The first in the series of four paintings. (Left to right) *Hancock, Fox, Boston, Flora*, sloop *Britannia, Rainbow*. Purchase, 1976. See color plate between pages 30 and 31. M16452

2077. Naval engagement of 7 July 1777 between the American Continental frigates *Hancock* and *Boston*; their prize, H.M.S. *Fox*; and the British frigates *Flora* and *Rainbow*. Oil. 24 × 36¼ in. (61 × 92 cm.). Signed, l.l., "Fx Holman 1779." The second in the series of four paintings. (Left to right): *Fox*, *Hancock*, *Flora*, *Boston*, *Rainbow*. Purchase, 1976. See color plate between pages 30 and 31. M16453

2078. Naval engagement of 7 July 1777 between the American Continental frigates *Hancock* and *Boston*; their prize, H.M.S. *Fox*; and the British frigates *Flora* and *Rainbow*. Oil. 24 × 36¼ in. (61 × 92 cm.). Signed, l.l., "Fx. Holman 1779." The third in the series of four paintings. (Left to right): *Hancock*, *Rainbow*, *Flora*, *Boston*, *Fox*. Purchase, 1976. See color plate between pages 30 and 31. M16454

2079. Naval engagement of 7 July 1777 between the American Continental frigates *Hancock* and *Boston*; their prize, H.M.S. *Fox;* and the British frigates *Flora* and *Rainbow*. Oil. 24 × 36¼ in. (61 × 92 cm.). Signed, l.l., "Fx Holman 1779." The fourth in the series of four paintings. (Left to right): *Hancock*, *Rainbow*, *Flora*, *Fox*, *Boston*. Purchase, 1976. See color plate between pages 30 and 31. M16455

2080

Hopkinson, Charles Sydney American
[1869–1962]

2080. Unidentified vessel. Watercolor. 7 × 9½ in. (17.8 × 24.2 cm.). Signed, l.r., "C. S. Hopkinson 1890." Gift, F.B.L., 1975. M16226

Humphries, H.

2081. "View of Nootka Sound with the Spanish Settlement in Nov 1792 . . ." Ink wash. 14⅜ × 19 in. (36.5 × 48.3 cm.). Unsigned, attributed to H. Humphries. Inscription on reverse: "For Lord Hood [illegible] Nootker." Bequest, Estate of Stephen Phillips, 1972. M14953

2081

2082

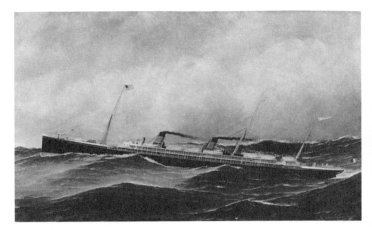

2083

Jacobsen, Antonio Nicolo Gasparo American
[1850–1921]

2082. JOSEPH W. FORDNEY [American steamer]. Oil. 22 × 36 in. (55.9 × 91.4 cm.). Signed, l.r., "Antonio Jacobsen, 1904". Built 1901, Newcastle, England, 2,297 tons. Deposit, Francis Lee Higginson. FLH 274

2083. LA TOURAINE [French steamer]. Oil. 30 × 50 in. (76.2 × 127 cm.). Signed, l.r., "A. Jacobsen, 1892 705 Palisade Av. West Hoboken, NJ." Built 1866, LaSeyne, France, 936 tons. Gift, Leonard E. Opdycke, 1977. M17072

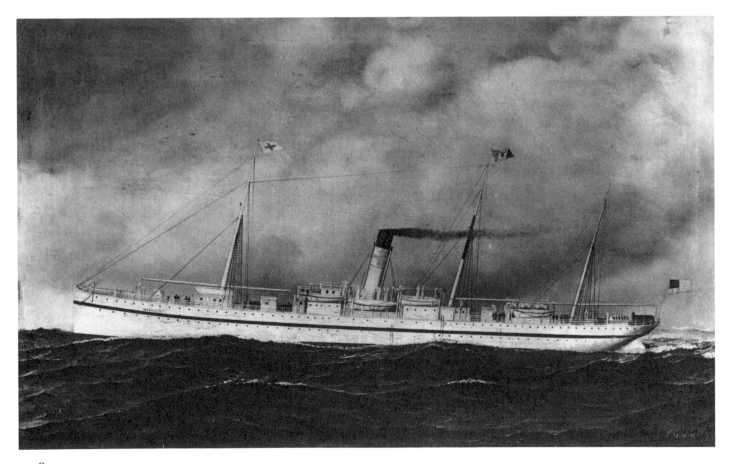

2084

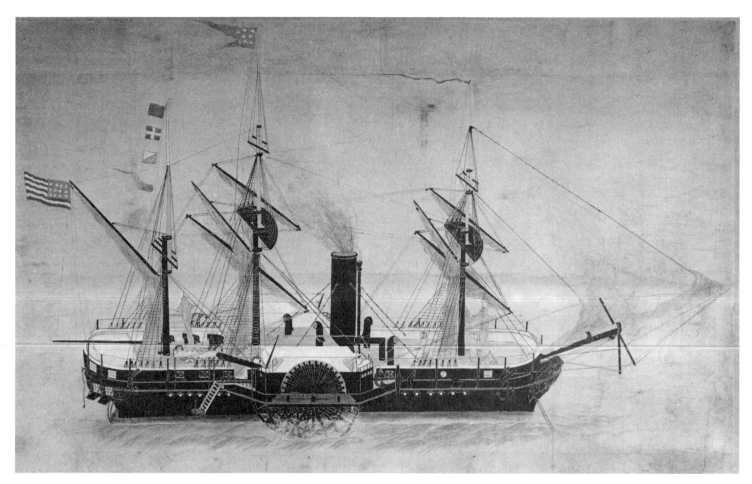

2085

2084. MISSOURI [American steamer]. Oil. 21⅞ × 35⅞ in. (55.6 × 91.1 cm.). Signed, l.r., "A. Jacobsen 1899." Built 1889, West Hartlepool, England, 1,857 tons. Deposit, Sailor's Snug Harbor, Boston, 1971. M14590

Japanese Artist, Unidentified

2085. Commodore Perry's ship. Watercolor scroll. 42 × 64 in. (106.6 × 162.6 cm.). Unsigned. In wooden box with Japanese inscriptions translating "Black Ship" and "Wide scroll." Purchase, 1972. M15244

Johnson, Marshall American [1850–1921]

2086. Four sketchbooks, containing 146 pages of sketches illustrating vessels, sailors, lighthouses, and various shore scenes around Mount Desert Island (Maine) and Boston. Purchase, Fellows and Friends Fund, 1977. Not illustrated.

M17046–M17049

Joliffe, J. H.

2087. Old Church, Malacca. Watercolor. 6 × 9¼ in. (15.2 × 23.5 cm.). Signed, l.r., "J. H. Joliffe 3 Mar 18 []." Circa 1870. Gift, Mr. and Mrs. John D. Holt, 1974. M16099

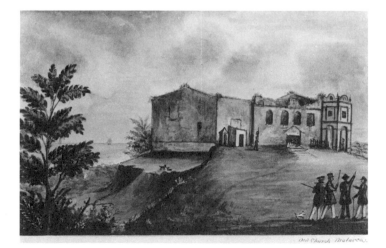

2087

Kendrick, Matthew British [1797–1874]

2088. Unidentified Sidewheel Steamer. Oil on panel. 37⅝ ×
51⅜ in. (95.7 × 130.5 cm.). Signed, l.l. (on buoy), "M. Kendrick." Deposit, Mrs. John E. Abele, 1974. M15689

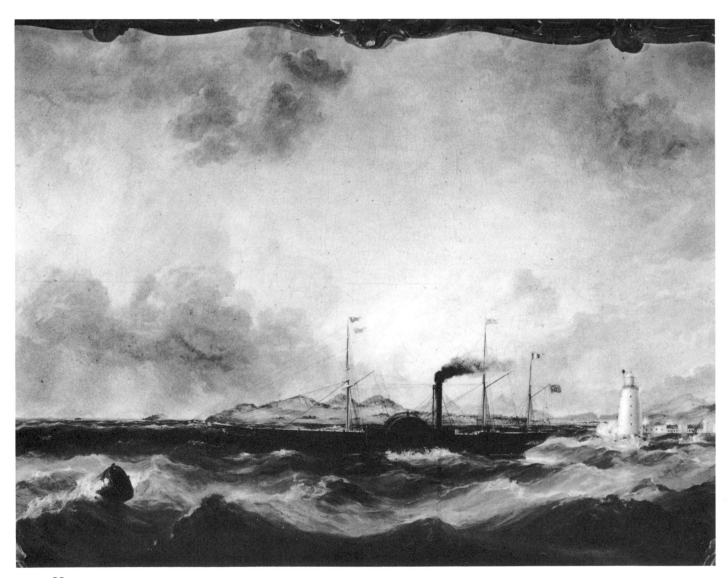

2088

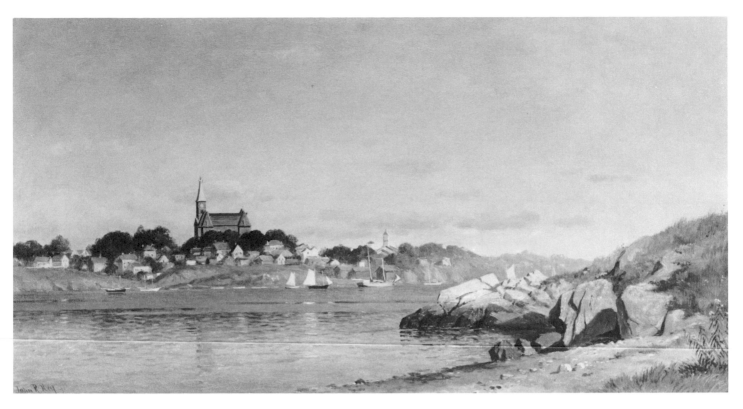

2089

Key, John Ross American [1837–1920]

2089. Marblehead Harbor, Massachusetts. Oil. 16 × 30¼ in. (40.6 × 76.8 cm.). Signed, l.l., "John R. Key." Dated, late 1880's. Gift, Russell W. Knight, 1969. M13691

Kokan, Shiba Japanese [1747–1818]

2090. View of Nagasaki with Western ships entering and the Dutch factory on Deshima. Hanging scroll painting. 6 ft. × 37 in. (183 × 94 cm.). Signed and dated 1799. Gift, Philip Hofer, 1968. M13393

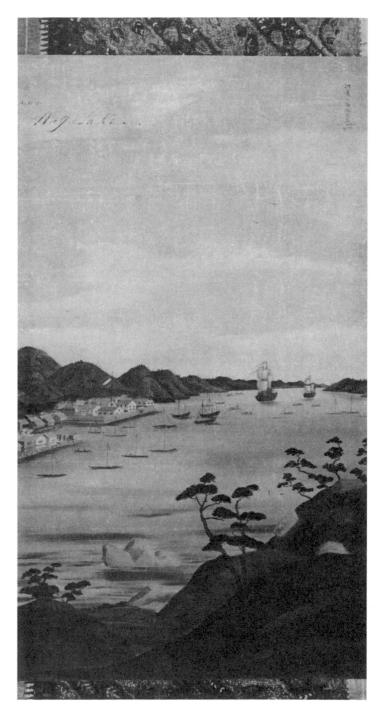

2090

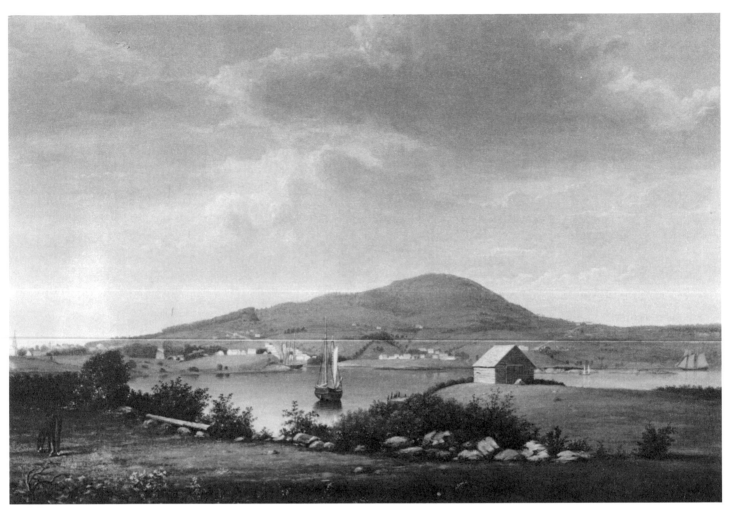

2091

Lane, Fitz Hugh American [1804–1865]

2091. View of Blue Hill, Maine, c. 1850. Oil. 19½ × 29½ in.
(49.5 × 74.9 cm.). Anonymous deposit, 1976. D-500-92

2092

2092. View of Southwest Harbor, Maine: Entrance to Somes Sound. Oil. 23³/₈ × 35⁵/₈ in. (59.2 × 90.5 cm.). Signed, l.r., "F.H. Lane 1852." Anonymous deposit, 1976. D-500-93

2093

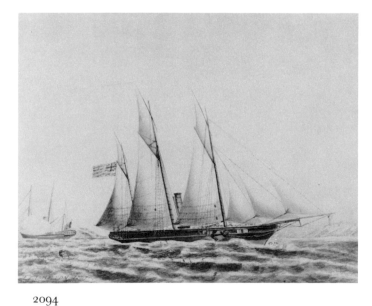

2094

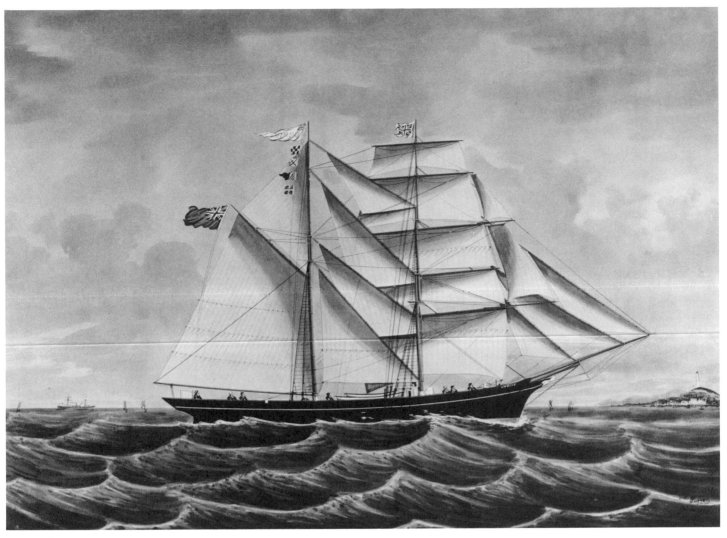

2096

Leavitt, John Faunce American [1905–1974]

2093. "Great Race to San Francisco off the Brazil Coast between the Clipper Ships *Flying Cloud* and *N. B. Palmer*, May – June 1853" [American ships]. Watercolor and gouache. 8 × 10 in. (20.3 × 25.3 cm.). Unsigned, attributed to John F. Leavitt, 1924. Gift, Stephen Wheatland, 1977. M17051

Le Breton, Louis French [1818–1866]

2094. British and French steam yachts. Watercolor. 8 × 11 1/2 in. (20.4 × 26.7 cm.). Signed, l.l., "Le Breton 1847/'Fourois'." Gift, Stephen Wheatland, 1970. M14444

Little, Philip American [1857–1942]

2095. Unidentified schooner in bay. Watercolor. 22 7/8 × 31 3/8 in. (58 × 79.6 cm.). Signed, l.l. "Philip Litt[l]e 1937." On reverse: a similar watercolor signed l.r., "Philip Little 1934." Gift, Philip Little, Jr., 1975. M16212

Luzro, A. Italian [active 1895]

2096. UNDINE [British hermaphrodite brig]. Watercolor. 20 1/2 × 28 in. (52 × 71.2 cm.). Signed, l.r., "A. Luzro, Genoa 1892." Built 1875, Fowey, England, 161 tons. Shown at Genoa. Purchase, 1969. M13557

2095

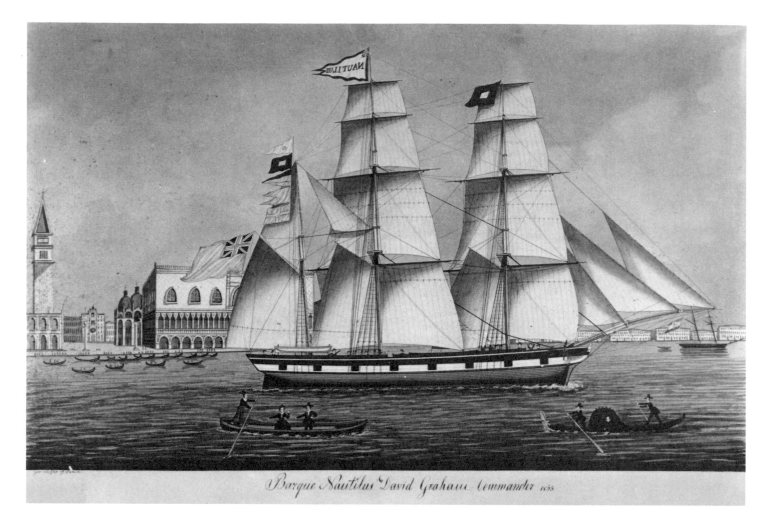

Barque Nautilus David Graham Commander 1853

2097

Luzro, Giovanni Italian [active 1853–1877]

2097. NAUTILUS. "Barque Nautilus David Graham Commander 1853" [British bark]. Watercolor. 14¹/₈ × 21³/₈ in. (36 × 54.3 cm.). Signed, l.l., "Gio Luzro of Venice." Built 1845, Shields, England, 268 tons. Venice in the background. Bequest, Miss Julia M. Fairbanks, 1969. M13667

2098

McDowall, ?

2098. "P. Episcopal Mission Station, Cavally, W. Africa, Dec. 1839." Pencil. 7 × 9³/₄ in. (17.6 × 24.8 cm.). Signed, l.l., "drawn by M^cDowall [?]." Gift, Annie P. Treadwell, 1933.
M16441

McPherson, Murdoch Canadian [1841–1915]

2099. ARABIA. "Ship 'Arabia' of Boston, Thomas Fuller, Master, John L. Gardner, owner" [American ship]. 14³/₄ × 20³/₈ in. (37.5 × 54.3 cm.). Unsigned, attributed to Murdoch McPherson. Built 1863, Kennebunk, Me., 1,034 tons. Bequest, Estate of Perley A. Tenney, 1970. M14312

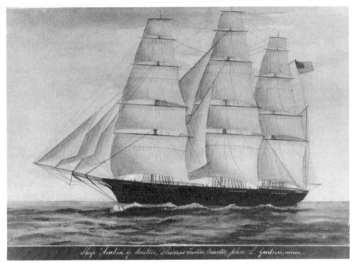

2099

Minden, Hendrik von German

2100. PRINZ CARL. "Prinz carl. Gefuhrt von Cap^t Carl Harder. Im Vorbeisegeln beim Kieler Seebade." [Danish West India ship]. Watercolor. 19³/₄ × 29³/₄ in. (50.2 × 75.6 cm.). Signed, l.r., "verfer^t v. H v Minden Kiel den 1 January 1827 (?)." Built 1826, Kiel, Germany, 294 tons. Bequest, Miss Julia M. Fairbanks, 1969. See color plate between pages 46 and 47. M13676

Montardier French [fl. 1814–1823]

2101. Naval Engagement between the U.S. Frigate CONSTITUTION and H.M. Frigate JAVA. Watercolor. 17 × 21¹/₂ in. (43.2 × 54.6 cm.). Signed, l.r., "Montardier du havre de grace." Gift, Robert Adams Cushman, 1977. See color plate between pages 46 and 47. M15683

2102. Naval Engagement between the U.S. Frigate CONSTITUTION and H.M. Frigate JAVA. Watercolor. 17 × 21¹/₂ in. (43.2 × 54.6 cm.). Signed, l.r., "Montardier du havre de grace." Gift, Robert Adams Cushman, 1974. M15682

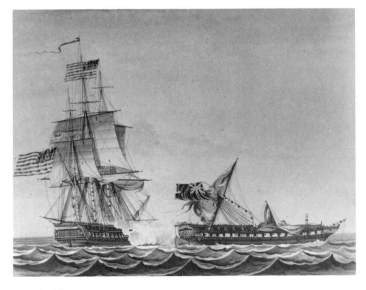

2102

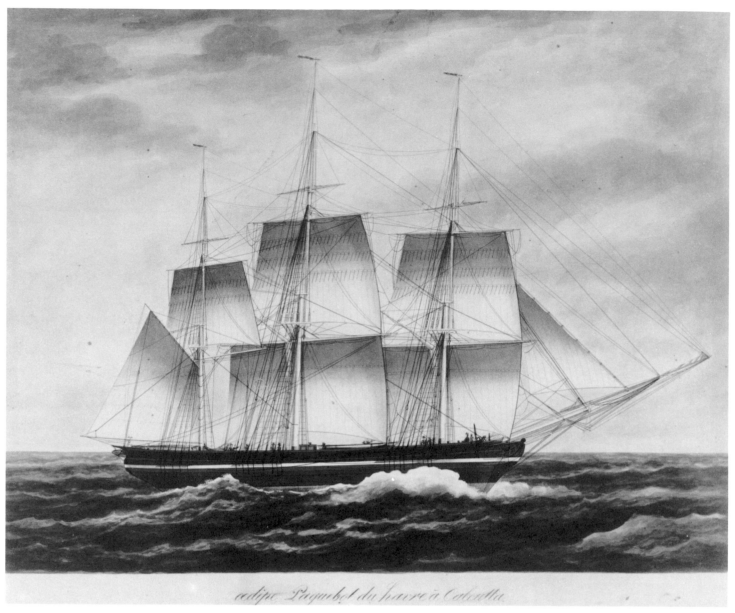

2103

oedipe Paquebot du havre à Calcutta

2103. OEDIPE. "Oedipe, Paquebot du havre a Calcutta" [French ? ship]. Watercolor. 17¹/₂ × 22 in. (44.5 × 55.8 cm.). Unsigned, attributed to Montardier. Gift, Stephen Wheatland, 1968. M13269

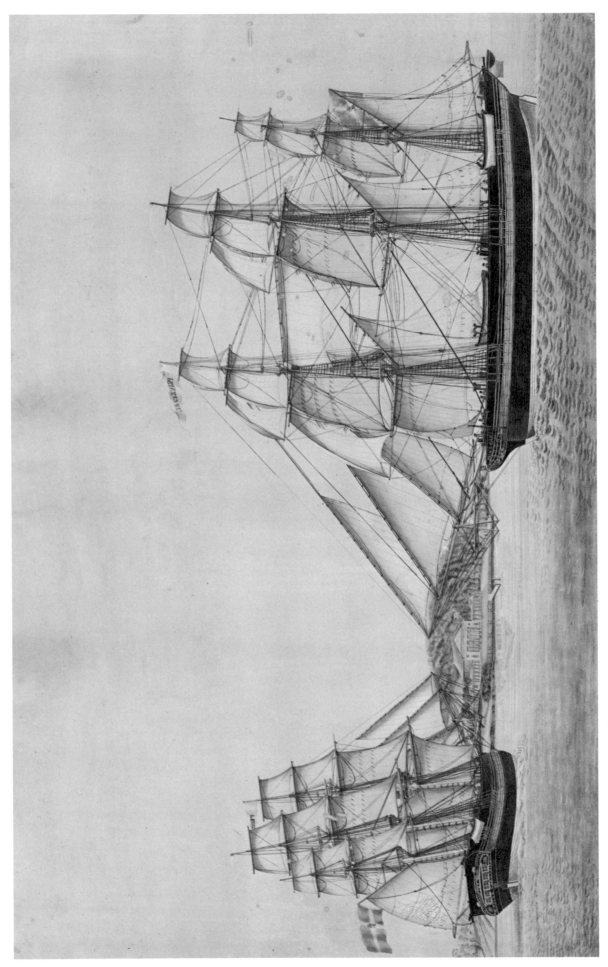

2100. DANISH WEST INDIA SHIP *PRINZ CARL* OFF THE KIEL SEABATHS

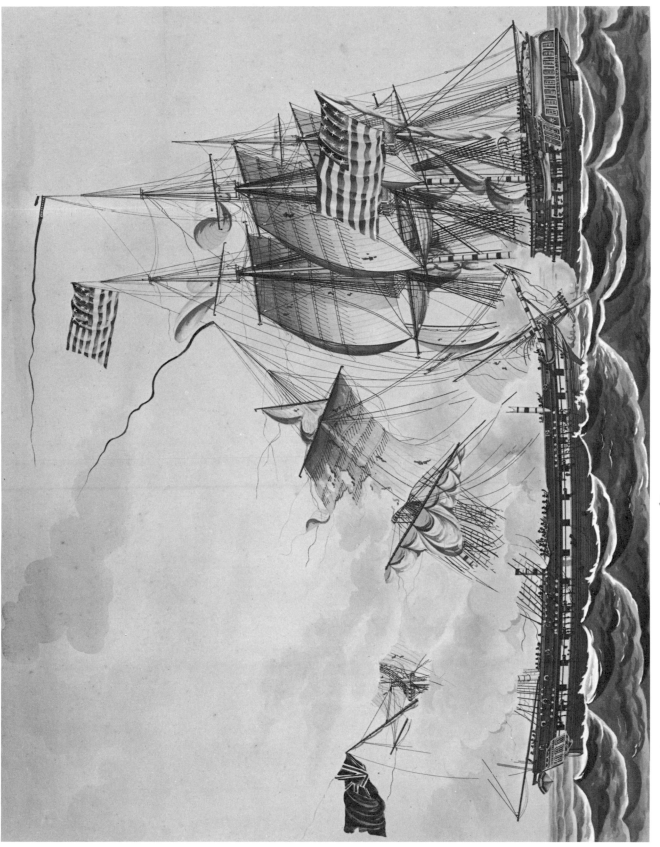

2101. U.S. FRIGATE *CONSTITUTION* BATTERS H.M.S. *JAVA*

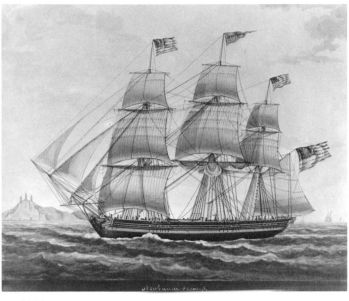

2104

2104. STEPHANIA. "Stephania of New York" [American ship]. Watercolor. $9^{1}/_{2} \times 11$ in. (24×28 cm.). Signed, l.r., "Montardier au Havre." Built 1819, New York, 315 tons. Gift, Leonard E. Opdycke, 1977. M17073

Müller, ?

2105. Shipping in Hamburg Harbor. Oil. $43^{1}/_{2} \times 63^{1}/_{4}$ in. (110.5×160.6 cm.). Signed, l.r., "Müller-Gossen." Deposit, Francis Lee Higginson. FLH 261

Noakes, J.

2106. Singapore (?). Watercolor. $12^{1}/_{4} \times 18^{1}/_{4}$ in. (31×46.2 cm.). Signed, l.l., "J. Noakes 1862." Gift, Mr. and Mrs. John D. Holt, 1974. M16103

Nobbs, A. J. British

2107. Unidentified Coast Lines Ltd. vessel loading refined chalk powder in the Thames River, England. Pen and ink. $13^{7}/_{8} \times 10$ in. (35.4×25.4 cm.). Unsigned, attributed to Cadet A. J. Nobbs of H.M.S. *Worcester*, 1928. Gift, V. Ralty Woolfe, 1970. M13905

2105

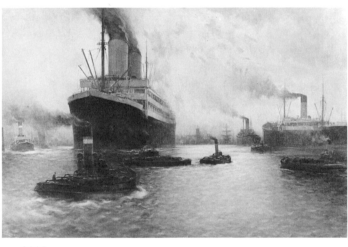

2106

2107

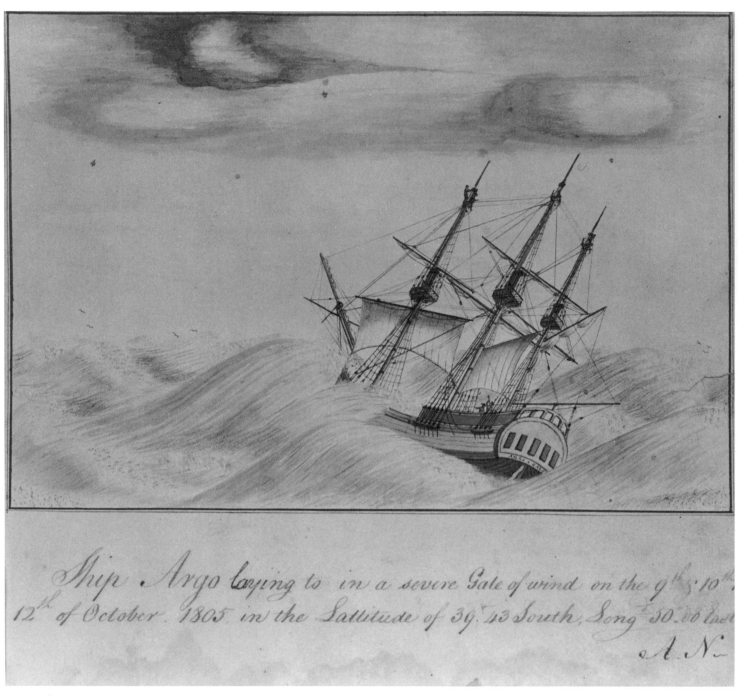

Ship Argo laying to in a severe Gale of wind on the 9th & 10th 12th of October. 1805, in the Lattitude of 39.°43 South, Long.d 50.°00 East

A. N.

2108

Northey, Abijah American [1774–1853]

2108. ARGO. [American ship]. "Ship Argo laying to in a severe Gale of wind on the 9th & 10th 11th & 12th of October 1805 in the Lattitude of 39°43 South, Long.d 50°00 East." Pen and ink. 8¼ × 7⅞ in. (21 × 20 cm.). Built 1803, Durham, N.H., 325 tons. Signed, l.r., "AN." Purchase, Salem Marine Society funds, 1969. M13830 A

2109. ARGO. [American ship]. "The Ship Argo and the Ketch in the United States Service commanded by Cap McNeele bound to Tripoly." Pen and ink. 8¼ × 7¾ in. (21 × 18.7 cm.). Built 1803, Durham, N.H., 325 tons. Signed, l.r., "AN." Purchase, Salem Marine Society funds, 1969. M13830 B

2110. Competition design for the Salem Custom House. Ink and wash rendering. 9½ × 12 in. (24.1 × 30.5 cm.). Signed at left, "A. Northey." Inscription on reverse: "Custom House Salem July 20th." Circa 1818. Purchase, 1976. M16508

Oursler, C. Leslie American [1913–]

2111. QUEEN ELIZABETH and QUEEN MARY [British steamers]. Oil. 24 × 38¼ in. (60.9 × 97.1 cm.). Signed, l.r., "Oursler '68". Inscription on reverse: "Passing of the Queens". The view shows the two liners passing in New York Harbor on the last homeward bound trip of the *Queen Mary*. Deposit, Francis Lee Higginson. FLH 269

48

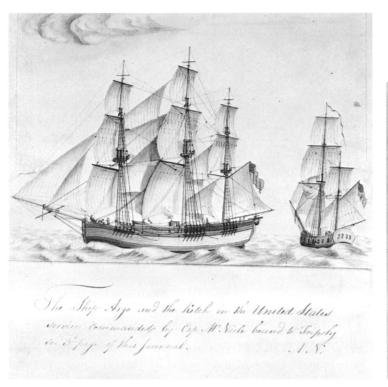

The Ship Argo and the Ketch in the United States Service commanded by Cap. M. Nicle bound to Tripoly See 8 page of this Journal. J.S.

2109

A. Norchey

10 feet to an Inch

2110

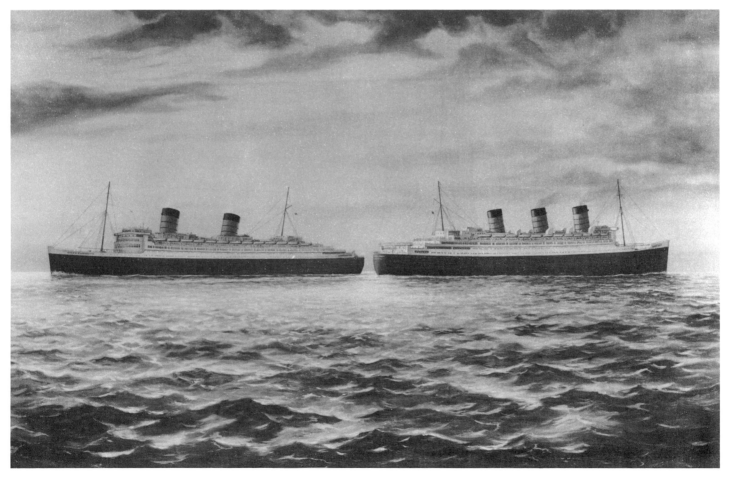

2111

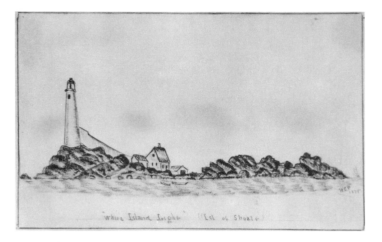

2112

2114

P., H.C. American

2112. "'White Island Light' (Isl of Shoals)." Pencil sketch. 14½ × 7¼ in. (11.5 × 18.4 cm.). Signed, l.r., "H.C.P. 1875." Gift, Essex Institute, 1918. M15597

Petersen, Jacob Danish [1774–1854]

2113. NEWPORT [American ship]. "Ship Newport of Newport [Rhode Island] Commanded by John Buroughs passing the Sound." Watercolor. 16½ × 25½ in. (42 × 64.7 cm.). Signed, l.r., "Drawn by Jacob Petersen." Built 1821, Newport, R.I., 407 tons. Elsinore Castle in background. Gift, J. Welles Henderson, 1974. M15747

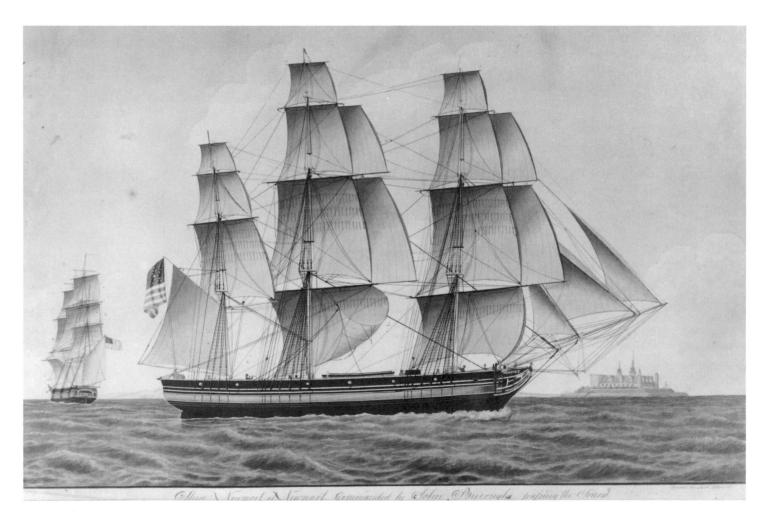

2113

Petersen, Lorentz Danish [1803–1870]

2114. STERLING [American bark]. Oil. 18 × 25¼ in. (45.8 × 64 cm.). Signed, l.r., "L. [?] Petersen fecit maker 1856[?]." Built 1834, Maine. Accession information not known. M14061

Priestman, Bertram British [1868– ?]

2115. R.M. S. AQUITANIA [British steamer]. 46 × 52½ in. (116.8 × 133.3 cm.). Signed, l.r., "B. Priestman 30." Built 1914, Clydebank, Scotland, 45,647 tons. Gift, Cunard Line Ltd., 1970. M14221

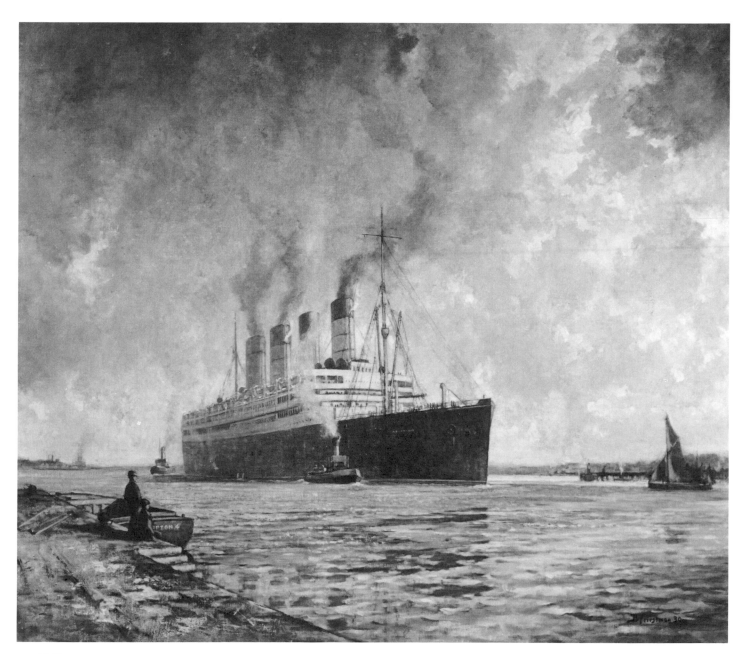

2115

Richards, William Trost American [1833–1905]

2116. Fort Dumpling, Fort Cove, Cananicut, Rhode Island. Watercolor. 9¼ × 14¼ in. (23.5 × 36.2 cm.). Signed, l.r., "W. T. Richards 1881." Inscription on reverse: "Fort Dumpling Cananicut I R.I. Wm T. Richards 1881." Also label: "B14 Fort Cove Cananicut R. I. William T. Richards painted for Mr. Geo Whitney 1881." Gift, J. Welles Henderson, 1975. M16244

2116

Raleigh, Charles Sidney American [1830–1925]

2117. MARY & HELEN [American bark]. Oil. 26³/₈ × 39³/₈ in. (69.5 × 100 cm.). Signed, l.l., "C.S. Raleigh 1879." Built 1879, Bath, Me., 450 tons. *Mary & Helen* was the first American steam whaler. Gift, F.B.L., 1976. M16518

Rice, Thomas G. American

2118. Three sketchbooks containing miscellaneous pencil sketches of seascapes and marine subjects. Gift, Mrs. Thomas G. Rice, 1968. Not illustrated. M13351–M13353

2117

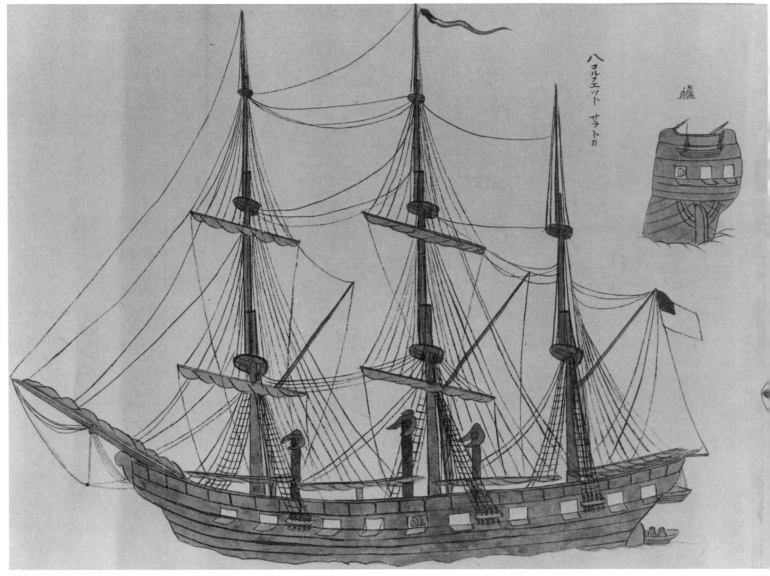

ハコルフェット　サラトカ

艦

2119 (Detail)

54

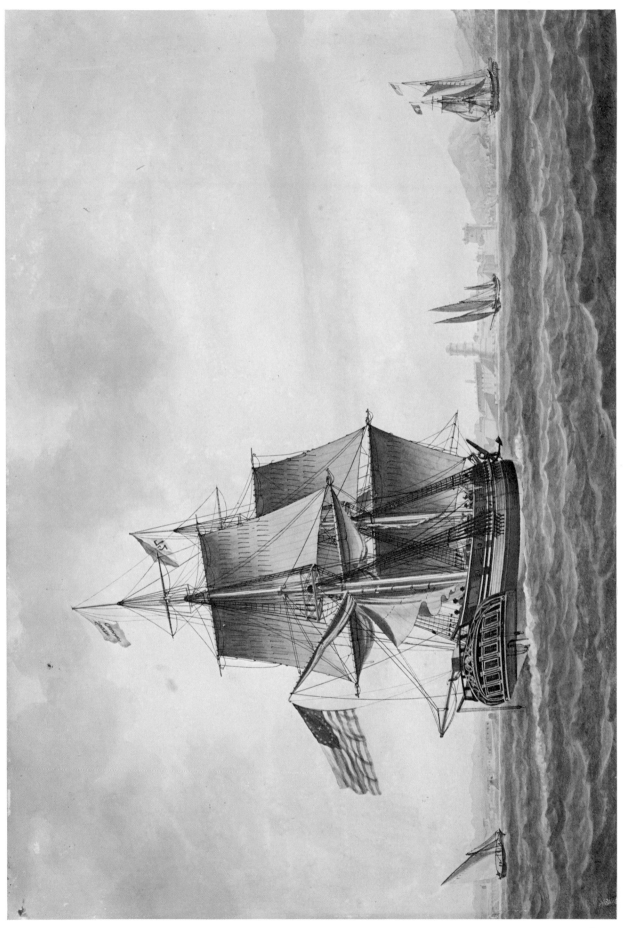

2125. THE AMERICAN SNOW *SOUTH CAROLINA* OFF MARSEILLES, 1819

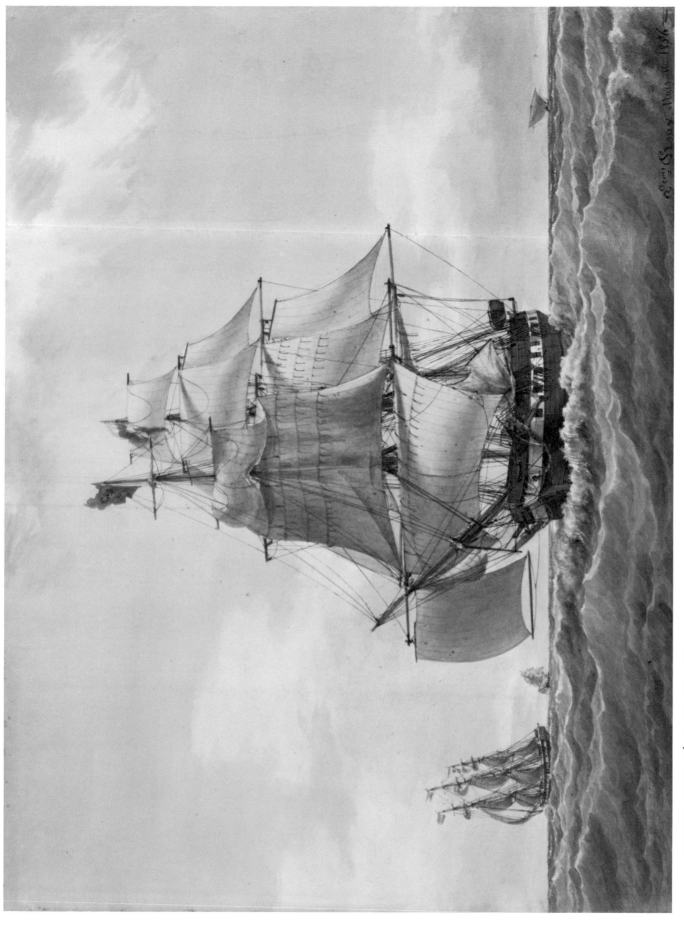

2134. FRENCH BARK *ZÉLIE* AT SEA, 1856

Richō, Ishibashi Japanese

2119. "Kurofune raikō zufu [illustration of the visit of the Black Ships]". Handscroll with sumi ink and colors. 12⅛ × 6 in. (30.8 × 19.2 cm.). Dated 1854. Depicting the expedition to Japan by Commodore Matthew C. Perry, 1854, and illustrating the Western ships, Japanese craft, the American officers, their comings and goings. Gift, F.B.L. and Philip Hofer, 1973.

M15579 A

2120. "Kurofune raikō zufu [illustration of the visit of the Black Ships]." Handscroll with sumi ink and colors. 12⅛ × 6 in. (30.8 × 19.2 cm.). Dated 1854. Depicting the expedition to Japan by Commodore Matthew C. Perry, 1854, and illustrating the Western ships, details of them and their equipment, portraits of officers, etc. Gift, F.B.L., and Philip Hofer, 1973.

M15579 B

2120 (Detail)

Robinson, W. T. American [1852– ?]

2121. Rye Beach, New Hampshire. Watercolor on board. 6 × 9 in. (15.2 × 22.9 cm.). Signed, l.r., "W. T. Robinson." Gift, Sargent Bradlee, 1968.

M13379

2121

Roux, Ange-Joseph Antoine French [1765–1835]

2122. LE DUBOURDIEU. "Corsaire, Le Dubourdieu, Capⁿ Fᶜᵒⁱˢ Mordeille, Capturant a L'Abordage le Loyalty de 450 Tˣ dans la Meditⁿᵉᵉ en 1810" [French privateer brig]. Watercolor. 17½ × 23⅝ in. (44.4 × 60 cm.). Signed, l.r., "Antᵉ Roux à Marseille 1823." Gift, Richard Wheatland Collection, 1977.

M17129

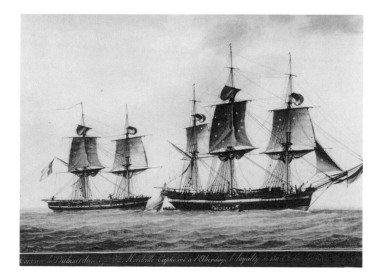

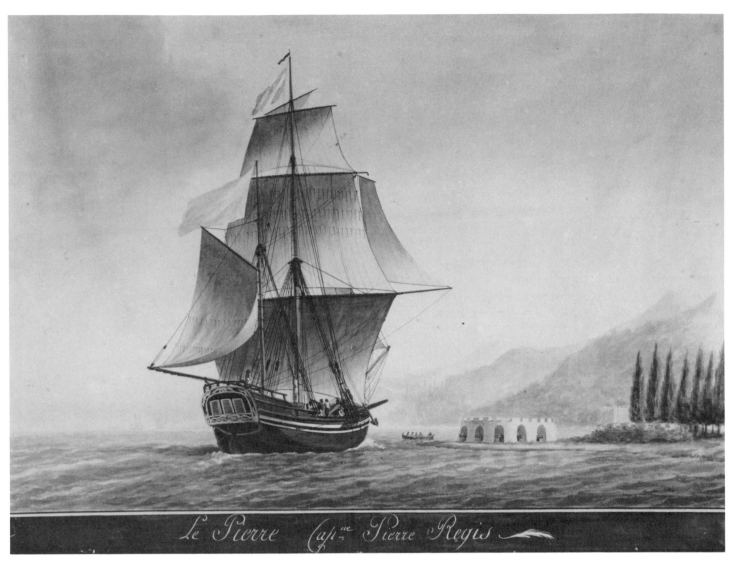

2123

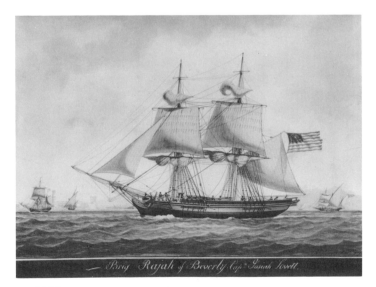

2124

56

2123. LE PIERRE. "Le Pierre Cap^ne Pierre Regis" [French ketch]. Watercolor. 16¾ × 23 in. (42.6 × 58.4 cm.). Signed, l.r., "Ant^ne Roux a Marseille 1816." Gift, Richard Wheatland Collection, 1976. M17030

2124. RAJAH. "Brig Rajah of Beverly, Cap^tn Josiah Lovett" [American snow]. Watercolor. 17¼ × 23½ in. (43.8 × 59.7 cm.). Signed, l.r., "Ant^e Roux à Mars^lle 1819." Deposit, 1977. D-500-101

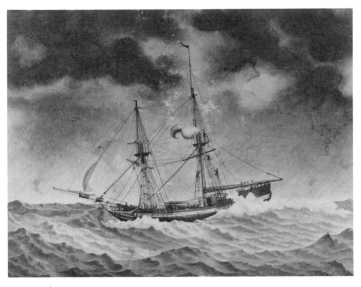

2126

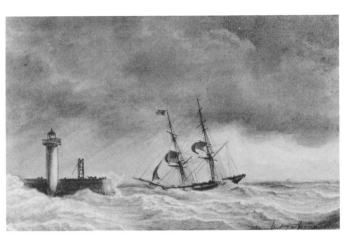

2127

2125. SOUTH CAROLINA. "South Carolina of New-Orleans, Cap^tn W. F. Wyer, leaving Marseilles for New Orleans, Sep^r the 4^th 1819" [American snow]. Watercolor. 17 × 23½ in. (43.2 × 59 cm.). Signed, l.r., "Ant^e Roux a Marseille 1820." Built 1809, Philadelphia, 245 tons. Gift, Richard Wheatland Collection, 1976. See color plate between pages 54 and 55. M17029

2126. Unidentified Brig in a Storm, Watercolor. 18½ × 24¼ in. (47 × 61.6 cm.). Signed, l.r., "1802 Ant^e Roux à Marsei-[lle]." Gift, Leonard E. Opdycke, 1977. M17076

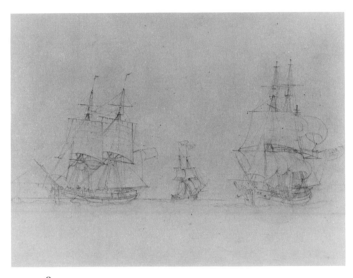

2128

2127. Brig entering harbor. Watercolor. 6¾ × 10¼ in. (17.2 × 26 cm.). Signed, l.r., "Ant^ony Roux 1818." The signature is not that of Antoine and the picture should probably be attributed to his son Frédéric. The quay and lighthouse is that at Havre where Frédéric worked from 1835–1870. Gift, Charles H. Taylor, 1972. M15238

2128. Unidentified shipping. Pencil. 8½ × 12 in. (21.6 × 30.5 cm.). Unsigned, attributed to Antoine Roux, 1817. Gift, Stephen Wheatland, 1972. M14877

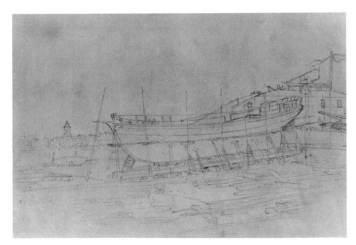

2129. Marseilles Old Port. Wash drawing. 9¾ × 14¾ in. (24.8 × 37.5 cm.). Unsigned, attributed to Antoine Roux. Dated upper left, "1812 Le 7 Mai." On reverse: pencil sketch of a vessel under construction. Gift, Richard Wheatland Collection, 1972. M15178

2129

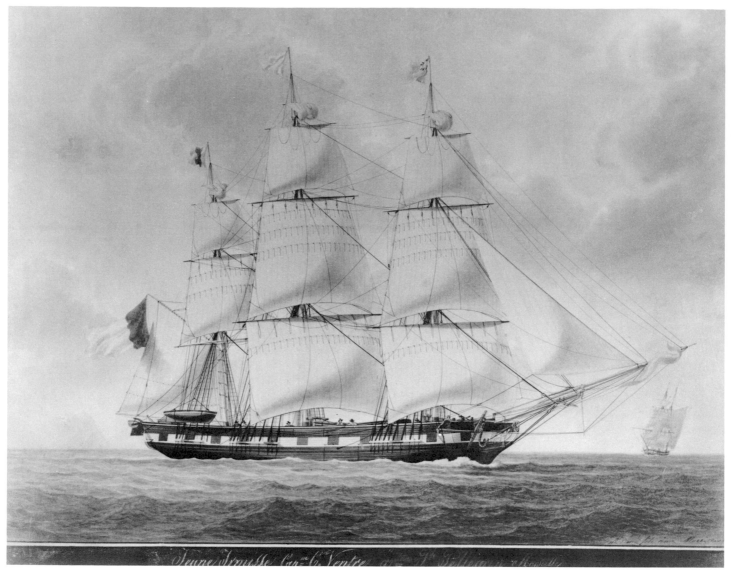

2130

Roux, Mathieu-Antoine French [1799–1872]

2130. JEUNE IRMISSE. "Jeune Irmisse, Capne C. Ventre, arteur Th Pellegrin Marseille" [French ship]. Watercolor. 17^1/$_2$ × 22^3/$_4$ in. (44.4 × 57.8 cm.). Signed, l.r., "Ante Roux fils ainé Marseille 1832." Gift, Leonard E. Opdycke, 1977. M17075

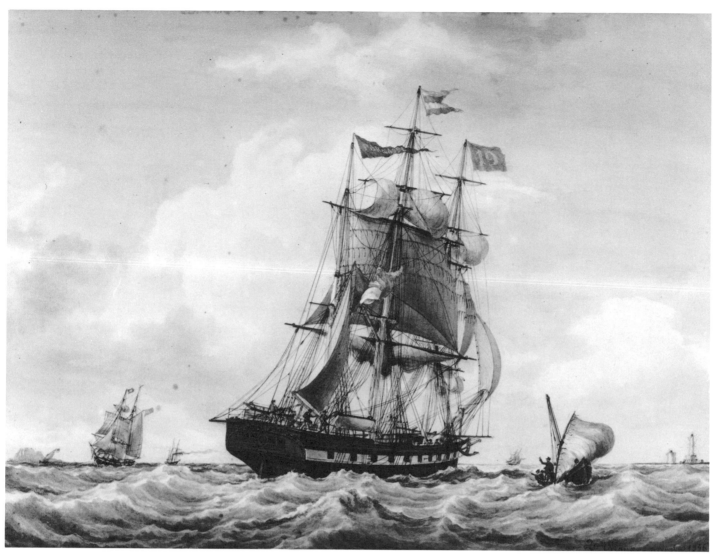

2131

Roux, François Geoffroi French [1811–1882]

2131. PARNASSE. "Parnasse" [French bark]. Watercolor. 16¹/₄ × 22 in. (41.3 × 55.9 cm.). Signed, l.r., "Fçois Roux novembre 1856." Built 1841, Bordeaux, 325 tons. Gift, Richard Wheatland Collection, 1976. M16524

2132. RAPIDE. "Rapide, Capne L. Luquet Armateur Mr Mor Fabry Fils 1845" [French bark]. Watercolor. 17³/₄ × 22¹/₂ in. (45.1 × 57.2 cm.). Signed, l.r., "Fçois Roux a Marseille en 7bre 1845." François Roux's trade card on reverse. Gift, Leonard E. Opdycke, 1977. M17074

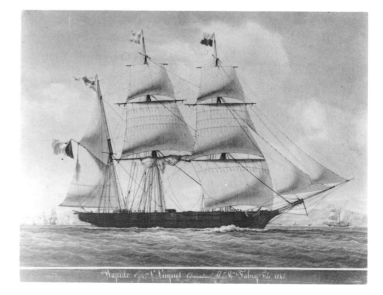

2132

2133

2133. LE RHÔNE. "Le Rhône" [French bark]. Watercolor. 18 × 23¹/₄ in. (45.7 × 59 cm.). Signed, l.r., "F^çois Roux Marseille, Juin 1857." Built 1835, Marseilles, 277 tons. Gift, Richard Wheatland Collection, 1976. M16523

2134. ZÉLIE. "Zélie" [French bark]. Watercolor. 17³/₄ × 22¹/₂ in. (45 × 57 cm.). Signed, l.r., "F^çois Roux, Marseille 1856." Built 1829, La Ciotat, 241 tons. Gift, Richard Wheatland Collection, 1977. See color plate between pages 54 and 55. M17128

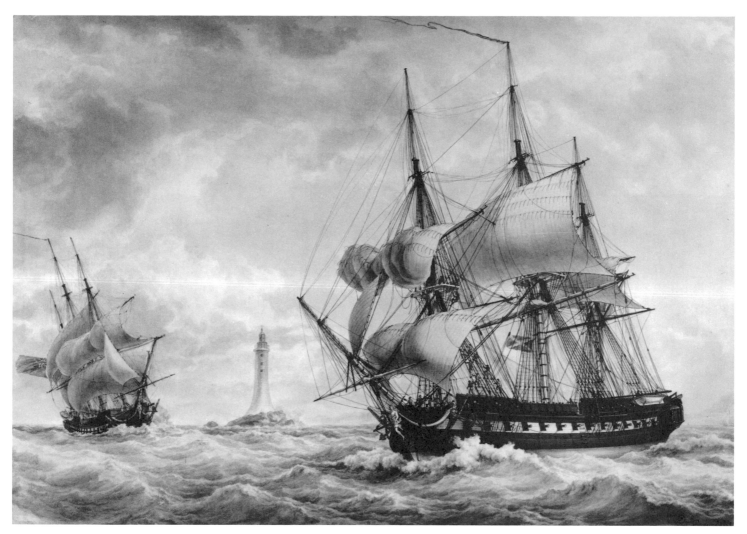

2135

2135. Unidentified British frigate off Eddystone Light. Water-color. 21 × 29 in. (53.3 × 73.6 cm.). Signed, l.r., "F^çois Roux 1882." Inscription with painting reads: "Type de 1810 Frégate de 44 Canons, mettant Vent-Arrière, Sur les parages de Phare d'Edystone, et faisant Signal à un autre Frégate au plus prés, d'arriver par ses Eaux." Gift, Richard Wheatland Collection, 1972. M15311

2136. Sketchbook. 9¼ × 12 in. (23.5 × 30.5 cm.). This sketch-book is embossed on the cover "F∗R∗∗" and contains 22 water-colors and 6 pencil sketches of ships and shipping. Purchase, 1972. M15278

Roux, François Joseph Frédéric French
[1805–1870]

2137. HAVRE. "Havre, Cap^tn A.C. Ainsworth" [American ship]. Watercolor. 25¼ × 31½ in. (64.1 × 80 cm.). Signed, l.r., "Frédéric Roux in 1845 – Havre." Built 1845, New York, 870 tons. Inscription on reverse: "Frédéric Roux hydrographe & Peintre de Marine au Havre en Mai 1845." Gift, Leonard E. Opdycke, 1977. See color plate between pages 62 and 63.

M17077

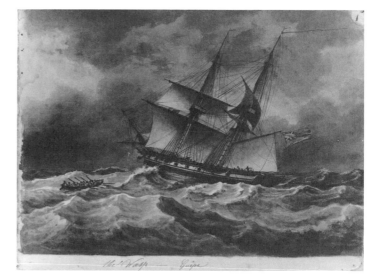

2136

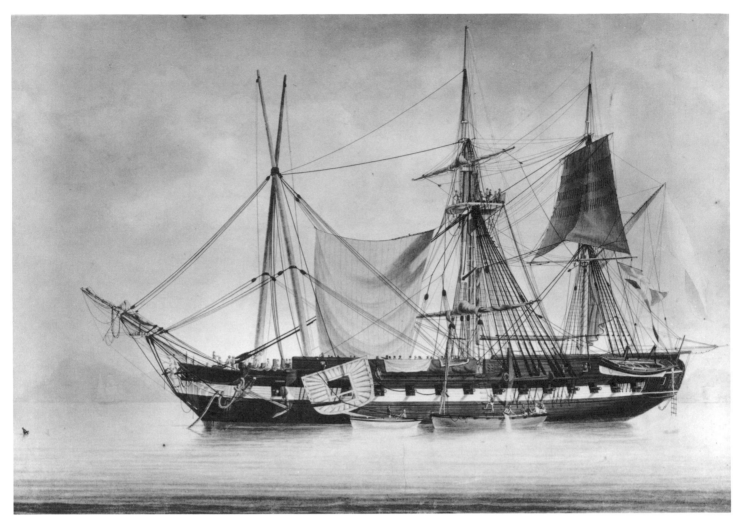

2138

2138. LA POMONE [French frigate]. Watercolor. 24 × 34⁷/₈
in. (61 × 88.6 cm.). Unsigned, attributed to Frédéric Roux.
Inscription on reverse: "Achêté le 20 Mars 1866." Gift, Richard
Wheatland Collection, 1977. M17136

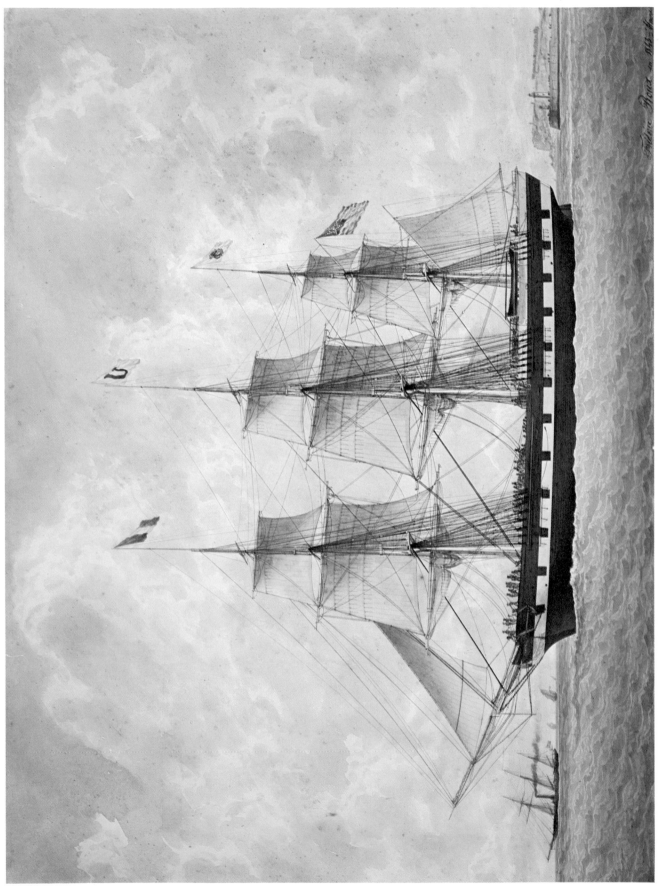

2137. THE AMERICAN SHIP *HAVRE* LEAVING HAVRE, 1845

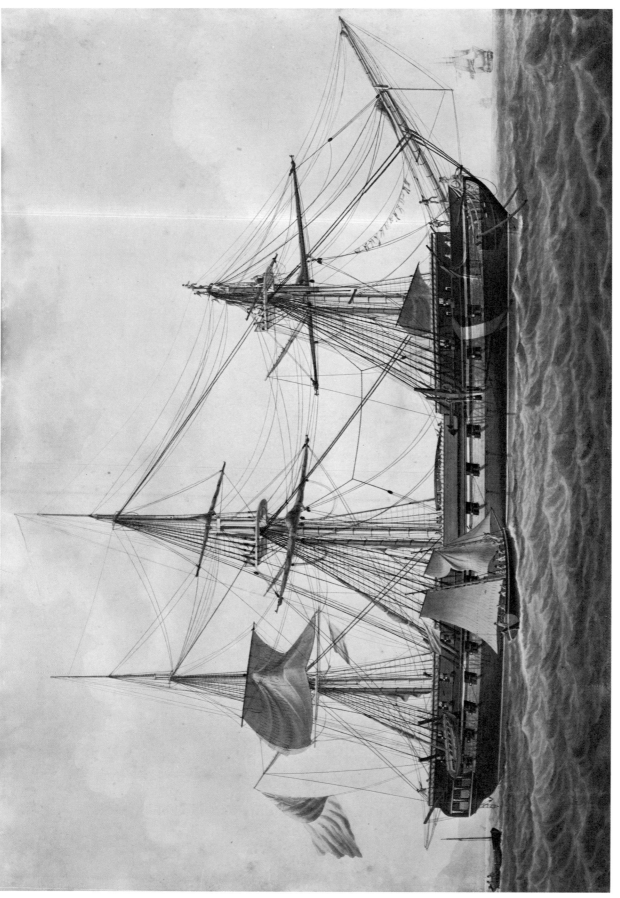

2140. FORETOPMAST BEING SENT DOWN ON BOARD THE BRITISH FRIGATE *PROSERPINE*

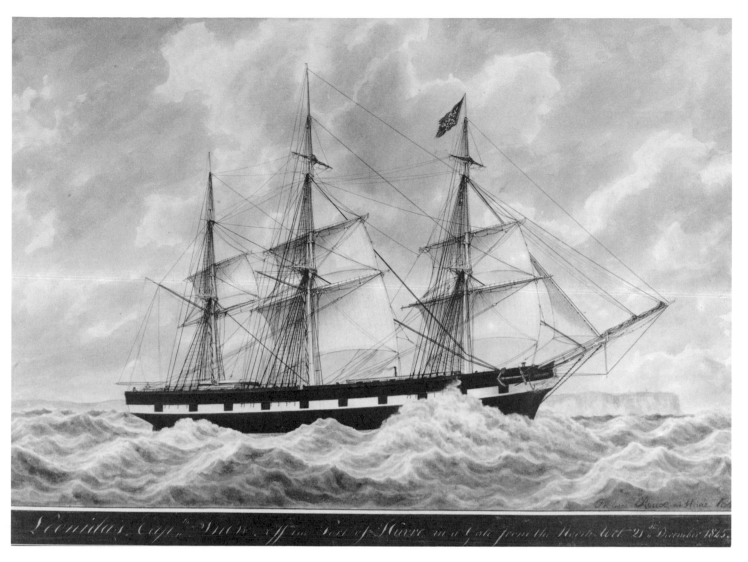

2139

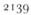

2139. LEONIDAS. "Leonidas, Cap^tn Snow off the Port of
Hâvre in a Gale from the North-Wet [*sic*] 21^st December 1845
[American ship]. Watercolor. 15³/4 × 22¹/2 in. (40 × 57 cm.).
Signed, l.r., "Frederic Roux au Havre 1846." Built 1826, Scit-
uate, Mass., 231 tons. Inscription on reverse: "Frédéric Roux
hydrographe & peintre de Marine au Havre en Janvier 1846 F.
Roux." Gift, Richard Wheatland Collection, 1967. M12845

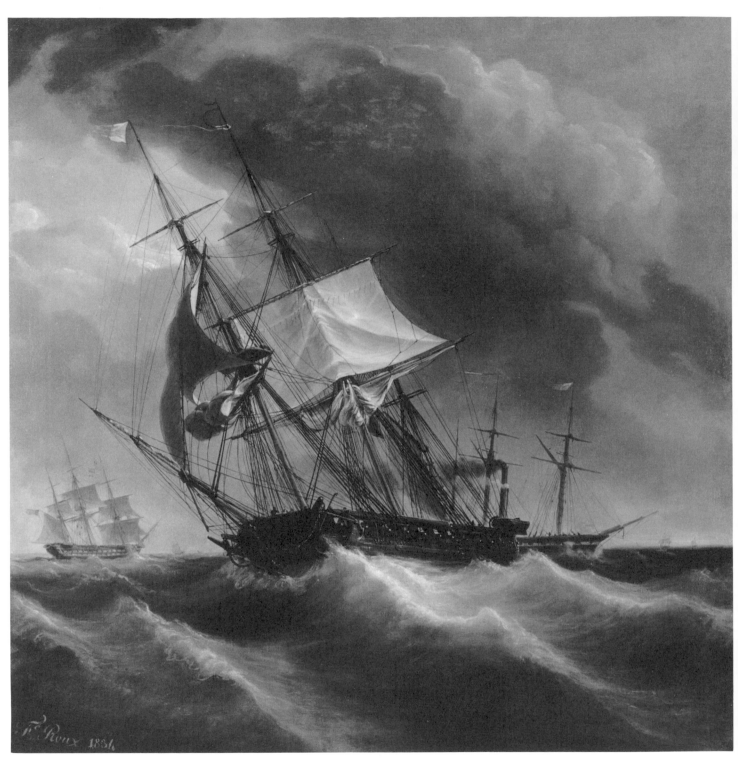

2141

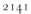

2140. PROSERPINE [British frigate]. Watercolor. 22³/₈ × 35 in. (61.9 × 89 cm.). Signed, l.r., "Fred Roux 1822." Gift, Richard Wheatland Collection, 1977. See color plate between pages 62 and 63. M17137

2141. Fleet Maneuvers by French warships. Oil. 31¹/₂ × 31¹/₄ in. (80 × 79.4 cm.). Signed, l.l., "Fᶜ Roux 1834 / 1834." Purchase, by Messrs. Stephen Wheatland, Stephen Phillips. F.B.L., and Fellows and Friends Funds, 1968. M13378

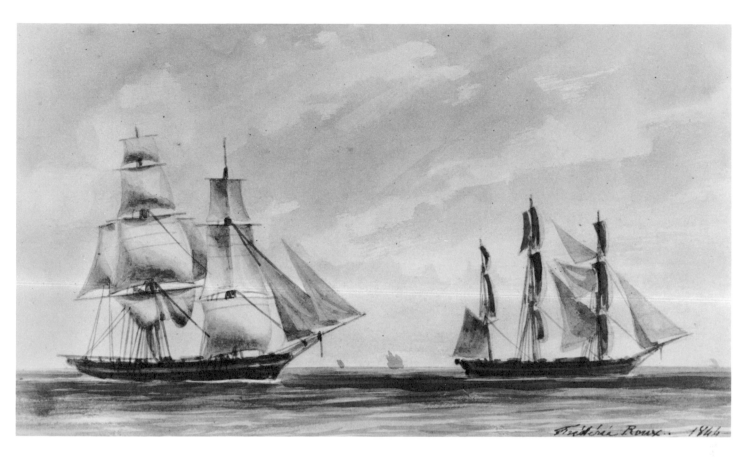

2142

2142. Unidentified Brig and Ship. Watercolor. 4¹/₄ × 7¹/₂ in. (10.8 × 19.1 cm.). Signed, l.r., "Frédéric Roux 1844." Gift, Richard Wheatland Collection, 1976. M16525

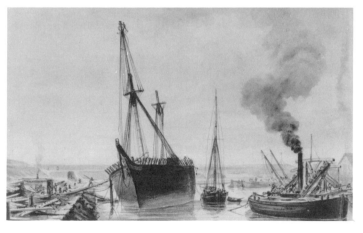

2143

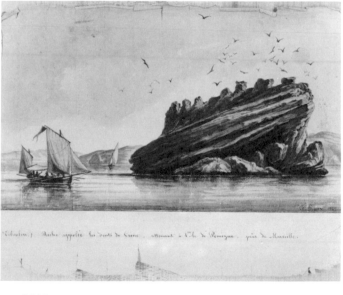

2144

2143. Vessel lying against a quay. Watercolor. 7⁷/₈ × 11³/₄ in. (20 × 29.9 cm.). Unsigned, attributed to Frédéric Roux. Dated, l.l., "le 13 Février 1862." Purchase, 1972. M15278 A

2144. "(Tiboulers) Roche appellée les dents de Crine, attenant à l'Ile de Pomèque, près de Marseille." Watercolor. 7⁷/₈ × 11³/₄ in. (20 × 29.9 cm.). Signed, l.r., "Fᶜ Roux 1862." Purchase, 1972. M15278 B

65

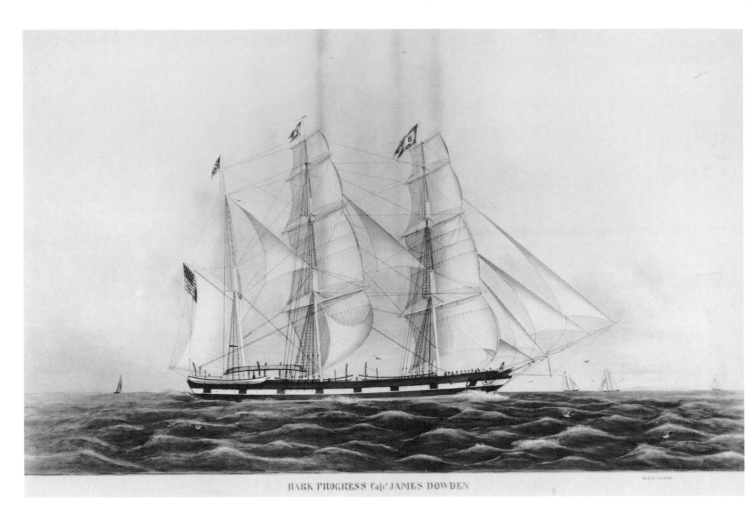

BARK PROGRESS Capt JAMES DOWDEN

2145

Russell, Benjamin American [1804–1885]

2145. PROGRESS [American bark]. "Bark Progress Capt James Dowden" off Block Island. Watercolor. 22 × 34 in. (56 × 86.4 cm.). Signed, l.r., "Russell". Built 1842, Westerly, Rhode Island, 340 tons. Gift, Charles H. Taylor, 1933. M3932

S., J.R.

2146. Unidentified shore scene. Oil on panel. 14 × 8 in. (35.5 × 45.7 cm.). On reverse is written "J.R.S." and an illegible number or date. Gift, Mrs. Thomas G. Rice, 1968. M13357

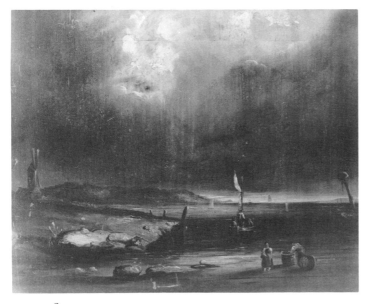

Smith, Philip Chadwick Foster American [1939–]

2147. Shop sign of nautical instrument maker William Williams (c. 1747–1792) of Boston. Gouache. 8⅞ × 7⅞ in. (22.5 × 20 cm.). Signed, "P.C.F. Smith." Gift, Philip C. F. Smith, 1972. M14874

2148. East India Marine Hall, Salem, Massachusetts. Twelve pencil perspective drawings illustrating the changes to the Hall and its surroundings from 1824 through 1974. Each approximately 6¼ × 17¾ in. (16 × 45 cm.). Signed, l.r., "P.C.F.S." Gift, Philip C. F. Smith, 1974. Not illustrated. M15743 (1–12)

2146

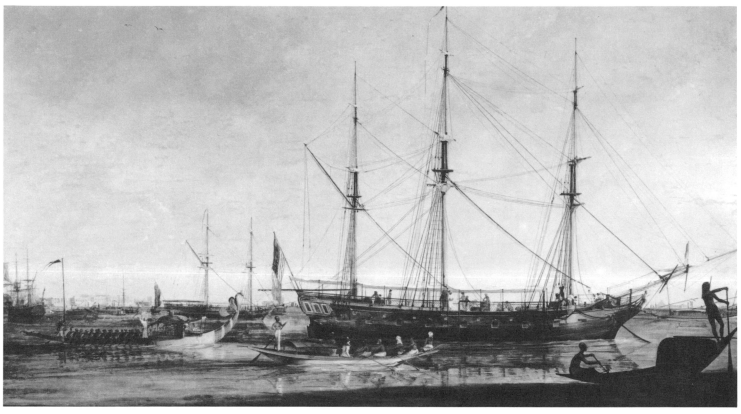

2149

Solvyns, Frans Balthazar Belgian [1760–1824]

2149. Unidentified British East Indiaman at Calcutta. Oil on panel. 26¹/₂ × 47⁷/₈ in. (67.3 × 121.5 cm.). Signed, l.r., "Solvyns Calcutta." Dated 1794. Purchase, Fellows and Friends Funds, 1968. M13461

Stobart, John Anglo–American [1929–]

2150. Freetown Harbor, Sierra Leone. Oil. 20 × 30 in. (50.8 × 76.2 cm.). Signed, l.r., "Stobart." Shows two Elder Dempster liners in the harbor. Gift, Elder Dempster Lines Ltd., 1969. M13837

WILLIAM WILLIAMS
SAMUEL THAXTER
BOSTON

2147

2150

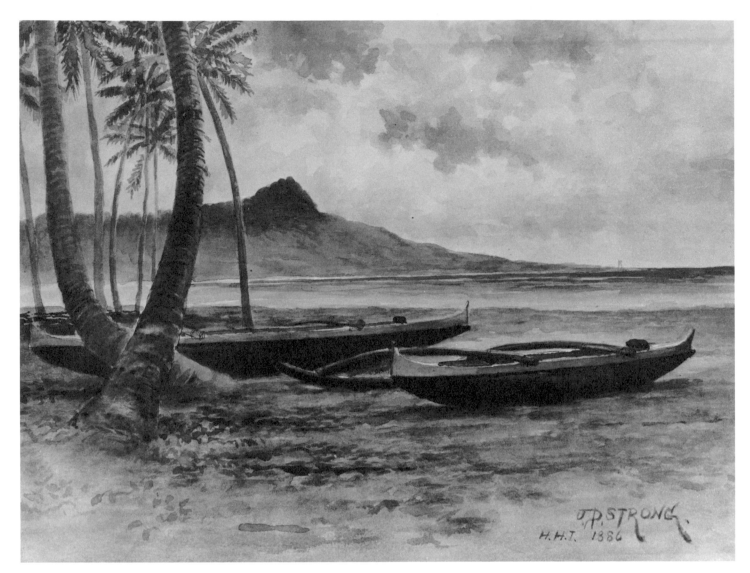

2151

Strong, J. P. American [1852–1900]

2151. Diamond Head, Hawaii. Watercolor. 10³/₄ × 14 in. (27.3 × 35.7 cm.). Signed, l.r., "J. P. Strong, H.H.I. 1886." Gift, Mrs. Rolf Pomeroy Emerson in memory of Justin E. Emerson, M.D. (1841–1923), 1972. M15119

Sunqua Chinese

2152. View of the Praya Grande, Macao. Oil. 18 × 23⁵/₈ in. (45.7 × 60 cm.). Unsigned, attributed to Sunqua. Dated circa 1799. Gift, Mr. and Mrs. Paul Mellon, 1974. M15684

Tory, ?

2153. MODJOKERTO [Dutch steamer]. Ink and colored pencil. 6¹/₄ × 15⁷/₈ in. (16 × 40.3 cm.). Inscribed, l.l., "29 Jan [19]38" and signed, l.r., "Tory [?]". Built Sunderland, England, 1922, 6,441 tons. Gift, Mrs. Frederick Reinert, 1976.
M16427

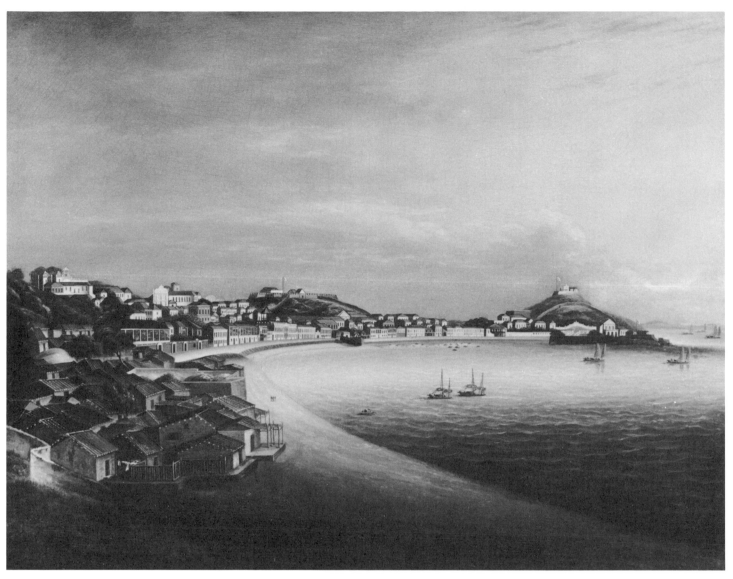

2152

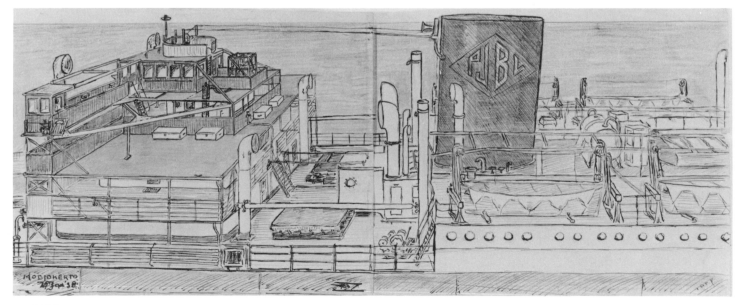

2153

Turner, Ross Sterling American [1847–1925]

2154. Unidentified ship. Pencil sketch. 6⅝ × 11¾ in. (16.9 × 29.8 cm.). Unsigned, attributed to Ross Turner. Gift, Cameron Turner, II, 1970. M14308

2155. Sketchbook, containing 25 pages of gouache and pastel sketches of Paris, including shipping in the River Seine. 12⅛ × 9¼ in. (30.8 × 23.6 cm.). Gift, Cameron Turner, 1972. Not illustrated. M15242

2154

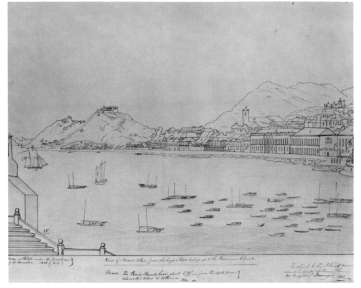

2157

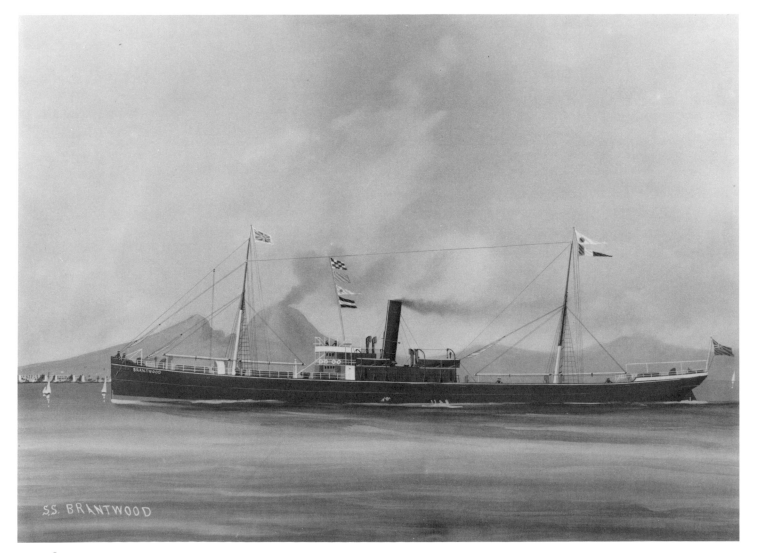

2158

2156. Sketchbook, containing 26 pages of gouache and pastel sketches of shipping and architectural subjects around Paris. 12 1/8 × 9 1/4 in. (30.8 × 23.6 cm.). Gift, Cameron Turner, 1972. Not illustrated. M15243

U., J.B. (?)

2157. "View of Macao, taken from the large Steps leading up to the Franciscan Church." Pen and ink. 19 1/4 × 27 1/8 in. (48.8 × 68.9 cm.). Signed, l.r., "J.B.U. [?]." Buildings and other features numbered and identified by a legend at the left. One British schooner identified in the harbor: "Company's Schooner Lavinia." Gift, F.B.L., 1971. M14503

Unidentified Artists

2158. BRANTWOOD [British steamer]. Gouache. 16 × 22 3/8 in. (40.6 × 56.8 cm.). Inscription, l.l., "S.S. Brantwood". Style resembles that of Michele Funno. Deposit, Francis Lee Higginson. FLH 264

2159. LUSITANIA [British steamer]. Watercolor. 8 7/8 × 14 1/2 in. (22.5 × 36.2 cm.). Built 1907, Clydebank, 31,550 tons. Deposit, Francis Lee Higginson. FLH 277

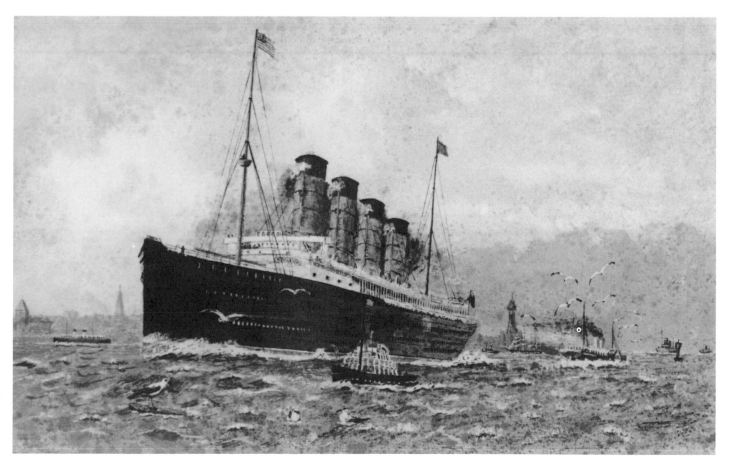

2159

2160. RECOVERY [British ship]. "The Ship Recovery [of London] going into Fare Habour Huahina, Society Islands, May 1st, 1832." Watercolor. 12⅝ × 14½ in. (32 × 37.4 cm.). Built, 1794, England. Gift, Frances Damon Holt, 1972.

M15355

2160

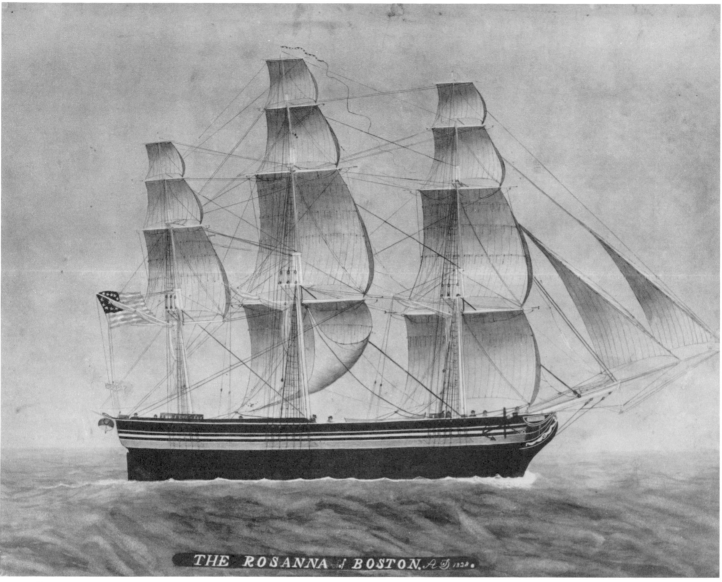

2161

2161. ROSANNA [American ship]. "The Rosanna of Boston. AD 1828." Watercolor, 18¹/₂ × 23³/₄ in. (47 × 60.3 cm.). Built 1827, Duxbury, 284 tons. Deposit, Misses Aimee and Rosamond Lamb, 1969. D-500-37

2162. SCOTIA [British steamer]. Oil. 30 × 54 in. (76.2 × 137.1 cm.). Built 1862, Glasgow, 3,871 tons. Deposit, Francis Lee Higginson. FLH 270

2162

2163

2163. WINFIELD SCOTT [American ship]. Oil. 26 × 40¹/₈ in. (66 × 102 cm.). Built 1851, Newcastle, Me., 1,240 tons. Gift, Edward A. Taft, 1972. M14891

2164. Unidentified ship in harbor during a storm. Pencil and chalk. 7 × 10¹/₄ in. (17.8 × 26.1 cm.). Gift, Mrs. Franc D. Ingraham, 1973. M15578

2165. BRIXTON. "The Brixton off Byrons Island, Kingsmill Group, S.P. Natives coming off to Trade" [British bark]. Pencil and wash. 9¹/₂ × 11³/₄ in. (24 × 29.9 cm.). Dated, l.r., "July 23ᵈ 1840." Building date unknown, prize ship, 317 tons. Bequest, Estate of Stephen Phillips, 1972. M14930

2166. Ships at sea. Oil. 15 × 12 in. (38.1 × 30.5 cm.). Deposit, Sargent Bradlee, 1975. Not illustrated. D-500-91

2167. Unidentified Austrian bark. Watercolor sketch. 3 × 5 in. (7.7 × 12.7 cm.). Inscribed "Le Vendredi 16 Octobre" and at upper right "Elesia C. 352/Trieste-Moricich/Lamaea 30 Aout/ Matte 8." Gift, Mrs. Howard Thayer Kingsbury, 1967. M13132

2168. Unidentified American bark. Oil. 30¹/₈ × 44¹/₈ in. (76.5 × 112.1 cm.). Unsigned. Signal flags do not read. Gift, W. A. Newhall, 1967. M13249

2169. Unidentified bark and native craft. Pen and ink. 12¹/₄ × 10¹/₂ in. (31.1 × 26.7 cm.). From the Edward S. Clark Collection. Accession information not known. M13963

2170. Unidentified barkentine. Pencil. 5¹/₂ × 7³/₈ in. (14 × 18.7 cm.). Unsigned. Accession information not known. M13962

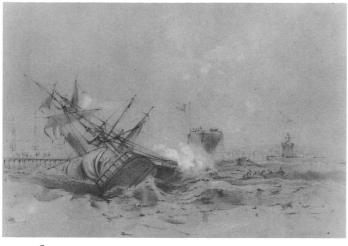

2164

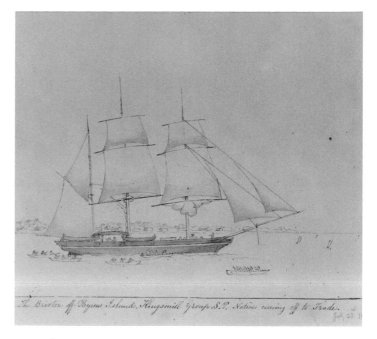

The Brixton off Byron Island, Kingsmill Group S.P. Natives coming off to Trade.

2165

Le Vendredi 10 Octobre

2167

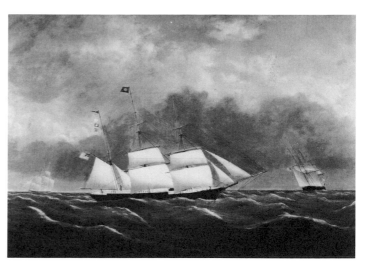

2168

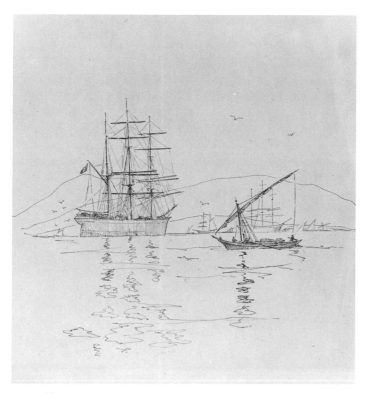

2169

2170

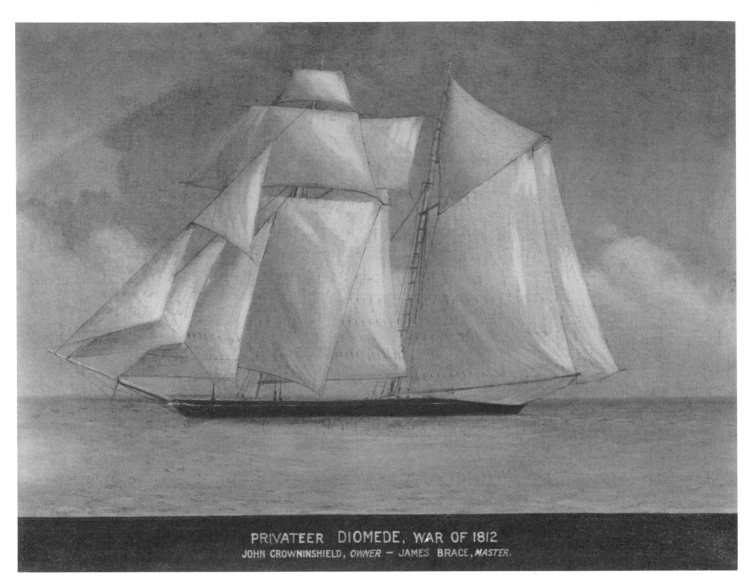

PRIVATEER DIOMEDE, WAR OF 1812
JOHN CROWNINSHIELD, *OWNER* – JAMES BRACE, *MASTER*.

2171

2171. DIOMEDE. "Privateer Diomede, War of 1812 John Crowninshield, owner – James Brace, Master" [American hermaphrodite brig]. Oil. 16³/₄ × 22¹/₄ in. (42.5 × 56.4 cm.). Built 1809, Salem, Mass., 223 tons. Accession information not known.
M14894

2172. Yacht of King Kamehameha III [Hawaiian topsail schooner]. Oil. 22¹/₈ × 30¹/₄ in. (56.2 × 76.7 cm.). Attached to the stretcher are: 1) a bookplate of Chester Guild, 2) memo on note paper of Chester Guild, 70 State Street, reading "This Schooner is the King's Yacht Kamehameha III. See 'The Friend' vol. V No X p. 79 issue of May 15th 1847," and 3) memo reading "This picture given me by my cousin Seth A. Fowle. It was brought from Honolulu 1849 by his father-in-law Capt Richard Mitchell of Nantucket. He said it was the King's yacht. Chester Guild Boston Oct 1916." Bequest, Estate of Stephen Phillips, 1972.
M14900

2173. Unidentified sloop. Watercolor. 3¹/₂ × 4¹/₂ in. (8.9 × 11.5 cm.). Gift, Sargent Bradlee, 1968.
M13267

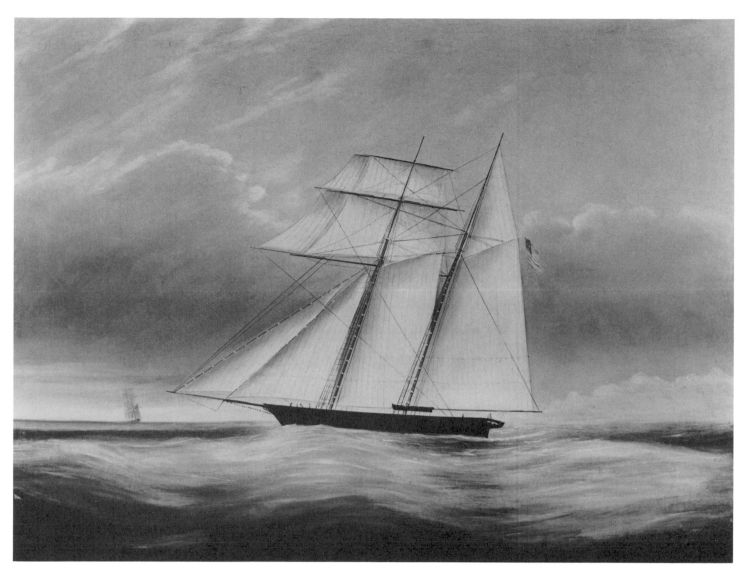

2172

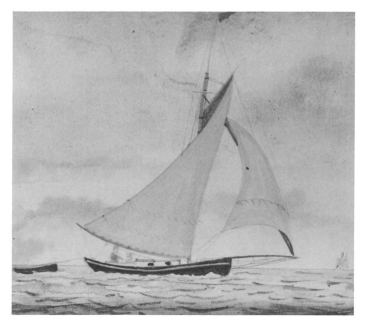

2173

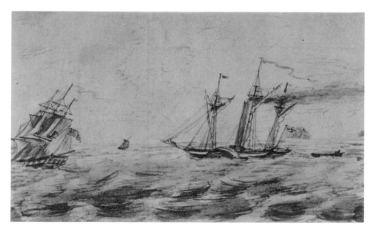

2174

2174. British Paddle steamer and British warship. Sepia pen sketch. 2¹/₂ × 4¹/₂ in. (6.5 × 11.4 cm.). Purchase, 1910.

M14193

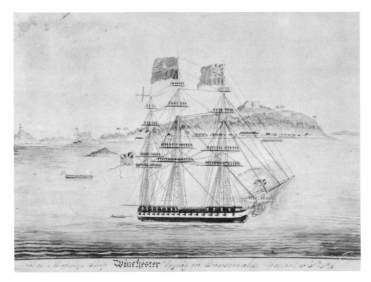

2175

2175. WINCHESTER. "His Majestys Ship Winchester laying in Trincomalee December 30th 1836." [British warship]. Watercolor. 10³/4 × 14³/8 in. (27.3 × 36.5 cm.). Gift, Mr. and Mrs. John Dominis Holt, 1976. M16743

2176. "Admiral Kepel's Squadron in suit of the Frenc Fleet." Watercolor on chickenskin fan. Fan radius 10¹/4 in. (26 cm.). Outside circumference of painting 18¹/2 in. (47 cm.). Width 4³/4 in. (12. cm.). On reverse, painting of dancing maidens. Gift, Mrs. Jerome Downes, 1970. M14309

2176

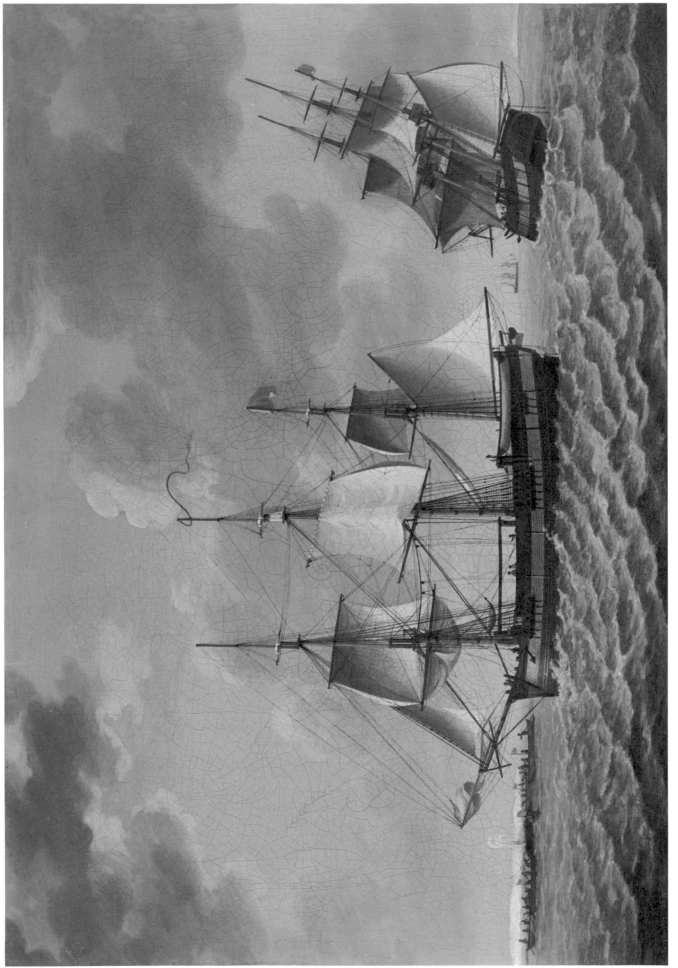

2313. ENGLISH WHALESHIP *MOLLY ATTACKING HER PREY*, 1806

2177

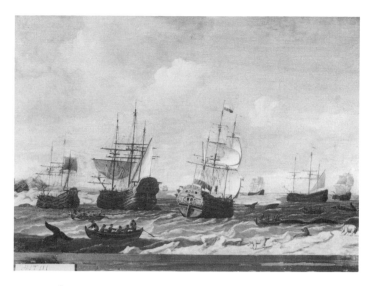

2178

2177. Unidentified British naval cutter. Unfinished watercolor sketch. 5 × 7¹/₈ in. (12.7 × 18.1 cm.). Gift, David P. Wheatland, 1967. M13232

2178. Arctic whaling. Oil. 17⁷/₈ × 26 in. (45.5 × 66 cm.). Deposit, Francis Russell Hart Nautical Museum, Massachusetts Institute of Technology, 1971. MIT 111

2179. Arctic whaling. Oil. 16¹/₄ × 20⁷/₈ in. (41.3 × 53 cm.). Deposit, Francis Russell Hart Nautical Museum, Massachusetts Institute of Technology, 1971. MIT 112

2180. Lifesaving scene. Watercolor. 3³/₄ × 5³/₄ in. (9.5 × 14.6 cm.). Gift, Richard B. Holman, 1976. M16486

2181. Lifesaving scene. Watercolor. 3³/₄ × 5³/₄ in. (9.5 × 14.6 cm.). Gift, Richard B. Holman, 1976. M16487

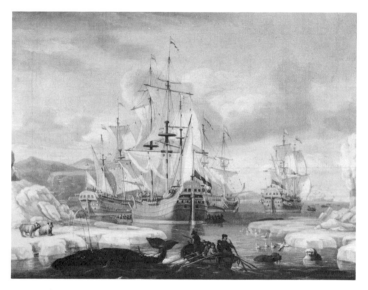

2179

2180

2181

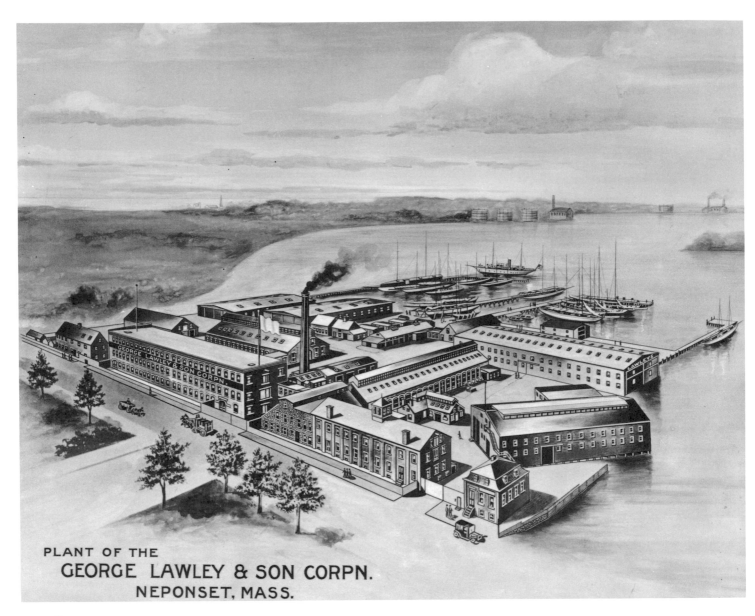

PLANT OF THE
GEORGE LAWLEY & SON CORPN.
NEPONSET, MASS.

2182

2182. "Plant of the George Lawley & Son Corpn. Neponset, Mass." Watercolor. $17^1/_2 \times 22^5/_8$ in. (44.5 × 57.4 cm.). Gift, John R. Herbert, 1972. M15295

2183. Sailors smoking. Oil on wood panel. $6^1/_8 \times 5^1/_8$ in. (15.6 × 13 cm.). Gift, Mr. and Mrs. Willard C. Cousins, 1968. M13268

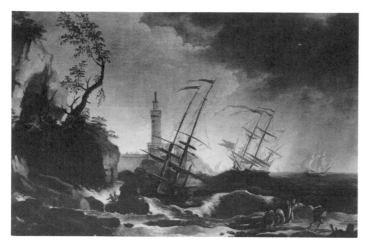

2184

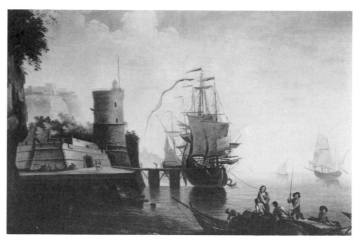

2185

2184. Fanciful harbor view. Oil. 29¼ × 44⅞ in. (74.3 × 113.8 cm.). Unsigned, in the style of Joseph Vernet. Gift, Monks Collection, 1944. M15288

2185. Fanciful harbor view. Oil. 29⅛ × 45 in. (74 × 113.3 cm.). Unsigned, in the style of Joseph Vernet. Gift, Monks Collection, 1944. M15289

2186. Sketchbook. Pencil and wash. 7⅛ × 10⅝ in. (18.1 × 27 cm.). Contains 62 pages of sketches of people, harbors, scenes between England and Ceylon via Suez. Gift, Philip Hofer, 1971. Not illustrated. M14223

2187. Sketchbook. Pencil. 7⅛ × 9⅜ in. (18.1 × 23.8 cm.). Contains 58 pages of sketches of scenes in China. Gift, Philip Hofer, 1971. Not illustrated. M14224

Africa

2188. "Fishtown, West Africa." Pencil sketch. 3¾ × 7¼ in. (9.5 × 18.5 cm.). Dated on reverse, "4 May [18] 46." No accession information. M15595 A

2189. "Cape Palmas W Africa." Pencil sketch. 5⅞ × 7¼ in. (14.9 × 23.5 cm.). No accession information. M15595 B

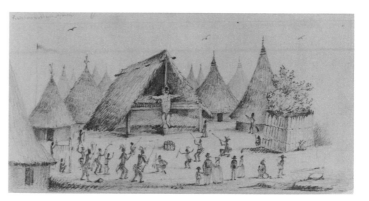

2188

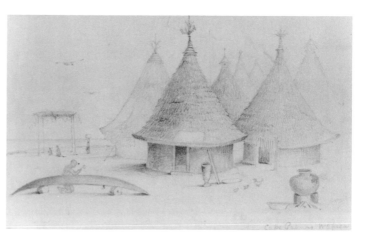

2189

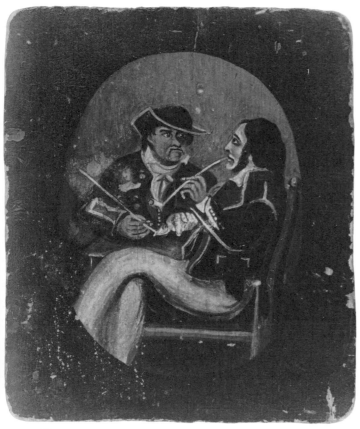

2183

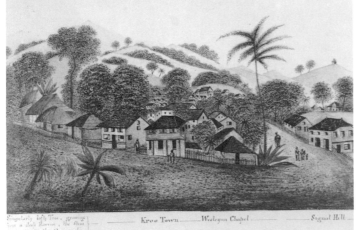

2190

2190. "A View of Cape Town at Cape of Good Hope." Ink and wash. 7⅝ × 12⅜ in. (19.3 × 31.5 cm.). Key along bottom identifying prominent landmarks and shipping. Dated circa 1790. Key letter "R" refers to the American bark *Light Horse* of Salem. Gift, Essex Institute, 1974. M15748

2191. Krootown, Sierra Leone. Watercolor. 7 × 10 in. (17.8 × 25.5 cm.). Purchase, John Robinson Fund, 1969. M13867

2192. "El Kantara, Canal de Suez." Watercolor. 5½ × 8½ in. (14 × 21.6 cm.). Illegible signature, lower right. Gift, Paul Blum, 1976. M16489

2191

2192

2193

2193. "La Drague a Long Couloir Suez." Watercolor. 5½ ×
8½ in. (14 × 21.6 cm.). Illegible signature, lower right. Gift,
Paul Blum, 1976. M16490

2194. View of Zanzibar. Watercolor. 15½ × 35¼ in. (39.2 ×
89.5 cm.). Key along bottom identifying prominent landmarks
and features. Dated circa 1840. Purchase, 1974. M15708

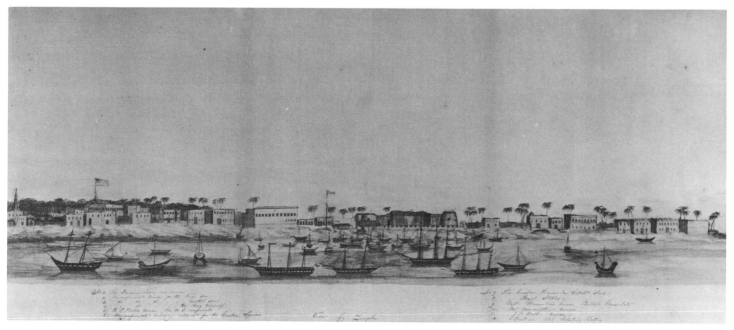

2194

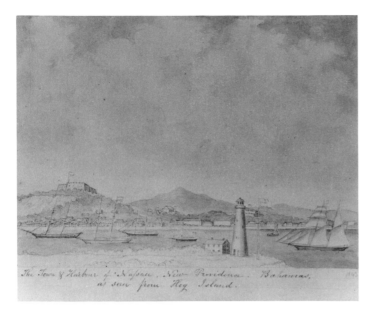

2195

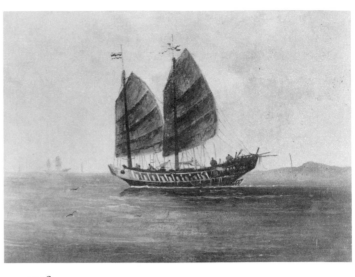

2196

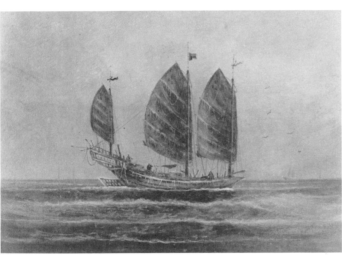

2197

Caribbean

2195. "The Town & Harbour of Nassau, New Providence – Bahamas, as seen from Hog Island." Watercolor. 9³/₈ × 11³/₄ in. (23.8 × 29.8 cm.). Latitude and longitude notes at l.l. Dated, l.r., 1843. Bequest, Estate of Stephen Phillips, 1972. M14916

China

2196. Chinese junk. Oil on cardboard. 8¹/₄ × 11¹/₄ in. (21 × 28.5 cm.). Gift, Donald Angus, 1969. M13532

2197. Chinese junk. Oil on cardboard. 8¹/₈ × 11¹/₄ in. (20.7 × 28.6 cm.). Gift, Donald Angus, 1969. M13533

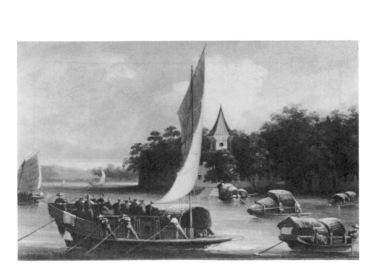

2198

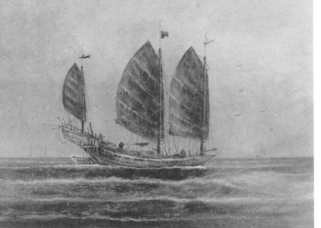

2199

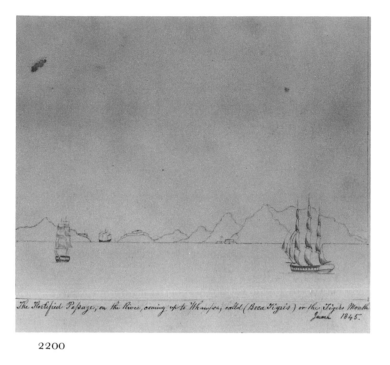

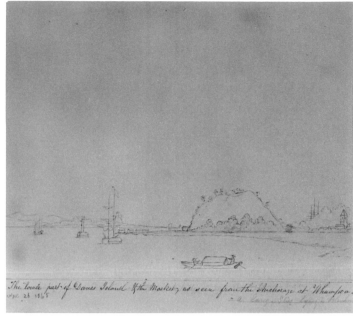

2200

2201

2198. Chinese River scene. Oil. 10³/4 × 17¹/8 in. (27.3 × 43.4 cm.). Gift, F.B.L., 1968.　　　　　　M13584

2199. "The Town & Harbour of Lintin, China." Pencil and wash. 9¹/2 × 11³/4 in. (24.1 × 29.8 cm.). Dated, l.r., "Apl 1845." Latitude and longitude notations in left margin. Bequest, Estate of Stephen Phillips, 1972.　　　　　　M14939

2200. "The Fortified Passage, on the River, coming up to Whampoa, called (Boca Tigris) or the Tiger's Mouth." Pencil. 9¹/2 × 11⁵/8 in. (24 × 29.6 cm.). Dated, l.r., "June 1845." Bequest, Estate of Stephen Phillips, 1972.　　　　　　M14937

2201. "The lower Part of Danes Island & the Market, as seen from the Anchorage at Whampoa." Pencil. 9¹/2 × 11³/4 in. (24.1 × 29.8 cm.). Dated, l.r., "Apl 26 1845." Latitude and longitude notations in left margin. Bequest, Estate of Stephen Phillips, 1972.　　　　　　M14942

2202. "A View looking up the River, at Whampoa, on the right looking up towards Canton." Pencil and wash. 9¹/2 × 11³/4 in. (24.1 × 29.8 cm.). Dated, l.r., "May 1845." Bequest, Estate of Stephen Phillips, 1972.　　　　　　M14938

2203. "Sketch on the Canton River near the Landing Place – Canton." Watercolor. 6¹/2 × 13 in. (16.5 × 33 cm.). Dated on mount "1-8-58." Gift, Frances Damon Holt, 1972.　　　　　　M15401

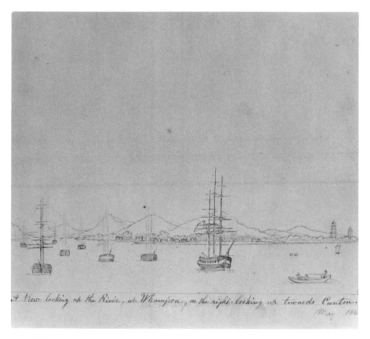

2202

2203

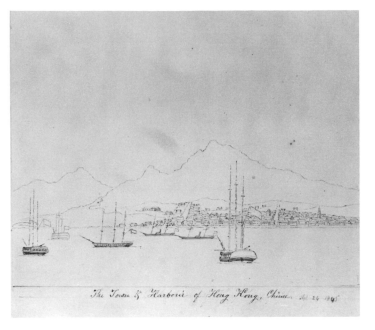

2204

2204. "The Town & Harbour of Hong Kong, China." Ink and wash. 9½ × 11¾ in. (24 × 29.8 cm.). Dated, l.r., "Apl 24 1845.' Bequest, Estate of Stephen Phillips, 1972. M14936

2205. British consulate at Shanghai, circa 1860. Watercolor. 10⅛ × 14 in. (25.8 × 35.5 cm.). Gift, Frances Damon Holt, 1972. M15400

East Indies

2206. East Indies Harbor. Watercolor in two sections. 6⅞ × 32⅛ in. (17.5 × 81.6 cm.). Gift, Donald Angus, 1969. M13531

2207. Panoramic view of Bangkok. Watercolor scroll. 8 × 151 in. (20.4 × 383.4 cm.). Paper watermarked 1872. Shows the buildings and temples on the banks of the river. Gift, Frances M. Damon, 1971. M14718

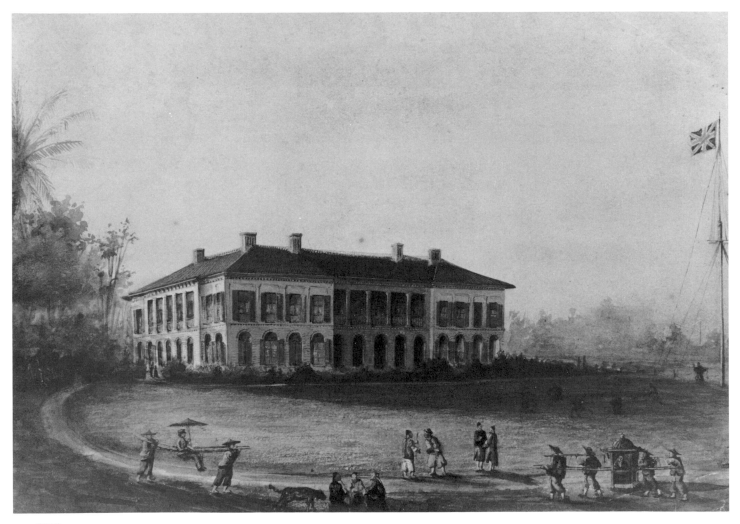

2205

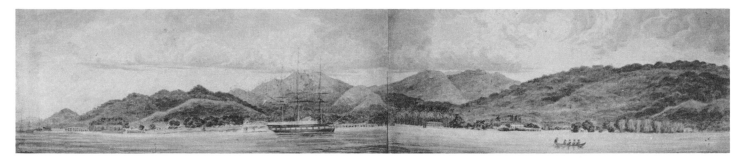

2206

2207 (Detail)

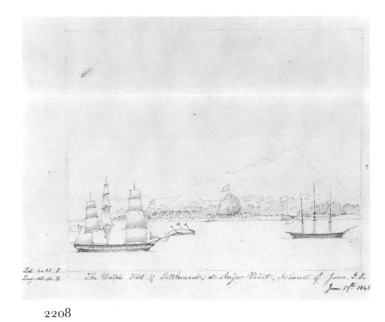

2208

2208. "The Dutch Fort & Settlement, at Anjier Point, Island of Java I.O." Pencil and wash. $9^{1}/_{2} \times 11^{5}/_{8}$ in. (24.1 × 29.5 cm.). Dated, l.r., "June 19th 1845." Latitude and longitude notations in left margin. Bequest, Estate of Stephen Phillips, 1972.

M14941

2209. Penang, Straits Settlement. Watercolor. $6^{1}/_{2} \times 10^{5}/_{8}$ in. (16.5 × 24.5 cm.). Dated circa 1860. Gift, Mr. and Mrs. John D. Holt, 1974.

M16098

2210. Cool Harbour, Singapore. Watercolor. $6^{3}/_{4} \times 9^{3}/_{4}$ in. (17 × 24.7 cm.). Dated circa 1860. Gift, Mr. and Mrs. John D. Holt, 1974.

M16102

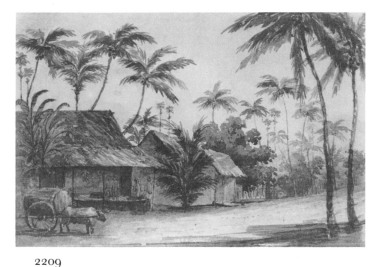

2209

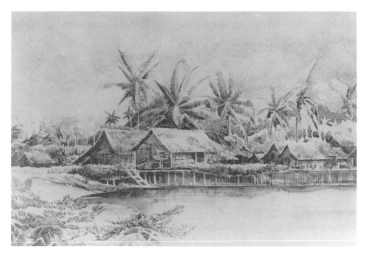

2210

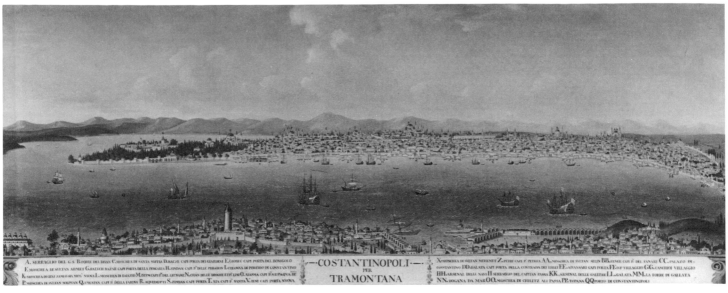

2211

Europe

2211. "Constantinopoli per Tramontana." Oil. 26½ × 67½ in. (67.2 × 171.5 cm.). Key painted along bottom identifying prominent landmarks and features. Dated circa 1730. Gift, Charles D. Childs, 1974. M15701

Indian Ocean

2212. "Dutch Fort & Settlement, Cajeli Bay, Island of Bouru, Indian Ocean." Pencil and wash. 9½ × 11¾ in. (24 × 29.9 cm.). Dated, l.r., "Mar 24 1845." Latitude and longitude notations in left margin. Bequest, Estate of Stephen Phillips, 1972. M14935

2213. "The Town & Harbour of Port Louis, Mauritius, or Isle of France. I. O." Pencil. 9⅜ × 11¾ in. (23.8 × 29.7 cm.). Latitude and longitude notes at l.l. Dated, l.r., "Decr 14 1844." Several landmarks noted under the title. Bequest, Estate of Stephen Phillips, 1972. M14915

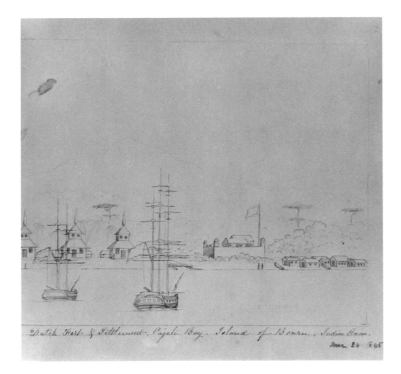

2212

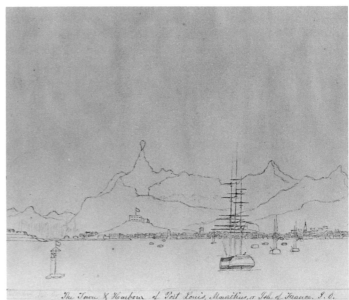

2213

Pacific

2214. "Black Beach, or Landing Place, Charles's Island, Gallapagos Group, South Pacific." Watercolor. 9½ × 11¾ in. (24.1 × 29.9 cm.). Dated, l.r., "Novʳ 27 1838." Latitude and longitude notations in left margin. Bequest, Estate of Stephen Phillips, 1972. M14921

2215. "Mʳ Williams' Residence (the Governor) of Charles's Island, Gallapagos Group." Watercolor. 9½ × 11¾ in. (24.1 × 29.7 cm.). Dated, l.r., "Novʳ 26 1828." Latitude and longitude notations in left margin. Bequest, Estate of Stephen Phillips, 1972. M14923

2216. "Canoe & Natives of Humphreys Island, Kingsmill Group. S.P." Pencil. 9½ × 11½ in. (24 × 29.9 cm.). Bequest, Estate of Stephen Phillips, 1972. M14928

2217. "Resolution Bay & Town of Ohitahoo, the Island of Christiana, Marquesas Group, S.P." Watercolor. 9½ × 11⅝ in. (24.1 × 29.5 cm.). Dated, l.r., "Mar 4 1837." Latitude and longitude notations in left margin. Bequest, Estate of Stephen Phillips, 1972. M14922

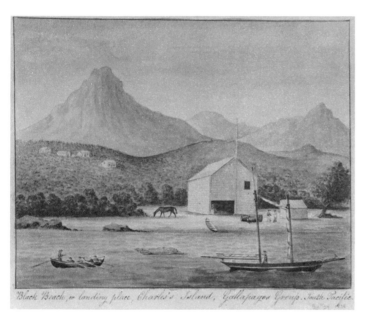

2214

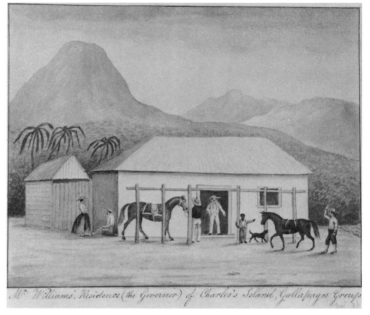

2215

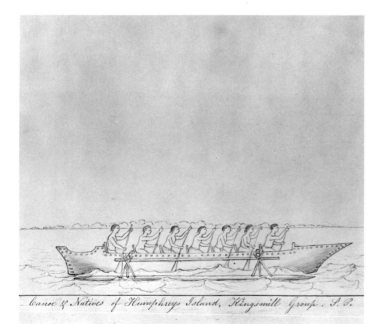

2216

2217

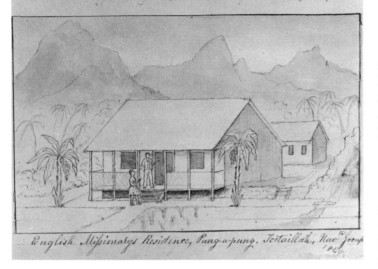

2218

2218. "Native Missionary Church, Punga-a-punga, Tootaillah, Navigator Group" and "English Missionary's Residence, Punga-a-pung, Tootaillah, Navtr Group." Two pencil and watercolor sketches on one sheet. 11 3/4 × 9 1/2 in. (29.8 × 24 cm.). Bequest, Estate of Stephen Phillips, 1972. M14918

2219. "Harbour of Apea & the Native Church, Island of Pola, Navigator Group South Pacific." Pencil and watercolor. 9 1/2 × 11 3/4 in. (24.1 × 29.9 cm.). Dated, l.r., "June 16th 1841." Latitude and longitude notations in left margin. Bequest, Estate of Stephen Phillips, 1972. M14919

2220. "Mr Williams' Residence, at the Village of Fasasoti, Island of Pola, Navigator Group, also the Native Church, with a small Schooner, then building." Pencil. 9 3/8 × 11 7/8 in. (23.9 × 30.1 cm.). Dated, l.r., "June 1841." Bequest, Estate of Stephen Phillips, 1972. M14926

2221. "Navigator Canoe & Natives, Fishing for Bonnetta" and "Navigator Double – bank Canoe, conveying the English Missionary to another Town." Two ink and wash sketches on one sheet. 9 1/2 × 11 3/4 in. (24 × 29.9 cm.). Bequest, Estate of Stephen Phillips, 1972. M14950

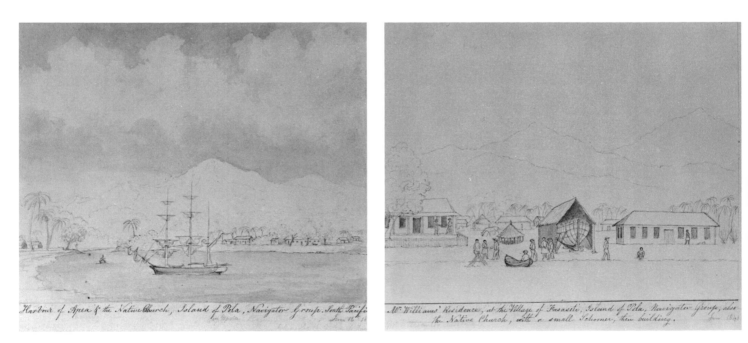

2219

2220

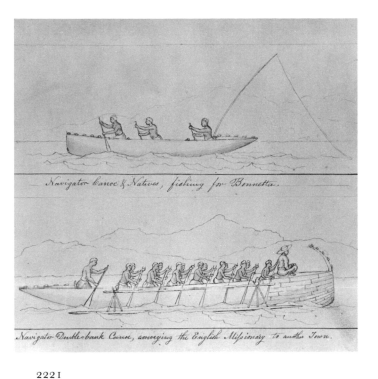

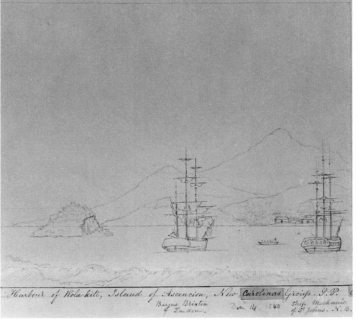

2221

2222

2222. "Harbour of Rola-kiti, Island of Ascencion, New Carolinas Group S.P." Pencil. 9³/₈ × 11³/₄ in. (23.8 × 29.9 cm.). Dated, l.r., "Dec 14 1840." Identified vessels in scene are the bark *Brixton* of London and the ship *Mechanic* of St. Johns, New Brunswick. Latitude and longitude notations in right margin. Bequest, Estate of Stephen Phillips, 1972. M14925

2223. "Ascencion Canoe proceeding to Matippa, with the 2 Captains; T.T. & Thompson the Pilot, to make an examination of the Supposed Tombs &c." Pencil. 9¹/₂ × 11⁷/₈ in. (24 × 30.1 cm.). Bequest, Estate of Stephen Phillips, 1972. M14929

2224. A large tomb near the town of Matippa, Ascencion, supposed to have been of Spanish origin owing to the discovery of a gold crucifix. Pencil. 9¹/₂ × 11³/₄ in. (24.1 × 29.9 cm.). Dated, l.r., "Decʳ 29 1840." Bequest, Estate of Stephen Phillips, 1972. M14931

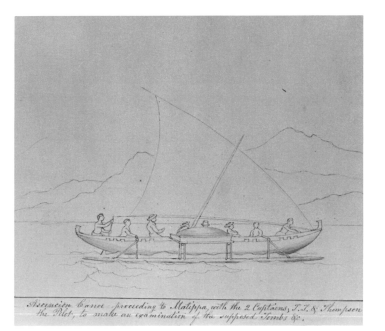

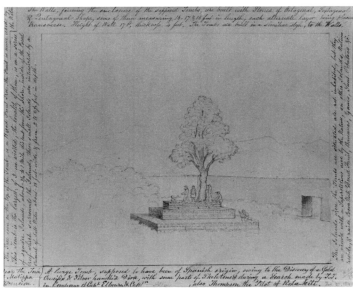

2223

2224

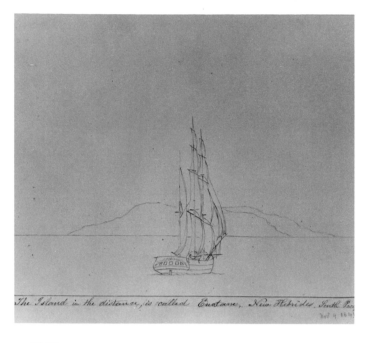

The Island in the distance, is called Enotane, New Hebrides, South Pac.

2225

This Island is supposed to have a level surface on the Top, as no person was ever known to have gained the Top, & the sides are nearly perpendicular, all round the Island.

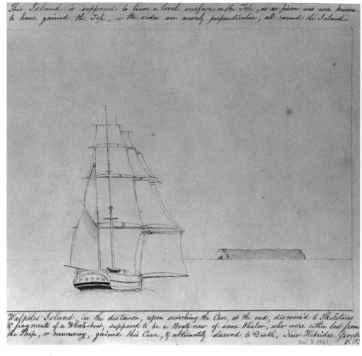

Walpoles Island, in the distance, upon searching the Cave, at the end, discover'd 6 Skeletons & fragments of a Whale-boat, supposed to be a Boats-crew of some Whaler, who were either Lost from the Ship, or runaway, gained this Cave, & ultimately starved to Death, New Hebrides Group

2226

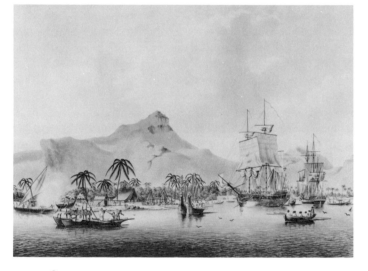

2228

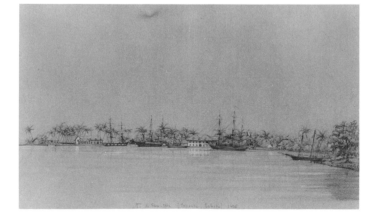

2229

2225. "The Island in the distance, is called Enotane, New Hebrides, South Pacific." Pen. $9^{1}/_{2} \times 11^{3}/_{4}$ in. (24 × 29.9 cm.). Dated, l.r., "Novr 4 1841." Latitude and longitude notations in left margin. Bequest, Estate of Stephen Phillips, 1972. M14932

2226. "Walpoles Island, in the distance . . . New Hebrides Group S.P." Pen and wash. $9^{1}/_{2} \times 11^{3}/_{4}$ in. (24.1 × 29.8 cm.). Dated, l.r., "Nov 5 1841." Latitude and longitude notations in left margin. Bequest, Estate of Stephen Phillips, 1972. M14940

2227. Philippine Island. Oil on cardboard. Oval. 7 × 9 in. (17.8 × 22.9 cm.). Gift, Mrs. Harold F. Eastman, 1969. Not illustrated. M13754

2228. "Huaheine, one of The Society Islands in the South Seas." Watercolor. $18^{3}/_{4} \times 25^{1}/_{2}$ in. (47.6 × 64.7 cm.). Bequest, Estate of Stephen Phillips, 1972. M15033

2229. "Pte de Fare-Me (Papeete Tahiti) 1866." Pencil and white chalk. $7^{3}/_{8} \times 12^{1}/_{2}$ in. (18.7 × 31.7 cm.). Gift, Donald Angus, 1970. M14478

2230. "Fort in the Harbour, opposite the Town of Papahiti, the Island of Emao in the Distance." Pencil and watercolor. $9^{1}/_{2} \times 11^{3}/_{4}$ in. (24.1 × 29.8 cm.). Dated, l.r., "Apl 13 1839." Latitude and longitude notations in right margin. Bequest, Estate of Stephen Phillips, 1972. M14920

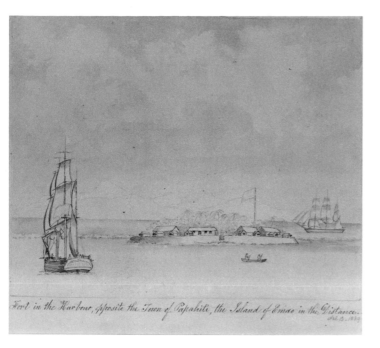

Fort in the Harbour, opposite the Town of Papahiti, the Island of Emao in the Distance.
Feby 3 1839

2230

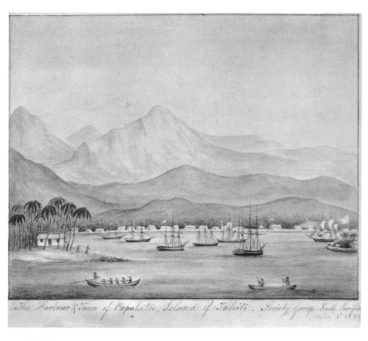

The Harbour & Town of Papahitie, Island of Tahiti. Society Group South Pacific
April 1st 1839

2231

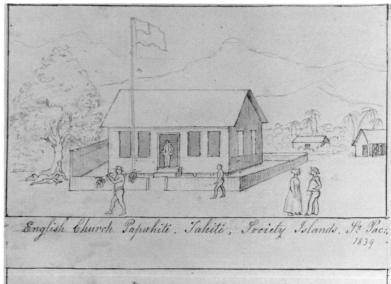

English Church Papahiti, Tahiti, Society Islands. So Pac:
1839

Native Church, Papahiti, Tahiti, also the place of Execution on the Hill.

2232

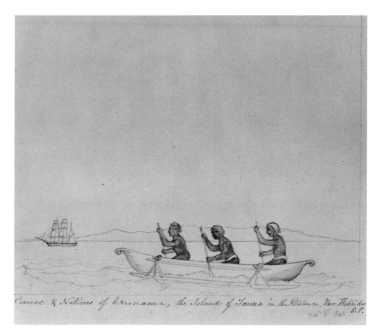

Canoe & Natives of Erronama, the Island of Tanna in the Distance, New Hebrides
Novr 3 1841 S.P.

2233

2231. "The Harbour & Town of Paphitie, Island of Tahiti Society Group South Pacific." Watercolor. 9¹/₂ × 11⁵/₈ in. (24.1 × 29.6 cm.). Dated, l.r., "April 1ˢᵗ 1839." Latitude and longitude notations in left margin. Bequest, Estate of Stephen Phillips, 1972. M14924

2232. "English Church Papahite Tahiti, Society Islands Sᵒ Pac. and Native Church, Papahite, Tahiti, also the place of Execution on the Hill." Two pencil and wash sketches on one sheet. 11⁵/₈ × 9¹/₂ in. (29.5 × 24.1 cm.). Both dated "1839." Bequest, Estate of Stephen Phillips, 1972. M14927

2233. "Canoe & Natives of Erronama, the Island of Tanna in the Distance, New Hebrides, S.P." Pencil and wash. 9³/₈ × 11³/₄ in. (23.8 × 29.9 cm.). Dated, l.r., "Novᵇʳ 3ʳᵈ 1841." Bequest, Estate of Stephen Phillips, 1972. M14948

93

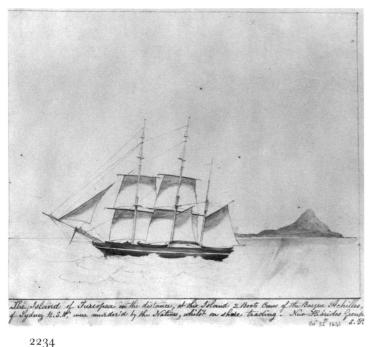

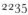
2234

2234. "The Island of Turcopea in the distance . . . New Hebrides Group S.P." Pencil and wash. 9¹/₂ × 11³/₄ in. (24.1 × 29.8 cm.). Dated, l.r., "Octr 25th 1841." Latitude and longitude notations in left margin. Bequest, Estate of Stephen Phillips, 1972. M14943

South America

2235. Cumberland Harbor, Juan Fernandez. Watercolor. 7³/₄ × 25¹/₄ in. (19.7 × 64.1 cm.). Believed to have been painted on a French voyage. Gift, Frances M. Damon, 1971. M14528

2236. Cumberland Harbor, Juan Fernandez. Watercolor. 7³/₄ × 25¹/₄ in. (19.7 × 64.1 cm.). Inscribed on reverse: "View of Cumberland Harbour, Juan Fernandez N12 Le meme Ile de Robison [sic] Crusoe." Believed to have been painted on a French voyage. Gift, Francis M. Damon, 1971. M14529

2237. Paramaribo, Surinam, Dutch Guiana. Oil. 26¹/₄ × 45 in. (66.5 × 114.2 cm.). Dated circa 1800. This is one of three known canvases which together form a panoramic view of the Paramaribo waterfront. Purchase, 1974. M15669

2238. Paramaribo, Surinam. Oil. 26³/₄ × 45 in. (68 × 114.2 cm.). Faint inscription on stretcher appears to be "PSE...R... 1767[?].Wanendall [?]" and on back of canvas "Evrie [?] fils [?]." This canvas is one of three known views by the same artist forming a panoramic view of the Paramaribo waterfront. See also M15669 and M17371. Gift, J. Welles Henderson, 1976. M16259

2235

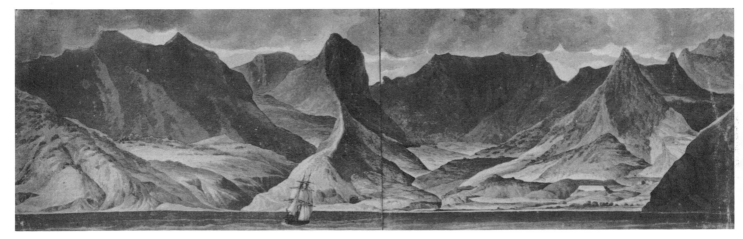
2236

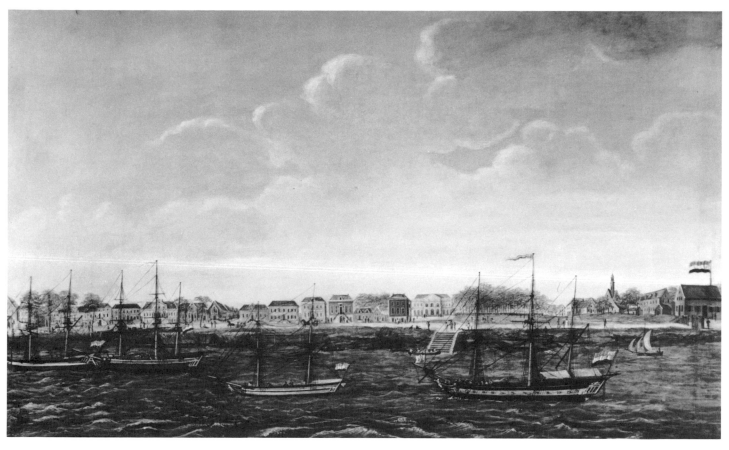

2237

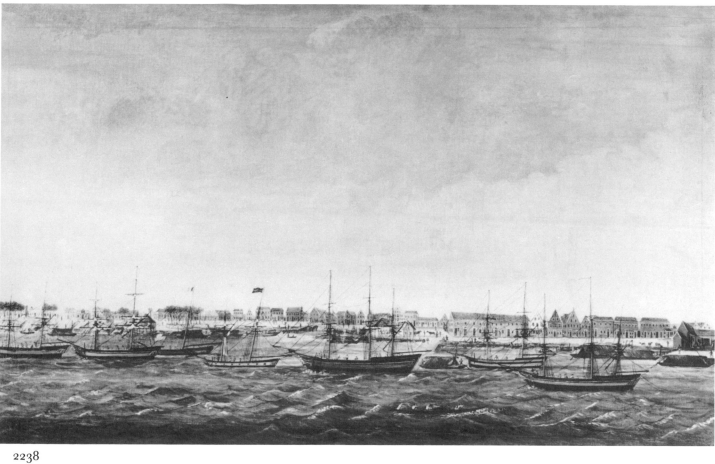

2238

95

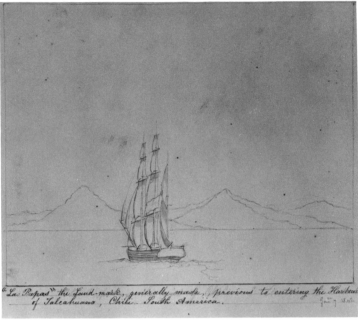

2239

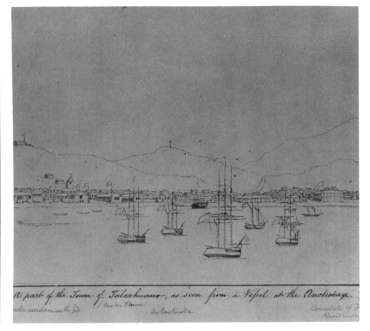

2240

2239. "'Las Papas' the Land-mark, generally made, previous to entering the Harbour of Talcahuano Chile South America." Pencil and wash. 9³/₈ × 11³/₄ in. (23.9 × 29.9 cm.). Dated, l.r., "Jan 7 1842." Bequest, Estate of Stephen Phillips, 1972.

M14933

2240. "A part of the Town of Talcahuano, as seen from a Vessel at the Anchorage." Pencil. 9¹/₂ × 11³/₄ in. (24 × 29.9 cm.). Dated, l.r., "Jan 14 1843." Several structures identified and latitude and longitude notations in left margin. Bequest, Estate of Stephen Phillips, 1972.

M14934

Unsen Japanese

2241. Twelve Japanese whaling scenes. Watercolor screen paper panels. 46³/₄ × 16 in. (121.2 × 40.6 cm.) each. Gift, F.B.L., 1968.

M13149

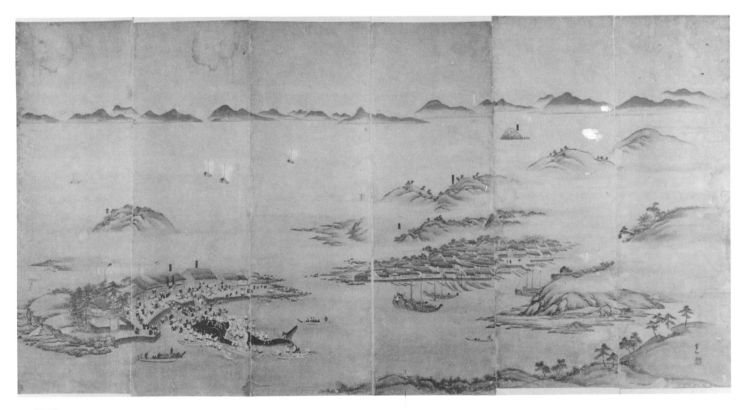

2241

Van de Velde Dutch–Anglo

2242. Unidentified ship. Pencil sketch on blue-grey paper. 5¹/₄ × 4³/₈ in. (13.3 × 11.1 cm.). Questionable attribution to Van de Velde. Purchase, 1923. Not illustrated. M13647 A

2243. Unidentified ship. Pencil sketch on blue-grey paper. 5⁵/₈ × 4¹/₂ in. (14.3 × 11.4 cm.). Questionable attribution to Van de Velde. Purchase, 1923. Not illustrated. M13647 B

Varnum, Warner British [w. 1835–1843]

2244. "Looking up the Inner harbour Macao from hills near the Barrier." Pencil. 7¹/₂ × 11 in. (19.1 × 28 cm.). Signed, l.r., "June 28th W. V." Color notes on reverse. Gift, F.B.L., 1970. M13911

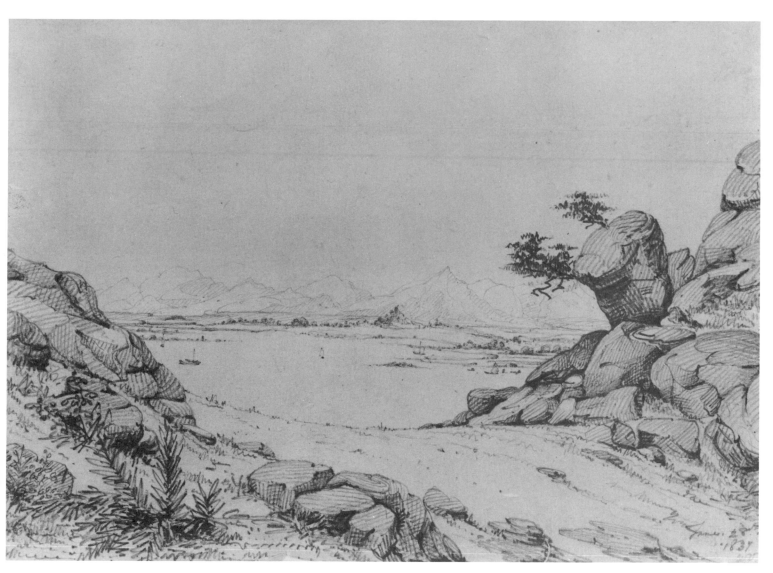

2244

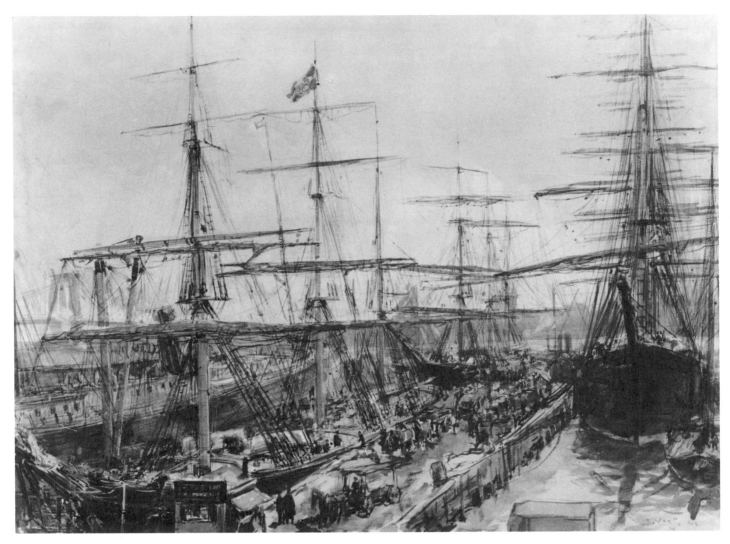

2245

2246

Vogt, Louis Charles American [1864– ?]

2245. South Street, New York. Watercolor. 10 × 13⁷/₈ in. (25.4 × 35.2 cm.). Signed, l.r., "L.C. Vogt 42." Gift, Richard B. Holman, 1969. M13523

W., G.

2246. "In the China Seas – Passengers sacrificing to Neptune" on board the P & O ship *Indus*, 10 April 1857. Watercolor. 8⁷/₈ × 12³/₄ in. (22.5 × 32.3 cm.). Signed, l.r., "G. W." Gift, F.B.L., 1973. M15625

Wales, George Canning American [1868–1940]

2247. CONSTITUTION. "Constitution luffs to rake Guerriere" [United States and British frigates]. Pencil. 10¹/₄ × 16¹/₈ in. (26 × 40.9 cm.). Signed, l.r., "George C. Wales – 1920." Gift, Mrs. Howard Thayer Kingsbury, 1967. M12954

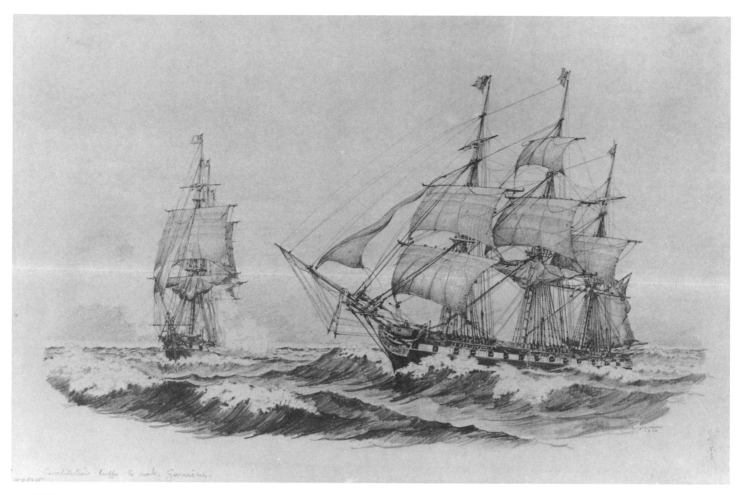

2247

2248. CONSTITUTION. "American Ships / V / 44-Gun Frigate / Constitution / 1812" [United States frigate] Ink wash. 15 × 19¹/₂ in. (38 × 49.5 cm.). Signed, l.l., "G.C.W. 1925," and l.r., "George C. Wales." Original study for lithograph of the same title. Gift, Mrs. Howard Thayer Kingsbury, 1967.

M13012

2249. MAURETANIA. "Mauretania Inbound." [British steamer]. Sepia wash. 8⁵/₈ × 11¹/₂ in. (21.9 × 29.2 cm.). Signed, l.r., "George C. Wales 1933." Built 1907, Newcastle, 12,542 tons. Shown passing the Nantucket lightship. Wales' notation in margin: "Study for drypoint – Mauretania Inbound drawn in reverse for transfer to plate." Gift, Mrs. Howard Thayer Kingsbury, 1967.

M13022

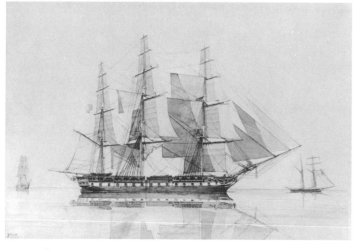

2248

2249

2250. MAYFLOWER [British ship]. Unfinished pencil sketch. 13³/4 × 11³/4 in. (35 × 29.8 cm.). Unsigned, attributed to George C. Wales. Pilgrim ship. Preliminary design for a dinner plate. Gift, Mrs. Howard Thayer Kingsbury, 1967. Not illustrated. M13032

2251. Unidentified gaff-rigged sloop. Pen and ink. 12 × 9⁷/8 in. (30.5 × 25.1 cm.). Signed, l.l., "G.C.W. 1930." Gift, Mrs. Howard Thayer Kingsbury, 1967. Not illustrated. M13001

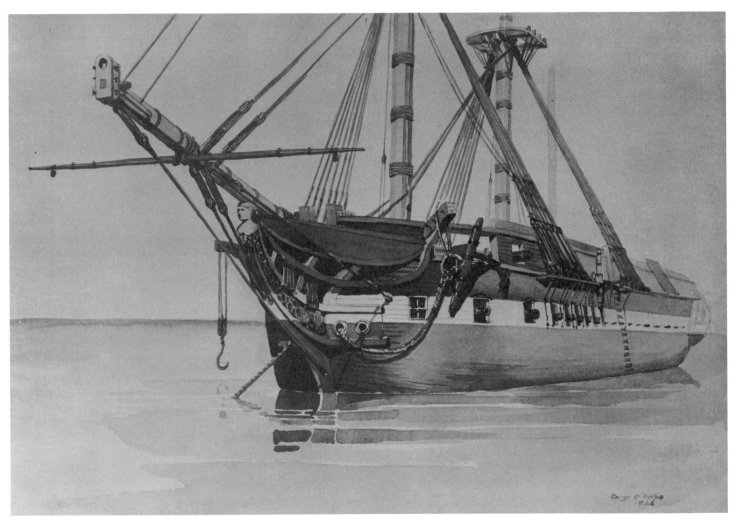

2252

2252. Unidentified frigate. Wash drawing. 12³/4 × 19¹/2 in. (32.4 × 49.5 cm.). Signed, l.r., "George C. Wales 1926." Gift, Mrs. Howard Thayer Kingsbury, 1967. M13009

2253. Unidentified ship. Pencil perspective sketch with notes. 8½ × 18⅛ in. (21.5 × 46 cm.). Unsigned, attributed to George C. Wales. Gift, Mrs. Howard Thayer Kingsbury, 1967. Not illustrated. M13010

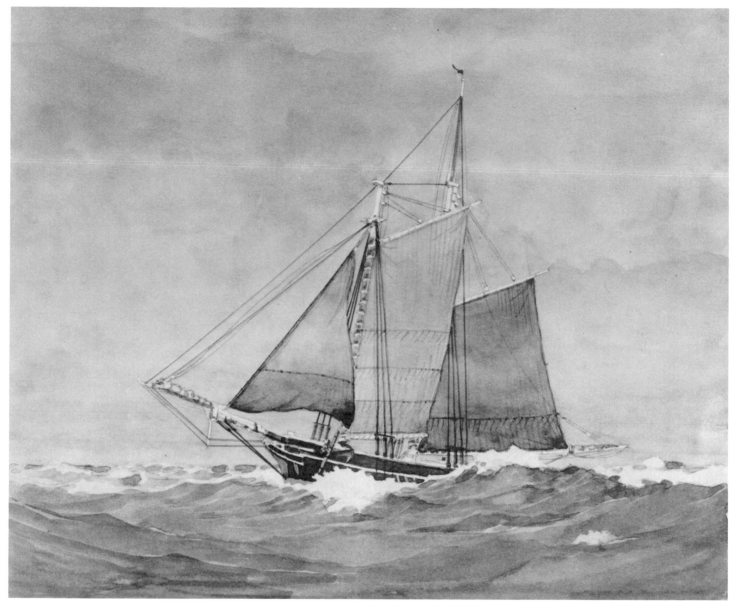

2254

2254. Unidentified schooner. Watercolor. 8⅛ × 10¼ in. (20.6 × 26 cm.). Signed, l.l., "George C. Wales 1935." On reverse: "Northeast." Gift, Mrs. Howard Thayer Kingsbury, 1967.
M13013

2255. Unidentified hermaphrodite brig in moonlight. Crayon on blue paper. 6³/₄ × 8 in. (17.1 × 20.3 cm.). Signed, l.l., "George C. Wales 1935." Gift, Mrs. Howard Thayer Kingsbury, 1967. Not illustrated.　　　M13014

2256. Stern of unidentified sloop of war. Pencil. 10 × 8 in. (25.4 × 20.3 cm.). Signed, l.r., "George C. Wales 1932 to Ellen Kingsbury." Gift, Mrs. Howard Thayer Kingsbury, 1967. Not illustrated.　　　M13015

2260. Unidentified vessel and tug. Pencil. 9 × 5⁵/₈ in. (22.8 × 14.4 cm.). Signed, l.r., "G.C.W." Gift, Mrs. Howard Thayer Kingsbury, 1967. Not illustrated.　　　M13020

2261. Unidentified whaleship. Pencil. 6¹/₈ × 8³/₈ in. (15.6 × 21.3 cm.). Signed, l.r., "G.C.W." Entitled: "Mainsl Haul." Gift, Mrs. Howard Thayer Kingsbury, 1967. Not illustrated.　　　M13021

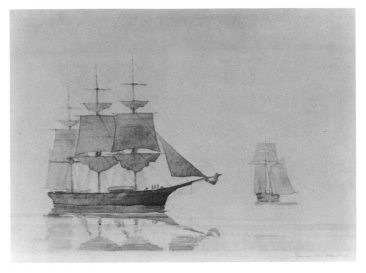

2262

2262. Original study for "Morning Mist," 1928. Wash drawing. 8³/₈ × 11³/₈ in. (21.3 × 28.8 cm.). Signed, l.r., "George C. Wales." Gift, Mrs. Howard Thayer Kingsbury, 1967. M13023

2263. "24 pdr. Gun – English Type Circa 1800." Ink wash. 6⁵/₈ × 9¹/₂ in. (16.8 × 24.7 cm.). Signed, l.r., "George C. Wales 1934." Gift, Mrs. Howard Thayer Kingsbury, 1967. Not illustrated.　　　M13024

2257

2257. Unidentified ship and brig. Pencil. 10⁵/₈ × 8 in. (27 × 20.3 cm.). Signed, l.r., "G.C.W." Gift, Mrs. Howard Thayer Kingsbury, 1967.　　　M13017

2258. Unidentified frigate at sea. Pencil. 9 × 6³/₄ in. (22.8 × 17.5 cm.). Signed, l.r., "G.C.W. 1930." Gift, Mrs. Howard Thayer Kingsbury, 1967. Not illustrated.　　　M13018

2259. Unidentified steamer at sea. Pencil. 6⁵/₈ × 9⁵/₈ in. (16.8 × 24.5 cm.). Signed, l.r., "G.C.W." Gift, Mrs. Howard Thayer Kingsbury, 1967. Not illustrated.　　　M13019

2264. "Gunner and Lobsterman." Wash drawing. 6³/₄ × 14³/₈ in. (17 × 36.5 cm.). Signed, l.r., "George C. Wales 1939." Gift, Mrs. Howard Thayer Kingsbury, 1967.　　　M13025

2265. Unidentified schooner and sloop yacht. Pencil. 7⁵/₈ × 9⁵/₈ in. (19.4 × 24.4 cm.). Signed, l.r., "George C. Wales 1931." Study for "off Shore" drypoint. Gift, Mrs. Howard Thayer Kingsbury, 1967. Not illustrated.　　　M13026

2266. Unidentified whaleship. Pencil. 13 × 18 in. (33 × 45.7 cm.). Unsigned, attributed to George C. Wales. Also a tracing of the same subject but with minor variations. Gift, Mrs. Howard Thayer Kingsbury, 1967.　　　M13028 A and B

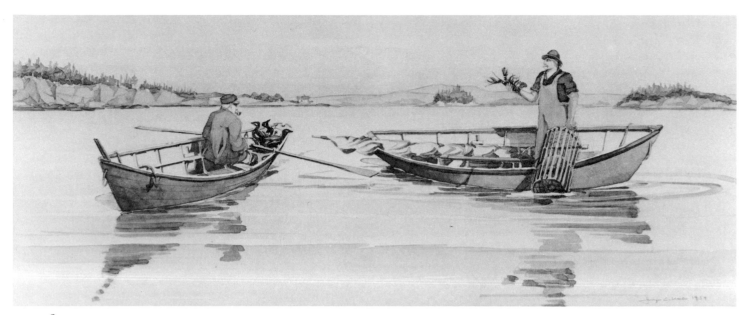

2264

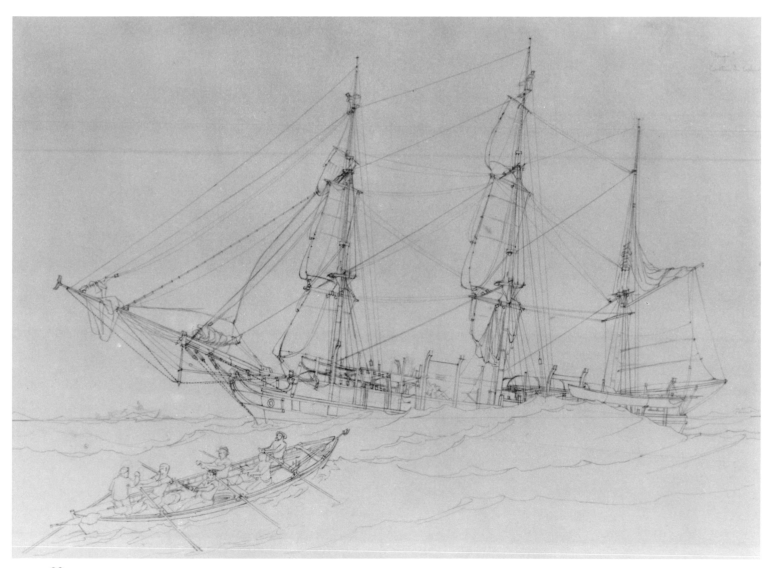

2266

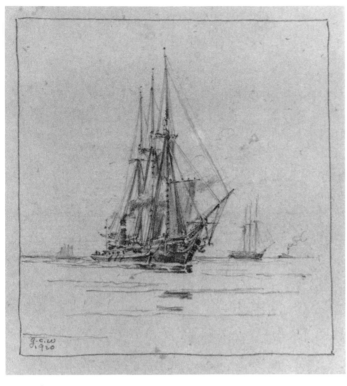

2267

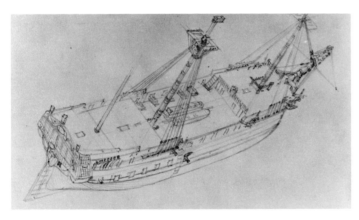

2268

2267. Unidentified schooner under tow by a tug. Pencil. 7¹/₄ × 4³/₄ in. (18.4 × 12.1 cm.). Signed, l.l., "G.C.W. 1920." Gift, Mrs. Howard Thayer Kingsbury, 1967.　　　M13042

2268. Unidentified British naval vessel hove down. Pencil sketch. 4¹/₈ × 7⁵/₈ in. (10.5 × 19.5 cm.). Gift, Robert J. Clark, 1941.　　　M16436 A

2269. Ship's cannon. Pencil sketch. 3¹/₂ × 3 in. (9 × 7.6 cm.). Unsigned, attributed to George C. Wales. Gift, Richard B. Holman, 1977. Not illustrated.　　　M17054

2270. Bowsprit details, figurehead, and anchors. Pencil sketch. 3³/₄ × 4³/₄ in. (9.5 × 12.1 cm.). Unsigned, attributed to George C. Wales. Gift, Richard B. Holman, 1977. Not illustrated.　　　M17055

2271. Whaler and frigate. Pencil sketches. 3³/₄ × 5¹/₈ in. (9.5 × 13 cm.). Signed, "George C. Wales." Gift, Richard B. Holman, 1977. Not illustrated.　　　M17056

2272. Ship under sail. Pencil sketch. 4³/₄ × 5³/₈ in. (12 × 13.7 cm.). Unsigned, attributed to George C. Wales. Gift, Richard B. Holman, 1977. Not illustrated.　　　M17057

2273. Hull details, gun ports. Pencil sketch. 7³/₄ × 3¹/₄ in. (19.7 × 8.3 cm.). Unsigned, but drawn on reverse of Wales & Holt, Architects, stationery. Gift, Richard B. Holman, 1977. Not illustrated.　　　M17059

2274. Helmsman and crewman. Pencil sketch. 8³/₈ × 6¹/₄ in. (21.3 × 15.9 cm.). Unsigned, attributed to George C. Wales. Gift, Richard B. Holman, 1977. Not illustrated.　　　M17060

2275. Sketchbook, approximately 240 pages of marine and shipping subjects. Pencil, pen. 11 × 8¹/₂ in. (27.9 × 21.6 cm.). By George C. Wales. Gift, Mrs. Howard Thayer Kingsbury, 1967. Not illustrated.　　　M12932

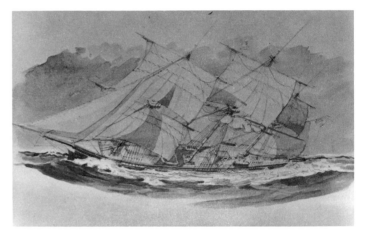

2276

2276. Sketchbook, 25 pages of shipping subjects. Pencil, pen and ink, watercolor. 10¹/₂ × 6¹/₂ in. (26.7 × 16.5 cm.). By George C. Wales. Gift, Mrs. Howard Thayer Kingsbury, 1967.　　　M12933

2277. Sketchbook, 31 pages of shipping subjects. Pencil. 10¹/₄ × 8 in. (26 × 20.3 cm.). By George C. Wales. Gift, Mrs. Howard Thayer Kingsbury, 1967. Not illustrated.　　　M12934

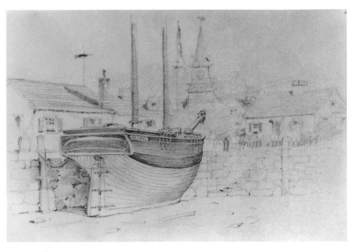

2280

2278. Sketchbook, 34 pages of shipping subjects. Pencil. 5½ × 8¼ in. (14 × 21 cm.). By George C. Wales. Gift, Mrs. Howard Thayer Kingsbury, 1967. Not illustrated. M12935

2279. Sketchbook, 25 pages of shipping subjects. Pencil. 5½ × 8¼ in. (14 × 21 cm.). By George C. Wales. Gift, Mrs. Howard Thayer Kingsbury, 1967. Not illustrated. M12936

2280. Sketchbook, 84 pages of pencil notes and shipping sketches. Pencil. 5½ × 8¼ in. (14 × 21 cm.). By George C. Wales. Inscribed: "'B' Project Plates H[oward]. I[rving]. C[hapelle]. List of Fisherman Perspectives 1938." Gift, Mrs. Howard Thayer Kingsbury, 1967. M12937

2281. Sketchbook, 47 pages maritime sketches. Pencil. 5½ × 8¼ in. (14 × 21 cm.). By George C. Wales. Inscribed: "Clipper Plates 1064...40 1937." Gift, Mrs. Howard Thayer Kingsbury, 1967. Not illustrated. M12938

2282. Sketchbook, containing 58 pages of pencil sketches and notes. 5⅜ × 8⅛ in. (13.6 × 20.7 cm.). Gift, John Pickering, Jr., 1974. Not illustrated. M15746

Walke, Henry American [1808–1896]

2283. NORTH CAROLINA. "The N. Carolina leaving her anchorage at the Naval Hospital" [United States ship-of-the-line]. Watercolor. 6¼ × 11¼ in. (15.6 × 28.5 cm.). Unsigned, attributed to Lt. Henry Walke, U.S.N., circa 1840–1843. Built 1820, Philadelphia, Pa., 2,633 tons. Gift, Stephen Phillips, 1967. M12838

2284. "Rio de Janeiro from the Bay." Watercolor in three sections. 4⅜ × 22 in. (11 × 55.9 cm.). Unsigned, attributed to Lt. Henry Walke, U.S.N., who served on board the U.S. frigate *Boston*, 1840–1843. Gift, Stephen Wheatland, 1967. M12836

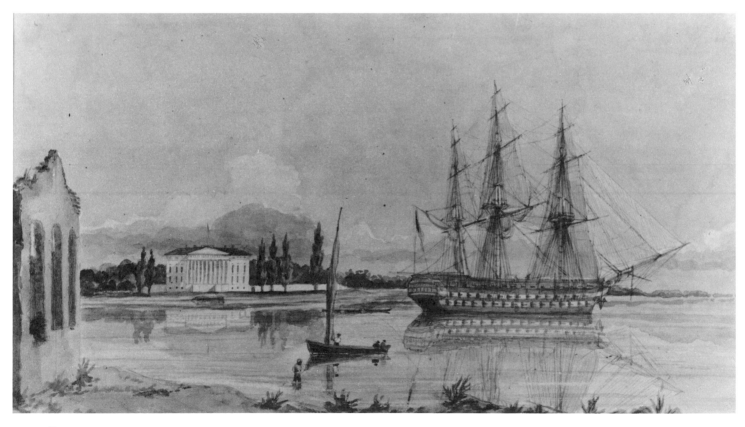

2283

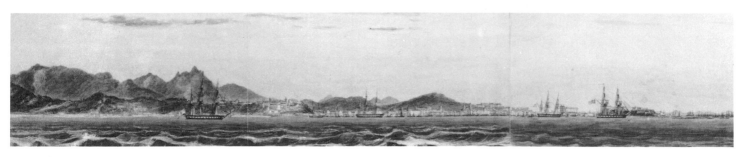

2284

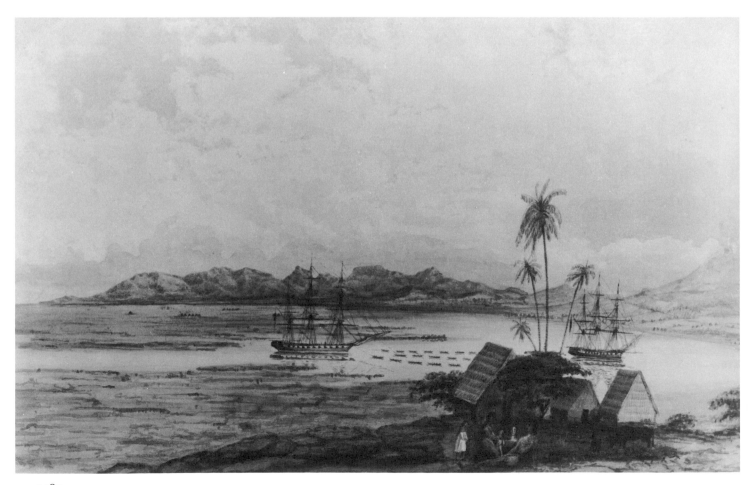

2285

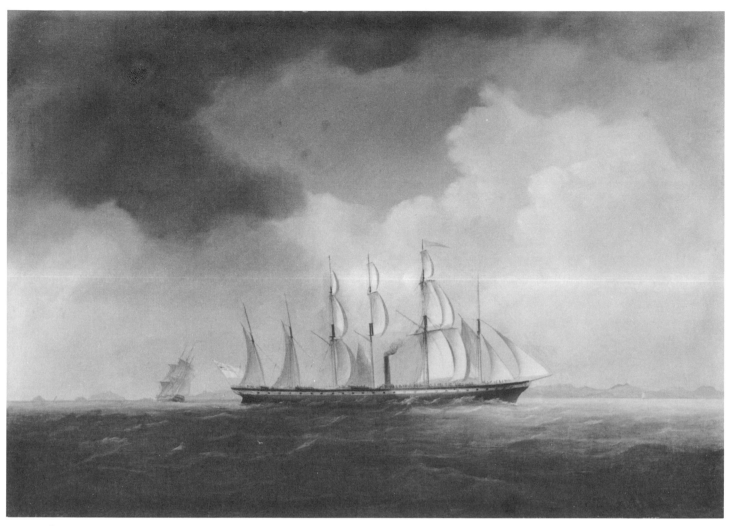

2286

2285. Pearl Harbor, Hawaii, and the Waianae Mountains. "Entrance to the Port of Honoloolo, in the Isl^d of Wahoo, one of the Sandwitch Islands." Watercolor. 8³/₄ × 14⁵/₈ in. (22.2 × 37.1 cm.). Unsigned, attributed to Lt. Henry Walke, U.S.N., who served on board the U.S. frigate *Boston*, 1840–1843. Gift, Stephen Wheatland, 1967. M12837

Walter, Joseph British [1783–1856]

2286. GREAT BRITAIN [British steamer]. Oil. 21 × 30 in. (53.3 × 76.2 cm.). Signed, l.r., "J. Walter." Built 1843, Bristol, England, 3,270 tons. Deposit, Francis Lee Higginson.

FLH 260

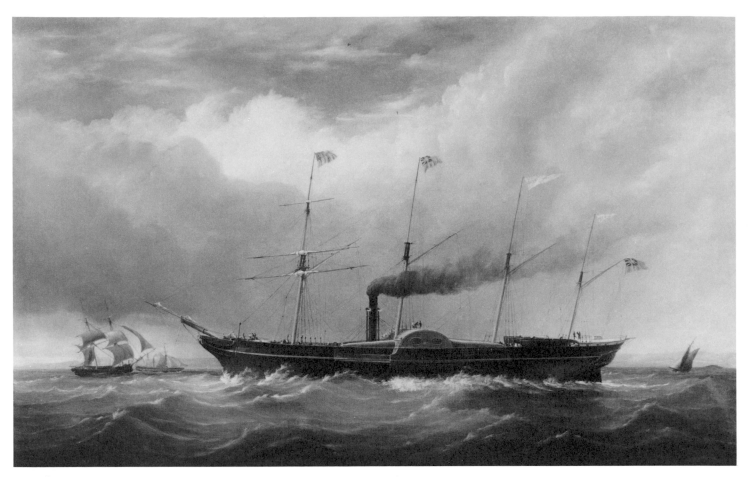

2287

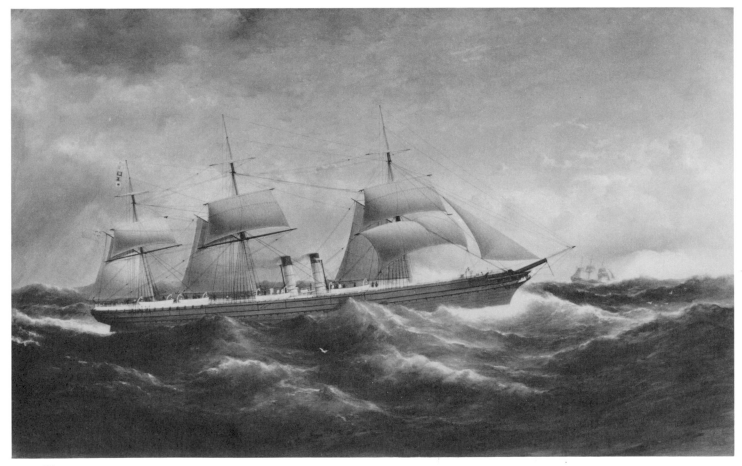

2288

2287. GREAT WESTERN [British steamer]. Oil. 26 × 42 in. (66 × 106.7 cm.). Signed, l.l., "J. Walter, 1838." Built 1838, Bristol, England, 1,340 tons. Deposit, Francis Lee Higginson.

FLH 272

Walters, Samuel British [1811–1882]

2288. AUSTRALASIAN [British steamer]. Oil. 31 × 51 1/4 in. (78.7 × 130.1 cm.). Signed, l.l., "S Walters, 1867." Built 1857, Glasgow, 2,902 tons. Deposit, Francis Lee Higginson.

FLH 275

2289. CITY OF RICHMOND [British steamer]. Oil. 35 3/4 × 61 3/4 in. (90.8 × 156.8 cm.). Unsigned, attributed to Samuel Walters. Built 1873, Glasgow, 4,623 tons. Deposit, Francis Lee Higginson. FLH 278

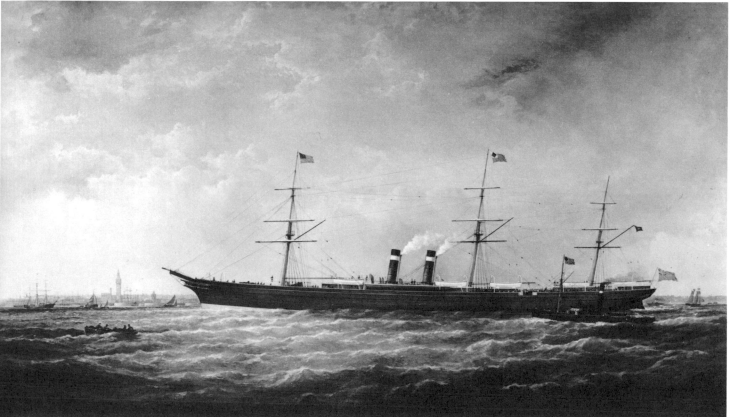

2289

2290. EMERALD ISLE [British steamer] off Holyhead. Oil.
14 × 20 in. (35.6 × 50.8 cm.). Signed, l.r., "Walters, 1831."
Deposit, Francis Lee Higginson. FLH 276

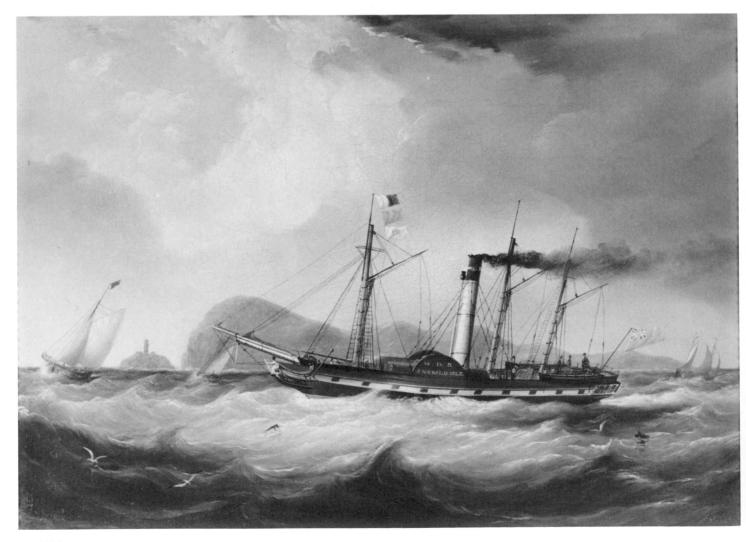

2290

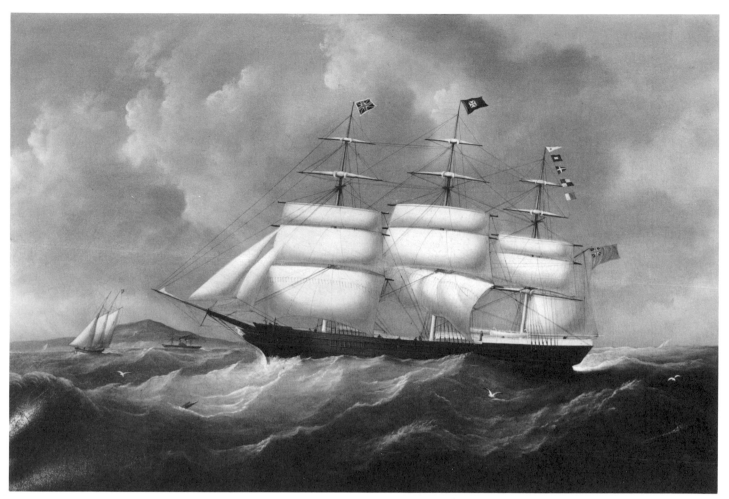

2291

2291. MONICA [British ship]. Oil. 24 × 36 in. (61 × 91.4 cm.). Unsigned, attributed to Samuel Walters. Built 1854, Quebec, 1,404 tons. Bequest, Miss Julia M. Fairbanks, 1969.

M14035

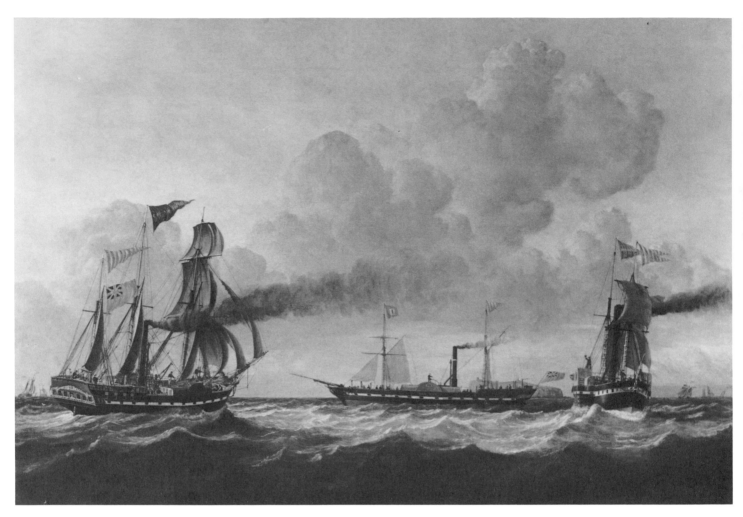

2292

Ward, John British [1798–1849]

2292. ROB ROY, QUEEN OF SCOTLAND, and HELEN McGREGOR [British steamers] of Hull, England. Oil. 24 × 36 in. (60.9 × 91.4 cm.). *Rob Roy* built 1836, Hull, 299 tons. *Queen of Scotland* built 1827, Aberdeen, 304 tons. *Helen McGregor* built 1843, Birkenhead. Deposit, Francis Lee Higginson. FLH 280

Watson, ? British

2293. SIMLA [British steamer]. Pen and ink sketch. 4³/₈ × 5¹/₈ in. (11 × 13 cm.). Sketch by —Watson, R.N., 28 December 1871. Built 1858, Birkenhead, England, 1,444 tons. Accession information unknown. M15569

2293

2294

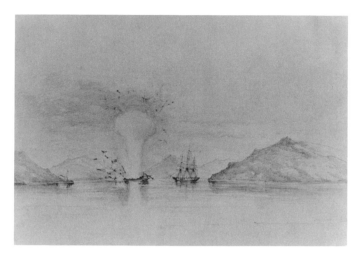

2295

2296

2297

Watson, Dr. T. Boswell British [1815–1860]

2294. HASTINGS, HONG KONG, and MEDEA [British vessels]. Pencil. 6³/₄ × 10¹/₄ in. (17.2 × 26 cm.). Unsigned, attributed to T. Boswell Watson. *Hong Kong* built 1849, Northfleet, 149 tons. Shown in Hong Kong Harbor. From the Hugh Beach Collection. Gift, F.B.L., 1968. M13446

2295. DONNA MARIA [Portuguese warship]. "The Blowing up of the 'Donna Maria,' Portuguese Man-of-War, in Macao Harbor 29th Septr. 1850." Pencil sketch. 8³/₈ × 12⁵/₈ in. (21.3 × 32 cm.). Unsigned, attributed to T. Boswell Watson. Gift, F.B.L., 1973. M15629

2296. Lintin Island, China. Pencil. 6³/₈ × 8⁵/₈ in. (16.2 × 21.9 cm.). Unsigned, attributed to T. Boswell Watson. From the Hugh Beach Collection. Gift, F.B.L., 1968. M13441

2297. Makok Temple, Joss House, Macao. Pencil and colored pencil. 10 × 14 in. (25.4 × 35.5 cm.). Unsigned, attributed to T. Boswell Watson. Dated, l.r., "16 Nov. 1858." From the Hugh Beach Collection. Gift, F.B.L., 1968. M13442

2298

2298. "At the Bogue Forts 13 May 1847." Pencil. 8¹/₄ × 13¹/₂ in. (21 × 34.4 cm.). Unsigned, attributed to T. Boswell Watson. From the Hugh Beach Collection. Gift, F.B.L., 1968. M13443

2299

2299. "Boulders, Lappa, near Macao." Pencil. 6⅞ × 10 in. (17.5 × 25.5 cm.). Unsigned, attributed to T. Boswell Watson. From the Hugh Beach Collection. Gift, F.B.L., 1968. Not illustrated. M13455

2300. Hong Kong Harbor. Pencil. 7 × 10 in. (17.8 × 25.4 cm.). Unsigned, attributed to T. Boswell Watson. From the Hugh Beach Collection. Gift, F.B.L., 1968. M13445

2301. Unidentified paddle wheeler. Pencil. 6¾ × 10¼ in. (17.2 × 26 cm.). Unsigned, attributed to T. Boswell Watson. Removed from the verso of M13446. From the Hugh Beach Collection. Gift, F.B.L., 1968. M13446 B

2302. Old Protestant Cemetery, Macao. Pencil. 8 × 7½ in. (20.3 × 19 cm.). Unsigned, attributed to T. Boswell Watson. Inscribed on reverse: "R. Rangel Esq. / F.T. Bush Esq. / Hong Kong." From the Hugh Beach Collection. Gift, F.B.L., 1968. M13447

2303. Franciscan Fort, Macao. Pencil. 3½ × 5⅞ in. (9 × 15 cm.). Unsigned, attributed to T. Boswell Watson. From the Hugh Beach Collection. Gift, F.B.L., 1968. M13448

2304. "English Burying ground, Macao. Mrs Speers Tombstone." Pencil. 9 × 7 in. (22.9 × 17.8 cm.). Unsigned, attributed to T. Boswell Watson. From the Hugh Beach Collection. Gift, F.B.L., 1968. M13449

2300

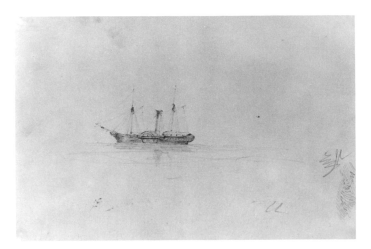

2301

2302

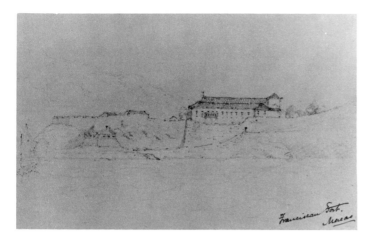

2303

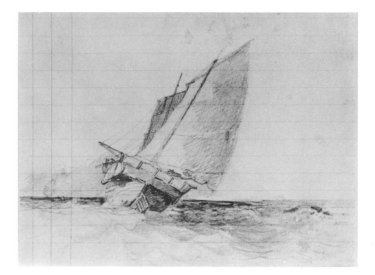

2305

2305. Chinese Junk. Pencil. 5¹/₂ × 7¹/₈ in. (14 × 18.2 cm.). Unsigned, attributed to T. Boswell Watson. From the Hugh Beach Collection. Gift, F.B.L., 1968. M13450

2306. "Back of Franciscan Fort. Macao." Pencil. 7⁷/₈ × 11¹/₈ in. (20.1 × 28.3 cm.). Unsigned, attributed to T. Boswell Watson. From the Hugh Beach Collection. Gift, F.B.L.,1968. M13451

2307. "Church at Macao." Pencil. 8 × 12¹/₄ in. (20.2 × 31.2 cm.). Unsigned, attributed to T. Boswell Watson. From the Hugh Beach Collection. Gift, F.B.L., 1968. M13452

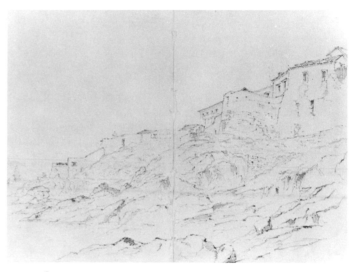

2306

2304

2307

2308

2309

2308. "At the Joss House, Macao Inner Harbour, Macao, 1856." Pencil. 7⅞ × 9¾ in. (20.1 × 24.7 cm.). Unsigned, attributed to T. Boswell Watson. From the Hugh Beach Collection. Gift, F.B.L., 1968. M13453

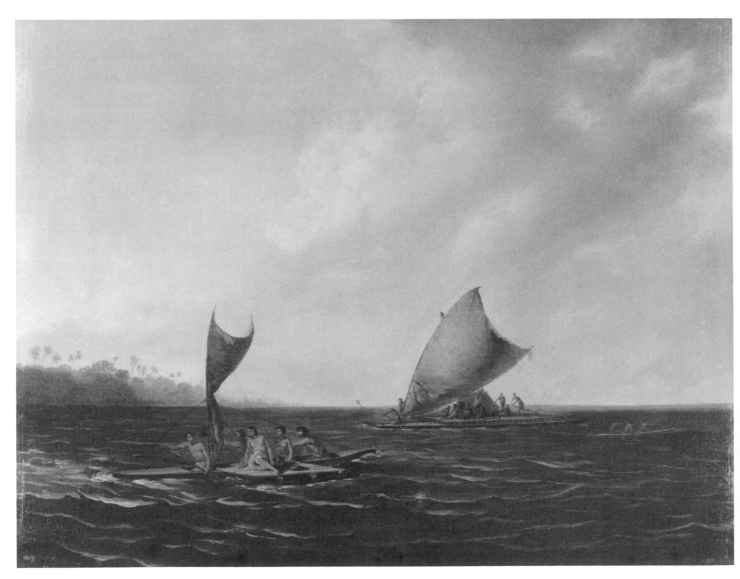

2310

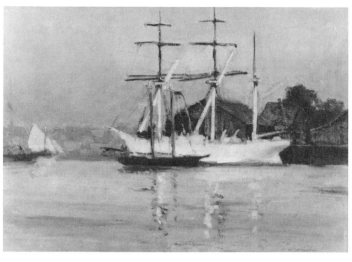

2311

2309. "Inner Harbor, Macao." Watercolor. 6⅞ × 10 in. (17.5 × 25.5 cm.). Unsigned, attributed to T. Boswell Watson. Gift, F.B.L., 1973. M15630

Webber, John British [1750–1793]

2310. Tonga canoes. Oil. 19 × 25 in. (48.3 × 63.5 cm.). Unsigned, attributed to John Webber. Gift, Stephen Wheatland, in memory of Stephen Phillips (1907–1971), 1974. M15651

Wheater, Joseph H. American [1885–1959]

2311. GIOCOMO [Italian bark]. "Giocomo of Genoa" at East Gloucester, Massachusetts, 1912. 10 × 14 in. (25.4 × 35.5 cm.). Signed, l.r., "J. H. Wheater." Gift, Francis W. Dolloff, 1976. M16480

Wilkinson, Norman British [1878–1934]

2312. OLYMPIC [British steamer]. Oil. 33¼ × 51⅜ in. (84.4 × 130.5 cm.). Signed, l.r., "Norman Wilkinson." Built 1911, Belfast, 45,324 tons. Deposit, Francis Lee Higginson. FLH 282

Willoughby, Robert British [1768–1843]

2313. MOLLY [English ship]. Oil. 28 × 40⅛ in. (71.1 × 102 cm.). Signed, l.l., "R. Willoughby 1806." Shown in the Arctic. Gift, F.B.L., 1976. See color plate facing page 79. M16519

Wilson, Charles J. A. American [1880–1965]

2314. ARETHUSA [British bark]. Watercolor. 19½ × 17⅝ in. (49.5 × 44.7 cm.). Signed, l.r., "C.J.A. Wilson '28." Built 1891, Dumbarton, Scotland, 1,198 tons. Inscription on reverse: "In Rex Clements Gypsy of the Horn." Purchase, Fellows and Friends Funds, 1967. Not illustrated. M12919

2312

2316

2317

2315. BENJAMIN F. PACKARD [American ship]. Watercolor. 19⁵/₈ × 28 in. (49.9 × 71.1 cm.). Signed, l.r., "C.J.A. Wilson 1927." Built 1883, Bath, Me., 2,076 tons. Purchase, Fellows and Friends Funds, 1967. Not illustrated. M12917

2319

2316. BIG HORN [American steamer]. Pen and ink. 11³/₈ × 14 in. (29 × 35.5 cm.). Unsigned, attributed to C. J. A. Wilson. Shown as a U.S. Coast Guard Q Ship. Built 1936, Chester, Pa., 4,337 tons. Gift, Stephen Wheatland, 1967. M12869

2318. COAMO [American steamer]. Watercolor. 9¹/₂ × 7 in. (24.1 × 17.8 cm.). Signed, l.r., "C.J.A. Wilson – 1919." Built 1891, Glasgow, 2,815 tons. Purchase, Fellows and Friends Funds, 1967. Not illustrated. M12906

2317. CARRIER X [container steamer]. Pen and ink. 15 × 21⁷/₈ in. (38.1 × 55.6 cm.). Unsigned, attributed to C. J. A. Wilson. Gift, Stephen Wheatland, 1967. M12896

2319. CAYUGA [United States Coast Guard cutter]. Pen and ink. 14⁷/₈ × 11³/₄ in. (37.8 × 29.8 cm.). Unsigned, attributed to C. J. A. Wilson. Built 1932, Staten Island, N.Y., 1,975 tons. Note at bottom reads: "Etching to be 5¹/₂″ × 7 ″." Gift, Stephen Wheatland, 1967. M12881

2320. CAYUGA [United States Coast Guard cutter]. Pencil. 11¹/₂ × 14³/₈ in. (29.2 × 36.5 cm.). Signed, l.r., "C.J.A. Wilson [anchor] 32." On reverse: pencil sketch for same subject. Built 1932, Staten Island, N.Y., 1,975 tons. Gift, Stephen Wheatland, 1967. Not illustrated. M12892

2321

2321. CHELAN [United States Coast Guard cutter]. Gouache. 21³/₄ × 28³/₈ in. (55.2 × 72 cm.). Signed, l.r., "C.J.A. Wilson 1940." Built 1928–29, Quincy, Mass., 1,975 tons. Purchase, Fellows and Friends Funds, 1967. M12925

2322

2322. COLUMBIA [American 12-meter yacht]. Sepia water-color. 13¹/₂ × 11³/₈ in. (35 × 28.9 cm.). Signed, l.r., "C.J.A. Wilson 58." Built 1958, City Island, N.Y. Purchase, Fellows and Friends Funds, 1967. M12852

2323. COLUMBIA [American 12-meter yacht]. Sepia water-color. 13¹/₂ × 9⁷/₈ in. (35 × 25 cm.). Signed, l.r., "C.J.A. Wilson 1958." Built 1958, City Island, N.Y. Purchase, Fellows and Friends Funds, 1967. Not illustrated. M12853

2324. COLUMBIA [American 12-meter yacht]. Sepia water-color. 13⁵/₈ × 10³/₄ in. (34.6 × 27.3 cm.). Signed, l.r., "C.J.A. Wilson." Built 1958, City Island, N.Y. Purchase, Fellows and Friends Funds, 1967. Not illustrated. M12867

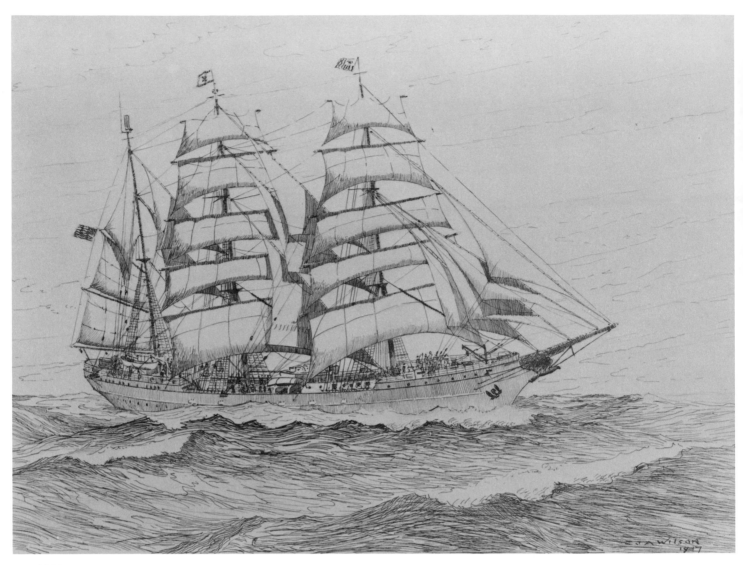

2325

2325. EAGLE [United States Coast Guard training bark]. Pen and ink. 11³/₈ × 14¹/₄ in. (28.9 × 36.2 cm.). Signed, l.r., "C.J.A. Wilson 1947." Built 1936, Hamburg, Germany, 1,816 tons. Gift, Stephen Wheatland, 1967. M12854

2326. EAGLE [United States Coast Guard training bark]. Pen and ink. 11¹/₄ × 14¹/₄ in. (28.5 × 36.2 cm.). Signed, l.r., "C.J.A. Wilson 1947." Built 1936, Hamburg, Germany, 1,816 tons. Gift, Stephen Wheatland, 1967. Not illustrated. M12857

2327. EAGLE [United States Coast Guard training bark]. Pen and ink. 10¹/₂ × 14¹/₄ in. (26.6 × 36.2 cm.). Unsigned, attributed to C. J. A. Wilson. *Eagle* is moored in a tropical harbor. Built 1936, Hamburg, Germany, 1,816 tons. Gift, Stephen Wheatland, 1967. Not illustrated. M12866

2328. EAGLE [United States Coast Guard training bark]. Pen and ink. 11 × 14¹/₄ in. (28 × 36.2 cm.). Unsigned, attributed to C. J. A. Wilson. *Eagle* is shown departing Havana Harbor. Built 1936, Hamburg, Germany, 1,816 tons. Gift, Stephen Wheatland, 1967. Not illustrated. M12868

2329. EAGLE [United States Coast Guard training bark]. Watercolor and gouache. 22¹/₂ × 18¹/₂ in. (57.1 × 47 cm.). Signed, l.r., "C.J.A. Wilson, 1947." Built 1936, Hamburg, Germany, 1,816 tons. Purchase, Fellows and Friends Funds, 1967. M12904

2330. EAGLE. [United States Coast Guard training bark]. Watercolor and gouache. 30 × 21⁷/₈ in. (76.1 × 55.5 cm.). Unsigned, attributed to C. J. A. Wilson. Built 1936, Hamburg, Germany, 1,816 tons. Purchase, Fellows and Friends Funds, 1967. Not illustrated. M12911

2331. EAGLE [United States Coast Guard training bark]. Watercolor. 19³/₄ × 26 in. (50.2 × 66 cm.). Signed, l.r., "C.J.A. Wilson 1959." Built in Hamburg, Germany, 1,816 tons. Purchase, Fellows and Friends Funds, 1967. Not illustrated. M12913

2332. ENDEAVOUR and RAINBOW [British and American yachts]. Pen and ink. 14¹/₂ × 11³/₈ in. (37 × 28.9 cm.). Unsigned, attributed to C. J. A. Wilson. *Rainbow* built 1934, Bristol, R.I. Gift, Stephen Wheatland, 1967. Not illustrated. M12888

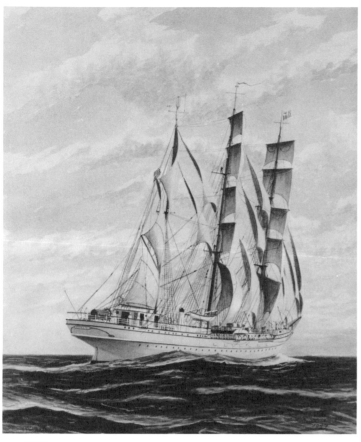

2329

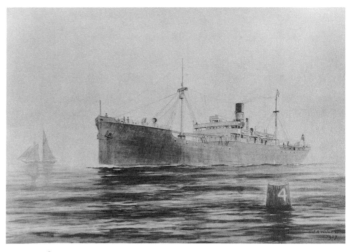

2336

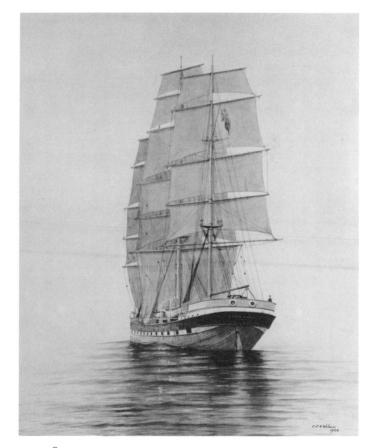

2338

2333. ENDEAVOUR II [British yacht]. Oil. 15 × 19¹/₂ in. (38 × 49.5 cm.). Signed, l.r., "C.J,A, Wilson 1934." Built Gosport, England. Purchase, Fellows and Friends Funds, 1967. Not illustrated. M12903

2334. ENDEAVOUR II [British yacht]. Gouache. 18¹/₂ × 24¹/₈ in. (47 × 61.2 cm.). Signed, l.r., "C.J.A. Wilson 1934." Built Gosport, England. Purchase, Fellows and Friends Funds, 1967. Not illustrated. M12916

2335. FLYING CLOUD [American ship]. Watercolor and gouache. 15 × 21 in. (38.1 × 53.3 cm.). Signed, l.r., "C.J.A. Wilson 1933." Built 1851, East Boston, Mass., 1,782 tons. Purchase, Fellows and Friends Funds, 1967. Not illustrated. M12918

2336. JEANNETTE SKINNER [American steamer]. Watercolor. 13¹/₂ × 20 in. (34.3 × 50.8 cm.). Signed, l.r., "C.J.A. Wilson 1927." Built 1917, Seattle, Washington, 4,384 tons. Purchase, Fellows and Friends Funds, 1967. M12915

2337. LEVIATHAN [American steamer]. 21¹/₈ × 16⁷/₈ in. (53.6 × 42.9 cm.). Signed, l.r., "C.J.A. Wilson 1927." Built 1914, Hamburg, Germany, 15,796 tons. Purchase, Fellows and Friends Funds, 1967. See color plate frontispiece. M12899

2338. LOCH ETIVE [British ship]. Watercolor. 25¹/₄ × 20¹/₄ in. (63.7 × 51.5 cm.). Signed, l.r., "C.J.A. Wilson 1926." Built 1877, Glasgow, 1,235 tons. Purchase, Fellows and Friends Funds, 1967. M12912

2339. MASSACHUSETTS [United States Revenue cutter]. Pen and ink. 10¹/₄ × 13 in. (26 × 33 cm.). Signed, l.r., "C.J.A. Wilson 1933." Built 1791, Newburyport, Mass., 70 tons. Gift, Stephen Wheatland, 1967. Not illustrated. M12876

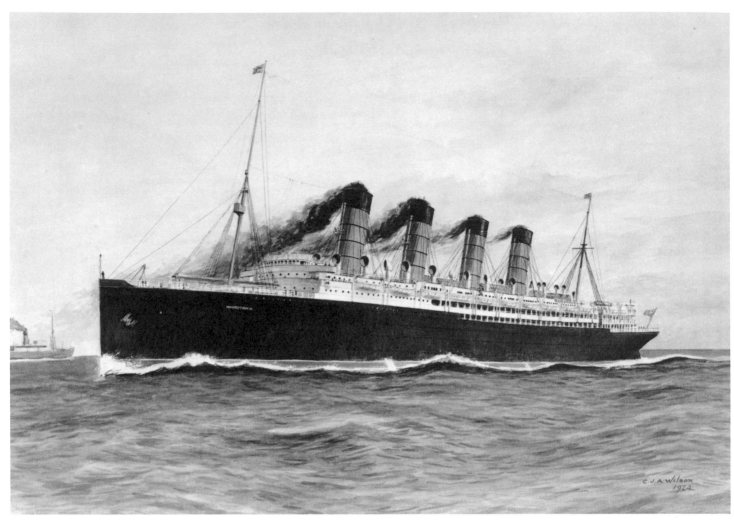

2340

2340. MAURETANIA [British steamer]. Watercolor. 18¼ × 27 in. (46.3 × 68.5 cm.). Signed, l.r., "C.J.A. Wilson 1924." Built 1907, Newcastle, 12,542 tons. On reverse: incomplete pencil sketch of the same subject. Purchase, Fellows and Friends Funds, 1967. M12924

2341. MERRIMACK [United States sloop of war]. Pen and ink. 14½ × 18⅞ in. (36.9 × 48 cm.). Signed, l.r., "C.J.A. Wilson 1933." Built 1798, Newburyport, Mass. 530 tons. Gift, Stephen Wheatland, 1967. Not illustrated. M12870

2342. MINDORO [American ship]. Pen and ink with charcoal wash. 16⅝ × 21⅝ in. (42.2 × 54.9 cm.). Signed, l.r., "C.J.A. Wilson." *Mindoro* shown at what probably is a Boston wharf. Built 1864, Boston, Mass., 970 tons. On reverse: unfinished pencil sketch of the motor vessel *Lawley* of Boston. Gift, Stephen Wheatland, 1967. M12895

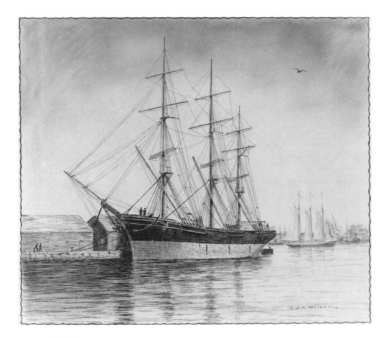

2342

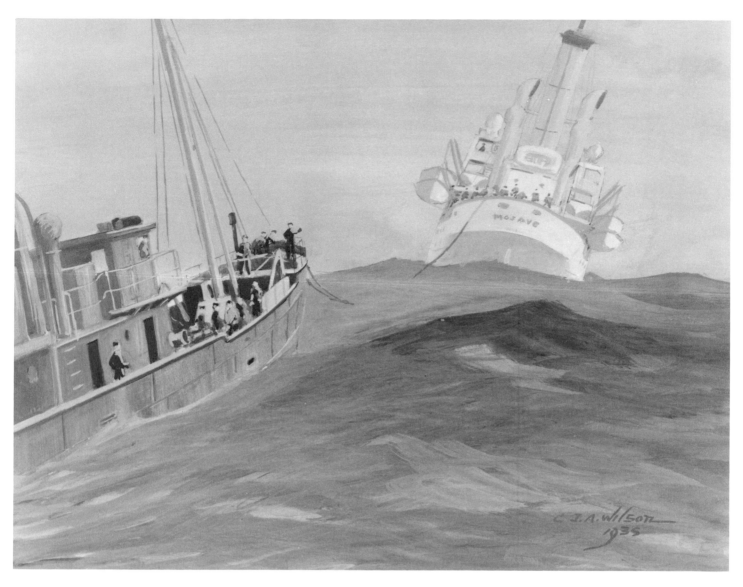

2343

2343. MOJAVE [United States Coast Guard cutter]. Gouache. 8⁷/₈ × 11³/₄ in. (22.5 × 29.9 cm.). Signed, l.r., "C.J.A. Wilson 1935." Built 1921, Oakland, California, 1,780 tons. On reverse: pencil sketch of a similar scene. Purchase, Fellows and Friends Funds, 1967. M12910

2344. MONTEREY [American steamer]. Pen and ink. 13⁷/₈ × 20³/₈ in. (35.3 × 51.7 cm.). Unsigned, attributed to C. J. A. Wilson. Tug *San Francisco* shown at right. *Monterey* built 1932, Quincy, Mass., 10,417 tons. Gift, Stephen Wheatland, 1967. M12885

2345. NANTUCKET [American lightship]. Watercolor. 10¹/₄ × 12 in. (26 × 30.5 cm.). Signed, l.r., "C.J.A. Wilson 1937." Built 1936, Wilmington, Del. Purchase, Fellows and Friends Funds, 1967. Not illustrated. M12908

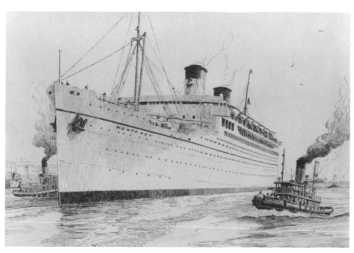

2344

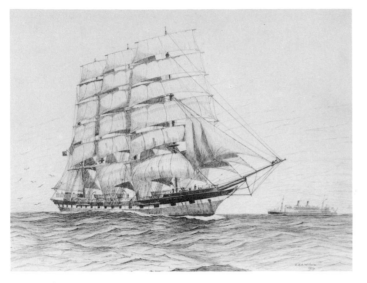

2346

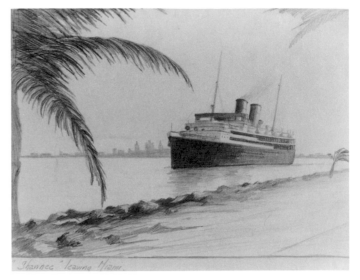

2348

2347

2346. PORT JACKSON [British bark]. Pen and ink and watercolor wash. 20 1/8 × 26 in. (51.1 × 66 cm.). Signed, l.r., "C.J.A. Wilson 1927." Built 1882, Aberdeen, Scotland, 2,132 tons. Purchase, Fellows and Friends Funds, 1967. M12920

2347. ROYALSHIRE [British bark]. Watercolor. 14 1/2 × 23 in. (36.8 × 58.4 cm.). Unsigned, attributed to C. J. A. Wilson. Purchase, Fellows and Friends Funds, 1967. M12902

2348. SHAWNEE. "'Shawnee' leaving Miami" [American steamer]. Pencil. 11 1/2 × 14 1/2 in. (29.2 × 36.8 cm.). Unsigned, attributed to C. J. A. Wilson. Built 1927, Newport News, Va., 3,405 tons. Gift, Stephen Wheatland, 1967. M12862

2349. STAR OF BENGAL [British bark]. Pen and ink. 11 3/8 × 14 5/8 in. (29 × 37.2 cm.). Signed, l.r., "C.J.A. Wilson 1932 [fouled anchor surmounted by "w"]." Built 1874, Belfast, Ireland, 1,797 tons. Gift, Stephen Wheatland, 1967. Not illustrated. M12877

2350. SURPRISE (?) [American ship]. Watercolor and gouache. 15 × 22 in. (38.1 × 55.9 cm.). Signed, l.r., "C.J.A. Wilson 1930." Built 1850, East Boston, Mass., 1,000 tons. Purchase, Fellows and Friends Funds, 1967. Not illustrated. M12914

2351. TEASER. "British brig Teaser – leaving New York 1885" [British brig]. Watercolor. 18 3/8 × 24 7/8 in. (46.6 × 63.2 cm.). Signed, l.r., "C.J.A. Wilson 1929 [anchor surmounted by "w"]." Built 1838, Canada, 132 tons. Purchase, Fellows and Friends Funds, 1967. Not illustrated. M12897

2352. THREE MARYS. "The Derelict." Pen and ink. 11 1/8 × 15 in. (28.2 × 38.1 cm.). Signed, l.r., "C.J.A. Wilson 1933." Built 1891, Bath, Me., 1,152 tons. Gift, Stephen Wheatland, 1967. M12886

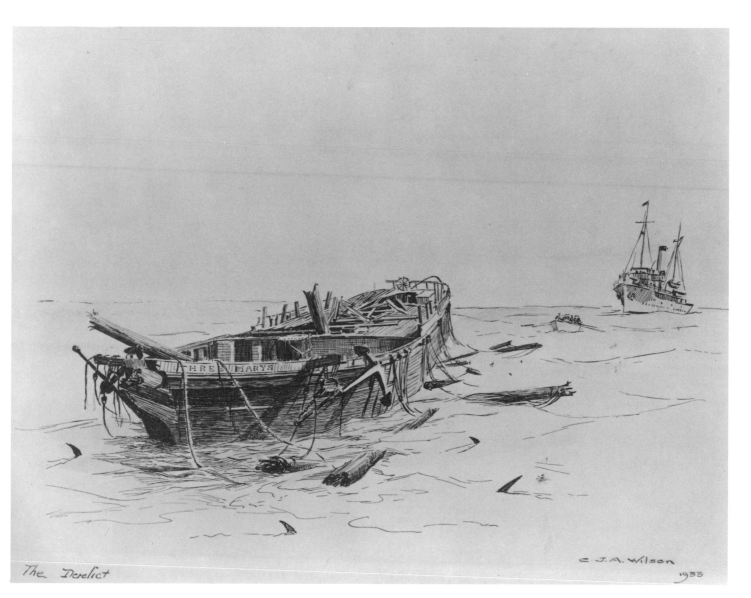

2352

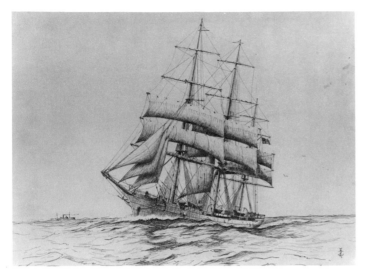

2354

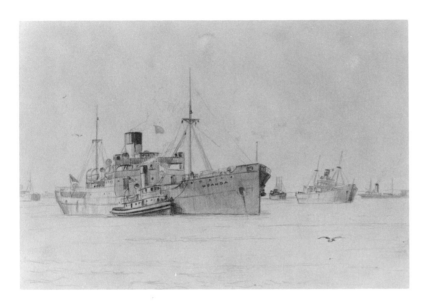

2355

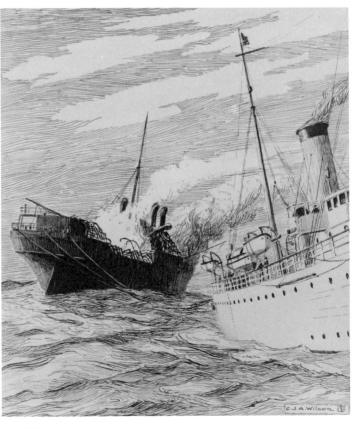

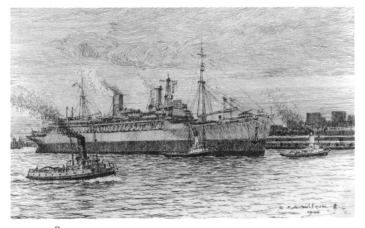

2358

2359

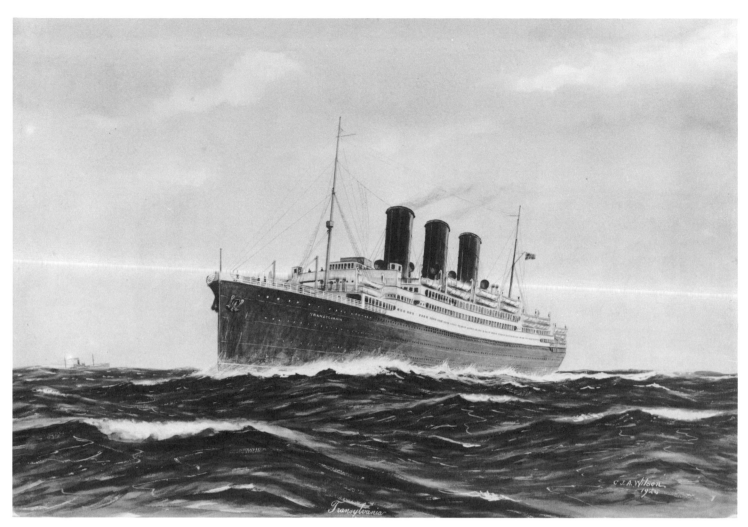

2353

2353. TRANSYLVANIA [British steamer]. Watercolor. 14¼ × 21 in. (36.2 × 53.4 cm.). Signed, l.r., "C.J.A. Wilson 1926." Built 1925, Glasgow, 10,035 tons. Purchase, Fellows and Friends Funds, 1967. M12898

2354. TUSITALA [American ship]. Pen and ink. 16¼ × 22 in. (41.3 × 55.9 cm.). Signed, l.r., with C. J. A. Wilson's mark [fouled anchor surmounted by "w"]. Built 1883, Greenock, Scotland, 1,748 tons. Gift, Stephen Wheatland, 1967. M12894

2355. UGANDA. "Arrived – Uganda (Br), Dew, Emden, Dec. 8" [British steamer]. Pencil. 11 × 14¼ in. (27.9 × 36.2 cm.). Unsigned, attributed to C. J. A. Wilson. Background possibly Boston Harbor. Gift, Stephen Wheatland, 1967. M12873

2356. WAKEFIELD. Troop transport at Gibraltar [American steamer]. Pen and ink. 11¼ × 14⅛ in. (28.6 × 35.9 cm.). Unsigned, attributed to C. J. A. Wilson. Built 1932, Camden, N.J., 13,924 tons. Gift, Stephen Wheatland, 1967. Not illustrated. M12855

2357. WAKEFIELD. Troop transport [American steamer]. Pen and ink. 11½ × 14½ in. (29.2 × 36.8 cm.). Signed, l.r., "C.J.A. Wilson 1944." Built 1932, Camden, N.J., 13,924 tons. Gift, Stephen Wheatland, 1967. Not illustrated. M12856

2358. WAKEFIELD. Troop transport [American steamer]. Pen and ink. 11½ × 14½ in. (29.2 × 36.8 cm.). Signed, l.r., "C.J.A. Wilson [anchor] 1944." Built 1932, Camden, N.J., 13,924 tons. Gift, Stephen Wheatland, 1967. M12859

2359. United States Coast Guard cutter taking a burning vessel in tow. Pen and ink. 14½ × 11½ in. (36.8 × 29.2 cm.). Signed, l.r., "C.J.A. Wilson 3[anchor]2." Gift, Stephen Wheatland, 1967. M12863

2360. United States Coast Guard flying boat. Pen and ink. 10⅞ × 13⅝ in. (27.7 × 34.6 cm.). Signed, l.r., "C.J.A. Wilson 3[anchor]2." Gift, Stephen Wheatland, 1967. Not illustrated. M12875

2361

2361. Icebreaker of the "Wind" Class [U.S. Coast Guard cutter]. Pen and ink. 13⁷/₈ × 20¹/₄ in. (35.3 × 51.4 cm.). Signed, l.r., "C.J.A. Wilson 1944." Gift, Stephen Wheatland, 1967.
M12884

2362. Thirty-eight foot U.S. Coast Guard picket boat No. 4306. Gouache. 8¹/₄ × 11³/₄ in. (21 × 29.8 cm.). Unsigned, attributed to C. J. A. Wilson. Purchase, Fellows and Friends Funds, 1967.
M12909

2363. United States Coast Guard amphibious aircraft. Watercolor and gouache. 13⁵/₈ × 21 in. (34.6 × 53.3 cm.). Signed, l.r., "C.J.A. Wilson 1932 [fouled anchor]." Purchase, Fellows and Friends Funds, 1967. Not illustrated.
M12921

2364. Coast Guard 24, formerly a U.S. Navy 4-stack destroyer. Watercolor. 16 × 21¹/₂ in. (40.6 × 54.6 cm.). Signed, l.r., "C.J.A. Wilson 1930." Purchase, Fellows and Friends Funds, 1967.
M12923

2365. Unidentified Down East lumber schooners [American schooners]. Pencil. 10 × 14 in. (25.4 × 35.6 cm.). Unsigned, attributed to C. J. A. Wilson. On reverse: unfinished pencil sketch of a steamer going through a drawbridge. Gift, Stephen Wheatland, 1967.
M12851

2366. Sail and motor yachts. Unfinished pencil and pen sketch. 13¹/₄ × 11³/₈ in. (33.3 × 29 cm.). Unsigned, attributed to C. J. A. Wilson. Gift, Stephen Wheatland, 1967. Not illustrated.
M12858

2367. Unidentified barkentine with tugboat *Jane*. Pen and ink. 11¹/₂ × 14¹/₄ in. (29.2 × 36.2 cm.). Unsigned, attributed to C. J. A. Wilson. On reverse: unfinished pencil sketch of an unidentified motor-sail yacht. Gift, Stephen Wheatland, 1967. Not illustrated.
M12860

2368. World War II convoy. Ink and sepia wash. 9⁷/₈ × 16⁷/₈ in. (25.1 × 42.8 cm.). Signed, l.r., "C.J.A. Wilson 1933." On reverse: pencil sketch of a convoy. Gift, Stephen Wheatland, 1967.
M12861

2369. Destroyer on North Atlantic convoy duty. Pen and ink. 10 × 8⁵/₈ in. (25.5 × 21.8 cm.). Unsigned, attributed to C. J. A. Wilson. On reverse: unfinished pencil sketch of an unidentified aircraft carrier. Gift, Stephen Wheatland, 1967. Not illustrated.
M12864

2370. Naval vessel No. 21 in the South Boston Naval Drydock. Pen and ink. 12⁵/₈ × 10¹/₄ in. (32.1 × 26 cm.). Unsigned, attributed to C. J. A. Wilson. Gift, Stephen Wheatland, 1967. Not illustrated.
M12865

2371. Freighter "In the Gulf Stream." Pencil. 11³/₈ × 14⁵/₈ in. (28.9 × 37.1 cm.). Unsigned, attributed to C. J. A. Wilson. Gift, Stephen Wheatland, 1967. Not illustrated.
M12871

2372. "The Skipper." Pencil. 6⁷/₈ × 7⁵/₈ in. (17.5 × 19.4 cm.). Unsigned, attributed to C. J. A. Wilson. On reverse: pen sketch of an unidentified ketch yacht. Gift, Stephen Wheatland, 1967. Not illustrated.
M12872

2362

2364

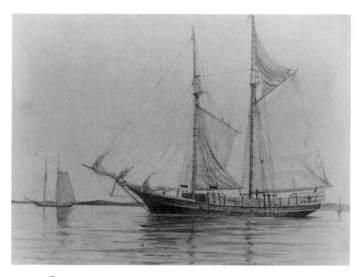

2365

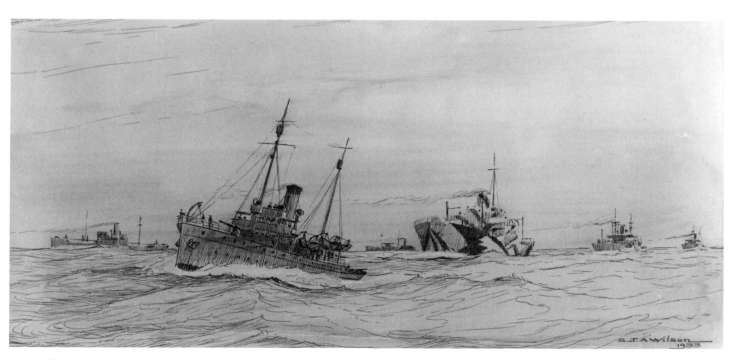

2368

2373

2374

2378

2373. "Industry" – shipping off the Merrimac Chemical Company. Pen and ink. 11³/₈ × 14¹/₂ in. (28.9 × 36.8 cm.). Signed, l.r., "C.J.A. Wilson 3[anchor]2". Gift, Stephen Wheatland, 1967. M12874

2374. Boatyard at Bristol, Rhode Island. Pen and ink. 9⁷/₈ × 12³/₄ in. (25.1 × 32.4 cm.). Unsigned, attributed to C. J. A. Wilson. Gift, Stephen Wheatland, 1967. M12878

2375. Schooner off St. Johns River, Florida. Pencil. 11³/₈ × 14¹/₂ in. (29 × 36.8 cm.). Unsigned, attributed to C. J. A. Wilson. Gift, Stephen Wheatland, 1967. Not illustrated. M12879

2376. "Schooner off Cape Hatteras." Pencil. 11³/₈ × 14⁵/₈ in. (28.9 × 37.2 cm.). Signed, l.r., "C.J.A. Wilson 3/20/29." Gift, Stephen Wheatland, 1967. Not illustrated. M12880

2377. Three Island steamship in heavy seas. Pen and ink. 14³/₄ × 11¹/₂ in. (37.5 × 29.2 cm.). Unsigned, attributed to C. J. A. Wilson. Gift, Stephen Wheatland, 1967. Not illustrated. M12882

2378. "Rummy Winona of La Have N[ova] Scotia." Pencil. 11¹/₄ × 14¹/₂ in. (28.5 × 36.8 cm.). Signed, l.r., "C.J.A. Wilson Apl 30/1930." Gift, Stephen Wheatland, 1967. M12883

2379. Rum runner illuminated by searchlight. Pencil. 9¹/₂ × 13 in. (24.2 × 33 cm.). Unsigned, attributed to C. J. A. Wilson. Gift, Stephen Wheatland, 1967. Not illustrated. M12887

2380. Fishing craft. Pencil. 11¹/₂ × 14³/₈ in. (29.2 × 36.5 cm.). Unsigned, attributed to C. J. A. Wilson. Shows vessels labelled *Cambridge*, a Canadian trawler, a dory No. 17 from the *Laura Y. Goulard* being rowed and overturned, and an unidentified vessel. Gift, Stephen Wheatland, 1967. Not illustrated. M12889

2381. "The Skipper," a helmsman at the wheel of a yacht. Pen and ink. 10⁷/₈ × 14¹/₄ in. (27.6 × 36.2 cm.). Unsigned, attributed to C. J. A. Wilson. On reverse: pen and pencil sketch of unidentified bark. Gift, Stephen Wheatland, 1967. Not illustrated. M12890

2382. Pilot schooner. Pen and pencil. 10 × 14¹/₂ in. (25.4 × 36.8 cm.). Unsigned, attributed to C. J. A. Wilson. Gift, Stephen Wheatland, 1967. Not illustrated. M12891

2383. Pilot schooner No. 8. Pen and ink. 11 × 12³/₈ in. (28 × 31.4 cm.). Unsigned, attributed to C. J. A. Wilson. Gift, Stephen Wheatland, 1967. Not illustrated. M12893

2384. Unidentified shipping, schooners and steamer, in a West Indian port. Watercolor. 9³/₄ × 10³/₈ in. (24.7 × 26.4 cm.). Unsigned, attributed to C. J. A. Wilson. Purchase, Fellows and Friends Funds, 1967. M12900

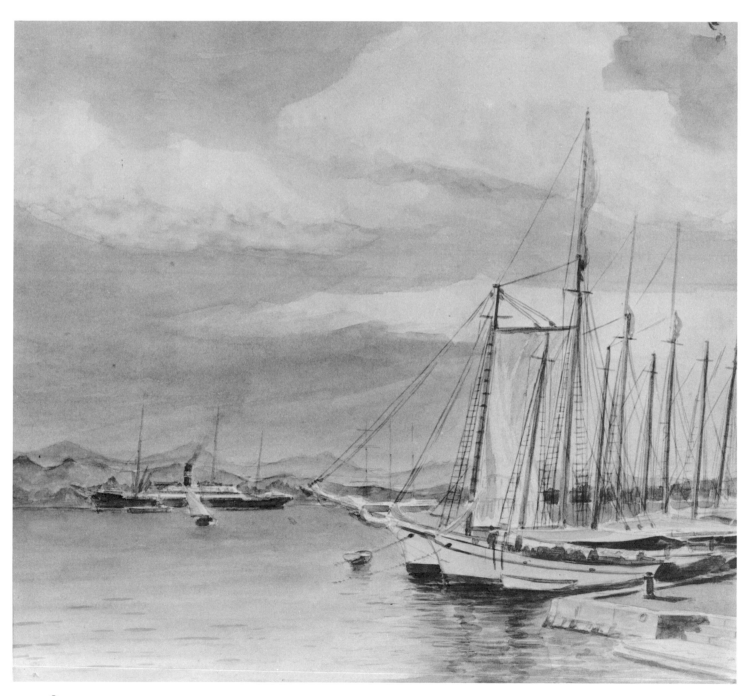

2384

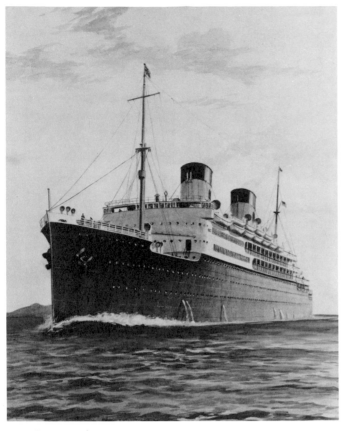

2385

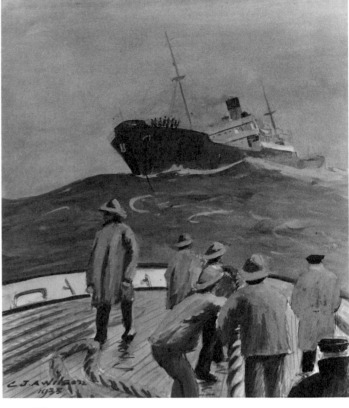

2386

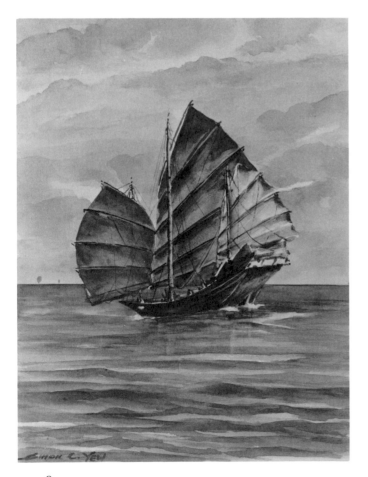

2389

2385. Unidentified American steamship entering a British port. Watercolor. 20 × 15⁷/₈ in. (50.8 × 40.3 cm.). Unsigned, attributed to C. J. A. Wilson. Purchase, Fellows and Friends Funds, 1967. M12901

2386. "Taking the Tow Rope." Gouache. 9¹/₄ × 8 in. (23.5 × 20.3 cm.). Signed, l.l., "C.J.A. Wilson 1935." On reverse: pencil sketch of unidentified brig. Purchase, Fellows and Friends Funds, 1967. M12905

2387. Unidentified hermaphrodite brig. Watercolor. 9¹/₈ × 12³/₈ in. (23.2 × 31.4 cm.). Signed, l.r., "C.J.A. Wilson 1917." Purchase, Fellows and Friends Funds, 1967. Not illustrated. M12907

2388. Unidentified American ship. Watercolor. 19³/₄ × 15³/₄ in. (50.1 × 40 cm.). Unsigned, attributed to C. J. A. Wilson. On reverse: pencil sketch of same subject. Purchase, Fellows and Friends Funds, 1967. Not illustrated. M12922

Yew, Simon C.

2389. Unidentified Singapore type junk. Watercolor. 9¹/₂ × 7¹/₄ in. (23.5 × 18.3 cm.). Signed, l.l., "Simon C. Yew," circa 1946. Gift, V. Ralty Woolfe, 1970. M13906

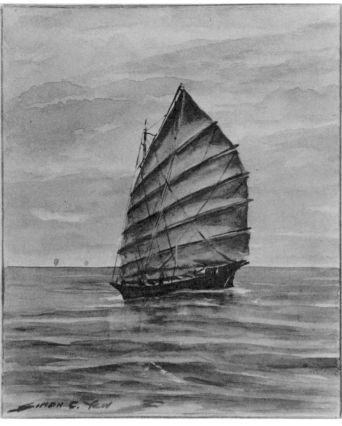

2390

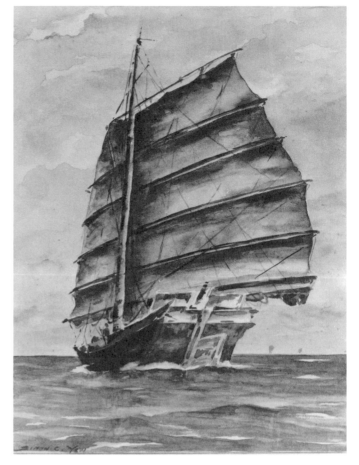

2391

2390. Unidentified Singapore type junk. Watercolor. 6³/₈ × 5⁵/₈ in. (17.2 × 14.3 cm.). Signed, l.l., "Simon C. Yew," circa 1946. Gift, V. Ralty Woolfe, 1970. M13907

2391. Unidentified Singapore type junk. Watercolor. 9¹/₂ × 7 in. (24 × 17.9 cm.). Signed, l.l., "Simon C. Yew," circa 1946. Gift, V. Ralty Woolfe, 1970. M13908

PART II

Check List of Illustrated Logbooks and Sea Journals

Among the several thousand logbooks and sea journals in the library of the Peabody Museum of Salem there are inevitably those which contain paintings and drawings. Those listed below form a check list of the more outstanding examples. Numerous others contain random doodlings or hastily drawn outlines of shore profiles, but, in selecting those which follow, the odd pencil smudge or ink jotting has not been deemed sufficient to warrant inclusion except for reasons of historic or geographical importance.

L1. ACTAEON, HMS. Japanese waters, 1860–1861. William Howard Brown, journal keeper. Watercolors of H.M. steam bark *Dove* and H.M. steam barkentine *Algerine* (drawn by Mr. Bedwell of *Actaeon* and painted by Brown); pencil sketches of H.M. steam barkentine *Leven*, an unidentified ship, and a cabin on board *Actaeon* (illustrated), 7 August 1860.

L2. ACUSHNET, whale ship of Fairhaven, Massachusetts. Fairhaven–South Pacific, 1845–1847. William B. Rodgers, captain; Henry M. Johnson, journal keeper. Two watercolors of *Acushnet* (one illustrated).

L3. ALBION, ship. Calcutta–Boston, 1817–1818. John Conway, captain; George W. Mansfield, journal keeper. Pen sketches of fanciful American ship of the line, a schooner, shore profile of the island of Bourbon (Mauritius), and numerous small doodlings.

L4. ANTIOCH, bark of Boston. Kronstadt–Boston–Rio de Janeiro, 1864. J. J. Giles, captain; David A. Preston, journal keeper. Two ink sketches of barks, one identified as *Antioch* (illustrated); two pencil drawings of unidentified ships.

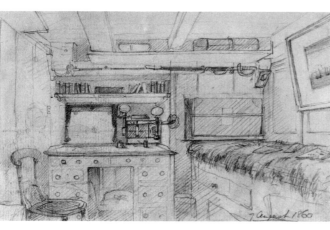

L1

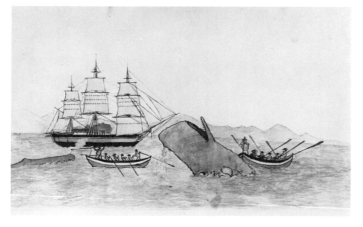

L2

L4

L5

L5. BRUNETTE, whaling bark of Falmouth, Massachusetts. South Atlantic, 1838–1839. Matthew Poole, captain; G. Cloutman, journal keeper. Pen sketch of *Brunette* (illustrated).

L6. CAROLINE & MARY, brig. Boston–Wilmington–Rio de Janeiro, 1848. J. C. Higgins, captain and journal keeper. Pencil silhouette of the schooner *Julie Ann*, Captain Dorr, of Winterport, Maine (illustrated); pencil shore profiles of Cape St. Vincent, the island of Fernando de Noronha, the entrance to Rio de Janeiro, and the entrance to Bahia showing the lighthouse.

L7. CARTHAGE, ship of Boston. Boston–Calcutta–Boston, 1841–1842. Henry Warden, captain; Henry L. Williams, journal keeper. Two pen sketches of St. Helena.

L8. CARTHAGE, brig of Newburyport, Massachusetts. Charleston–Kronstadt–Boston–Newburyport–Virginia–London–Virginia, 1842–1843. S. W. Knapp, captain and journal keeper. Nineteen small watercolor sketches of *Carthage*; watercolor sketches of Papa Westra Island, North Ronaldasha, Fair Island, the Norwegian coast, Robsmont (?), Anchor lightship and the land of Koll, Bornholm, and Gotland.

L9. CARTHAGE, ship. Boston–India–Boston, 1849–1850. Francis A. Tilton, journal keeper. Numerous pencil sketches of *Carthage*; others of brig *Concordia*, a lighthouse, and various unidentified vessels of different rig.

L6

LII

L10. CHARLOTTA, ship of Boston. Manila–Malacca–Calcutta, 1803. William Haswell, captain and journal keeper. Ink and wash sketches of Pulo Amore, a palanquin and bearers, and India Grab and Snake Boat, and three birds ("Manchot, Cassowary and Ajutant or Bone Eater").

L11. CHILDE HAROLD, ship. New York–Liverpool, 1862. Henry Hicks, captain; F. A. Moreland, journal keeper. Pencil sketch of a Liverpool flat (illustrated).

L12. CLEOPATRA'S BARGE, hermaphrodite brig-yacht of Salem. Salem–Mediterranean, 1817. Benjamin Crowninshield, captain. Book of sketches by Hannah Crowninshield. Watercolors of unidentified British topsail sloop, *Cleopatra's Barge* (illustrated), and unidentified American ship; unfinished pencil sketch of unidentified ship.

L13. COLON, Pacific Mail steamer. Voyages between New York and Colón, 1874–1875. J. L. Tanner, captain; John Clement Lord, First Officer, journal keeper. Pencil shore profiles of Cuba and adjacent Caribbean, pencil portrait of "Nuestro Official de Aduana Sin Nariz En Habana" (illustrated).

L14. COMMISSARY, brig of Boston. Several voyages: Boston–Caribbean, 1832–1834. Charles A. Ranlett, captain and journal keeper. Miscellaneous sketchy shore profiles, several unidentified vessels, and pencil sketch of *Commissary*.

L15. CONTEST, clipper ship of New York. New York–Manila–Hong Kong, 1863. Fred G. Lucas, captain; William D. Huntington, journal keeper. Deck plan of *Contest* (illustrated).

L12

L13

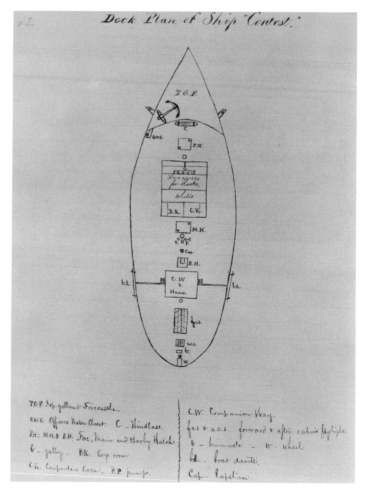

L15

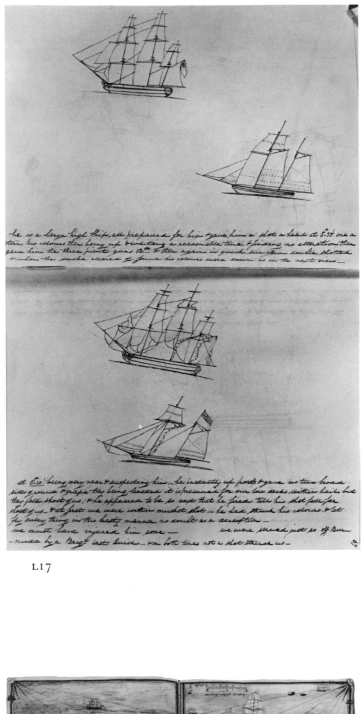

he is a large high ship, all prepared for him & gave him a shot a head at 5.55. one a stern. his colours then being up. & waiting a reasonable time. & finding no alteration then gave him the three piece guns 12ᵗᵘ & then again in quick succession double shotted & when the smoke cleared up found his colours were down as in the next view —

at 6.10 being very near & suspecting him. he instantly up ports & gave us two broad sides of round & grape they being levelled it is presumed for our low decks. within hail, but they fell short of us. & he appeared to be so vexed that he fired till his shot fell far short of us. & at first we were within musket shot — he had struck his colours. & let fly every thing in this hasty manner. no doubt as a deception —
we must have injured him some — we were served just so off Ber-
-muda by a Brigᵗ last cruise — & in both times not a shot struck us —

L17

L16. DANIEL WEBSTER, bark. Boston–San Francisco, 1849 –1850. J. C. Higgins, journal keeper. Pencil silhouette of *Daniel Webster*.

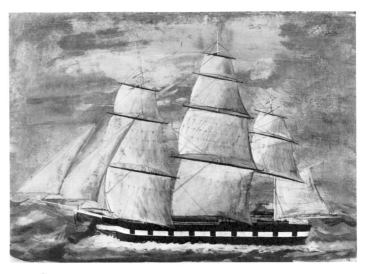

L18

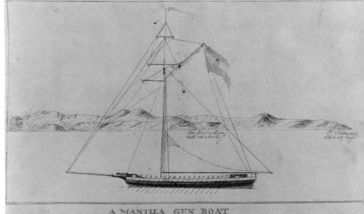

A MANILLA GUN BOAT
LAT 17ᵈ⁵⁰ˢ COAST OF ILLOCOS ON THE WEST SIDE OF LUCONA LONG. 113·25' E

L21

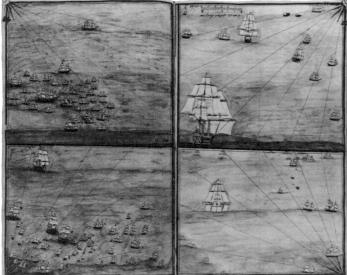

L22

L23

140

L17. DIOMEDE, privateer schooner of Salem. Coastal cruise, 1814. John Crowninshield, captain and journal keeper. Forty-one pages of pen sketches illustrating the coastline seen during the cruise and *Diomede* in action against numerous British vessels (sample illustrated).

L18. EBEN PREBLE, ship of Boston, Boston–Manila, 1840. Franklin Hallet, captain; Eustice Bacon, journal keeper. Gouache painting of *Eben Preble* (illustrated).

L19. EIGHT SONS, brig of Alexandria, Virginia. Alexandria–Amsterdam–Havana–Kronstadt–Jersey, 1823–1824. Pen sketches of small brigs, *Eight Sons*, and a flying fish.

L20. ELIZABETH, whale ship of Salem. South Pacific, 1836–1840. Isaac G. Hodge, captain; Jonathan P. Saunders, journal keeper. Shore profiles and Pacific views.

L21. ELIZABETH, snow of Boston. Batavia–Manila, 1802. William Haswell, captain and journal keeper. Pen sketches of the Bay of Manila, the entrance to Manila Bay, view of Cairte (Manila), and a Manila gun boat (illustrated).

L22. FAME, British brig. Europe–North America–London, 1779–1783. Robert Richmond, captain. Four ink wash sketches (illustrated) of French warship attacking *Fame's* convoy (7 June 1780) en route from Torbay to Quebec; watercolor map of St. John's, Newfoundland; one wash sketch of *Fame*, one pen sketch of *Fame*, various shore profiles of Newfoundland and vicinity.

L23. FORUM, ship of Boston. Boston–Marseilles, 1833. E. M. Leach, journal keeper. Three pencil sketches of unidentified vessels, one of the brig *Forum*, one of the ship *Forum* towing into Marseilles (illustrated), one of brig *Lunar*.

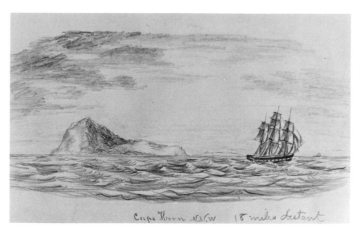

L24

L24. FRANCIS A. PALMER, ship. San Francisco Callao–Chincha Islands–Cork–London–New York, 1860–1861. Addison Richardson and William W. Allen, captains. Pencil sketch of Cape Horn (illustrated); pen sketch of St. Paul Rocks with passing shipping.

L25. GALAXY, ship. Marseilles–New York, 1829. Asa H. Swift, captain; Joseph P. Curtis, journal keeper. Pencil sketch of unidentified vessel, pen sketches of hermaphrodite brig *Fancy* and American brig *Wasp*.

L26. GEORGIANA, bark. Glasgow–Australia–Callao–Cork, 1852–1853. Robert Murray, captain. Four wash sketches of the island of Trinidad, South Atlantic (illustrated).

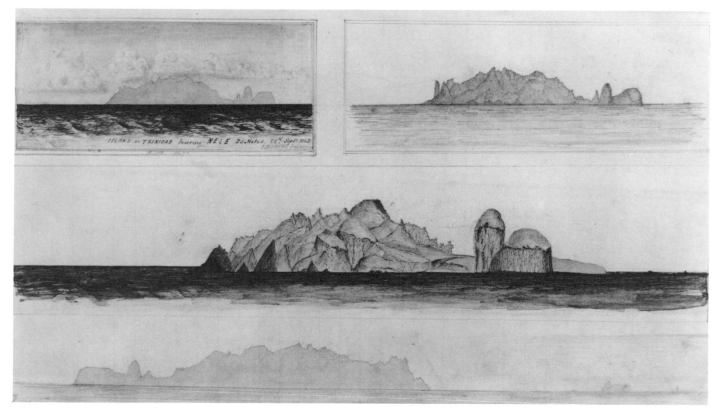

L26

BOSTON LIGHT-HOUSE.

L28

L29

L30

L27. HENRY, brigantine of Salem. Salem–Indian Ocean, 1788–1790. Benjamin Crowninshield, captain. Watercolor of ship and eagle, shore profiles of Rodrigues, Mauritius, Trinidad.

L28. HERCULES, ship of Salem. Boston–Indian Ocean–Northern Europe, 1792–1794. Benjamin Carpenter, captain. Pen sketches of Boston Lighthouse (illustrated), prospect of Santa Cruz off Teneriffe, view of Praya Bay in the island of St. Jago, map of Praya Bay, map of the island of Mayo, view of Gingeram on the Malabar Coast, map of Fayal, miscellaneous sketches of icebergs and shore profiles.

L29. HIBERNIA, whale ship of New Bedford. Indian Ocean–Pacific, 1844–1846. N. P. Simmons, captain; Henry Eldredge, journal keeper. Ink sketches of *Hibernia* (illustrated) and of the bark *Canton*.

L30. HORACE, ship of Salem. Boston–Richmond–Manila–Salem, 1806–1807. John Parker, captain; Daniel Hopkins, journal keeper. Pen sketches of brig and ship (illustrated) and of two ships, one of which is identified as *Lively*.

L31. ICE KING, ship of Boston. Boston–Batavia–New York, 1879–1880. H. Sargent, captain. Pen sketches of *Ice King's* sail plan, after-house plan, deck plan; pencil sketches of Java Head, Princess Island Light, Anjier, unidentified vessels, and waterspouts.

L32. JONES, bark of Salem. Havana–Cowes–Hamburg–Cowes–Rio de Janeiro, 1833. David Ingersoll, captain. Pen sketch of *Jones*.

L33. LA GRANGE, bark of Salem. Salem–San Francisco, 1849–1850. Joseph Dewing, captain; William F. Morgan, journal keeper. Pencil sketches of shipping of Cape Ann, Massachusetts; schooner *Grace Darling* (by Delia C. Morgan); pen sketches of Port Richard (Falkland Islands); *La Grange* in Fanning's Harbor; schooner *Loo Choo* of Gloucester, Massachusetts; pen and gouache drawings of shipping in Eagle Harbor; *La Grange* and brig *Lawrence* (illustrated); *La Grange* with whales and porpoises, *La Grange* hove to; and two others of *La Grange*.

L34. LA GRANGE, bark of Salem. Salem–San Francisco, 1849–1850. Joseph Dewing, captain; Charles Augustus Dole, journal keeper. Two watercolors of *La Grange* (illustrated), two pencil sketches of *La Grange*, fourteen pen sketches of *La Grange* (similar to the illustrations in the foregoing logbook).

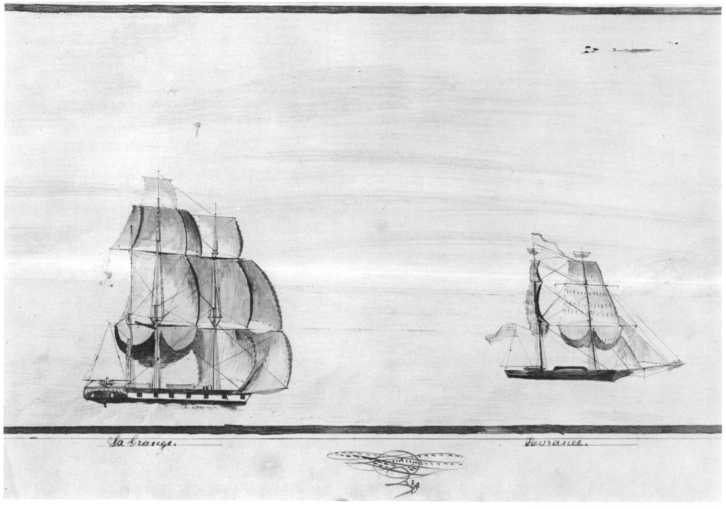

La Grange. Lawrance.

L33

L34

L35. LIVERPOOL, HMS. South America–Australia–New Zealand–Japan–U.S. West Coast, 1869–1870. John O. Hopkins, captain. Pencil sketch of Iron Pot Lighthouse off Hobarton, Tasmania (illustrated).

The Iron Pot Light-House bearing N.E.E. 1 mile.

L35

143

L36

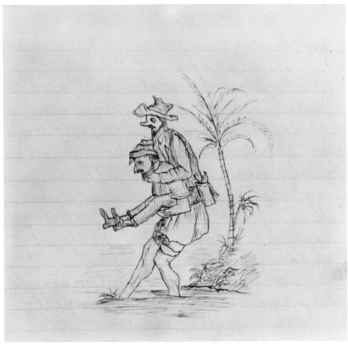

L38

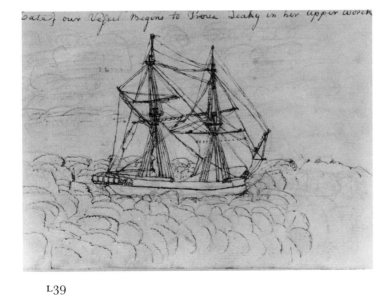

L39

L36. LYDIA, bark of Boston. Boston–East Indies–Pacific, 1801–1802. Moses Barnard, captain; William Haswell, journal keeper. Pen drawings of Trinidad, Tristan da Cunha (illustrated), Amsterdam Island, Mew Bay (Java), a plan of the harbor on the southwest side of Guam, "the appearance of de Caldera Guam taken from the *Lydia*'s masthead 1802," the appearance of Aguana from the pass in the reef, and a flying proa.

L37. MACEDONIAN, USS. A cruise at sea–South America–Hampton Roads, 1827–1828. James Biddle and B. V. Hoffman, captains; Joseph Lanman, journal keeper. Ink wash of Sugar Loaf Mountain, Rio de Janeiro.

L38. MARY & LOUISA, bark. East Indies and China, 1860. Jones, captain; Freeman Pulsifer, journal keeper. Numerous shore profiles, maps, small sketches of watercraft, voyage life, and humorous drawings (illustrated).

L39. MASSACHUSETTS, ship. Boston–Northwest Coast–Hawaiian Islands–Canton, 1790. Joab Prince, captain; John Bartlett, journal keeper. Watercolors of a Chinese junk and a two-masted lateen vessel; ink sketches of a native "Winter House" with totem pole near "Cloake Bay," snow *Gustavous* (illustrated), unidentified brig, Queen Charlotte Sound; pencil sketches of brig surrounded by native craft in the Hawaiian Islands, and of unidentified ship and brig.

L40. OCEAN, whaling brig of Sandwich, Massachusetts. St. Domingo–Falmouth, 1852–1853. Joshua Chadwick, captain; Ervin N. Fisher, journal keeper. Watercolor shore profiles, unidentified vessels, bark *President* of Westport, ship *Thomas Dickinson* of New Bedford, bark *Winslow* of New Bedford, brig *Phoenix* of Provincetown, schooner *Amelia* of Sandwich.

L41. PALLAS, ship of Salem. Calcutta–Salem–New York, 1803–1804. John Rose Dalling, captain; William Haswell, journal keeper. Ink wash of St. James Valley in the island of St. Helena (illustrated), shore profiles of St. Helena and "Cape LaGullas."

L42. POTOMAC, ship. Newburyport–Batavia–Cape Town–Antwerp, 1825–1826. Caleb W. Norris, captain. Watercolors of St. Anthony's (Cape Verde Islands) as seen through a fog and Cape Town and Table Mountain (illustrated).

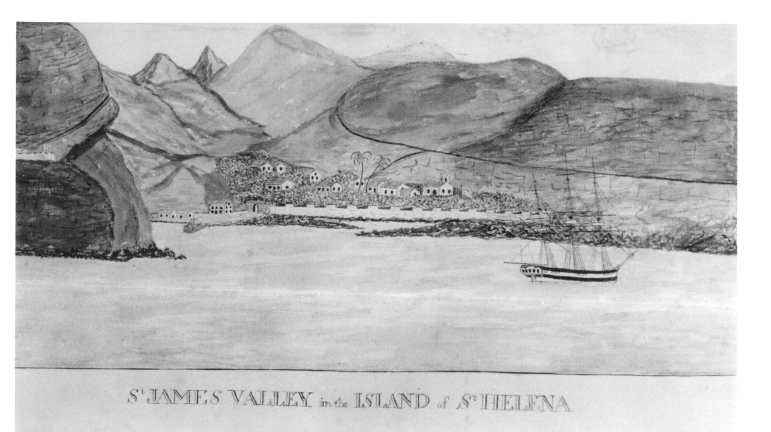

St JAMES VALLEY in the ISLAND of St HELENA

L41

L43. POTOMAC, ship. Newburyport–Batavia–Amsterdam, 1834–1835. A. H. White, journal keeper. Two pen sketches of *Potomac*.

L44. POTOMAC, ship. Batavia–Boston and Newburyport–Batavia, 1836 and 1838. A. H. White, journal keeper. Miscellaneous watercolors of *Potomac* and St. Paul Rocks.

L42

L45. R. C. WINTHROP, ship of Boston. Boston–San Francisco–Calcutta, 1850–1851. H. W. Young, captain; George C. Crehore, journal keeper. Pencil sketches of unidentified bark, *R. C. Winthrop* (illustrated), and miscellaneous doodlings.

L46. RICHMOND, brig. New York–South America–New York and New York–Madeira–Boston, 1851–1852. J. C. Higgins, journal keeper. Pencil silhouette of the two-masted schooner *Sarah Hall*, Captain Gilman, Winterport, Maine.

L47. ROCKALL, ship. Boston–Calcutta–Boston, 1854. Martin, captain; Edwin Blood, journal keeper. Pencil sketches of Cape Agulhas, Cape of Good Hope, two of St. Helena, cook of *Rockall*.

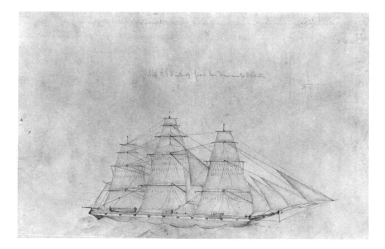

L45

145

L48. RODMAN, whale ship. Pacific cruising; 1827–1830. Robert M. Joy, captain. Numerous shore profiles in South Atlantic and Pacific; small watercolor sketches of whaling vessels spoken (sample illustrated).

L49. RUBY, ship. Boston–Indian Ocean, 1789–1790. Benjamin Carpenter, captain. Various ink sketches of shore profiles.

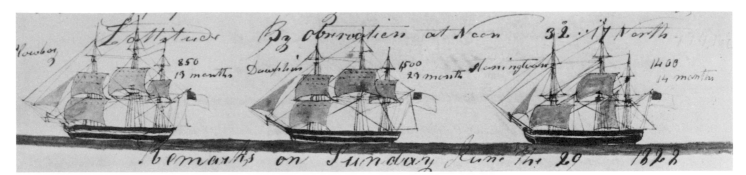

L48

L50

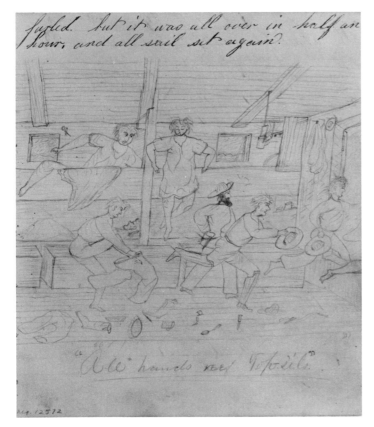

L53

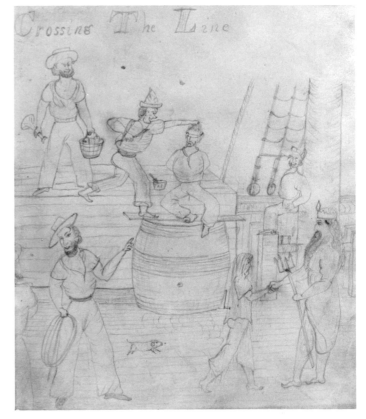

L53

L50. SURPRISE, ship of New York. London–China–London, 1851–1852. Charles A. Ranlett, captain and journal keeper. Pencil sketches of shore profiles: St. Helena, Ascension Island, Trinidad, Martin Vas, Anjier Lighthouse (illustrated).

L51. SURPRISE, ship. Three China voyages from New York, 1854–1856. Charles A. Ranlett, captain and journal keeper. Pencil sketches of Sulphur and Volcano Islands (southern Bonins), Barren Islands, Cape Agulhas, and signal flags.

L52. SURPRISE, ship. Two China voyages from New York, 1865–1868. Charles A. Ranlett, captain and journal keeper Pencil sketch of 332-foot high iceberg seen on 24 February 1865 in the South Indian Ocean.

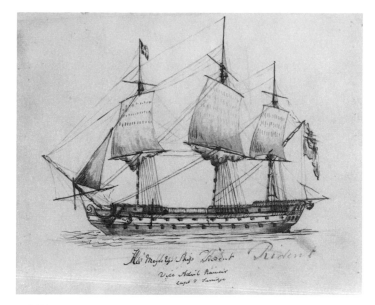

L54

L53. TARQUIN, ship of Boston. Boston–East Indies–Marseilles, 1862–1863. Edward H. Haskell, journal keeper. Watercolor sketches of Danish, English and American flags, Martin Vas Rocks, shark, Annallaboo Point, "Jack at Supper," native of Sumatra, grave of First Mate Baker, seaman in rain gear. Watercolor sketches of "On the Look-Out," "Forecastle Lamp," "Slushing the Spanker Gaff," "Furling the Royal"; pencil drawings of six sailors in forecastle called "All Hands Reef Topsails" (illustrated), "Rolling Round the Cape" of Good Hope, "Sunday Job" (sailor being shaved), "Heaving the Log," profile of St. Paul Island, burial of the First Mate, seaman with harpoon, "Our Largest Gun 'Rip van Winkle'," "Crossing the Line" (illustrated), native canoe, seaman holding aloft an American flag, men carrying a casket. Pencil sketch of a school of porpoises

L54. TRIDENT, HMS. Indian and East Indian waters, 1803–1804. Herbert W. Hore, captain. Three pencil and ink sketches of unidentified ships and ink wash drawing of *Trident* (illustrated).

L55. UNCAS, whale ship of New Bedford. Pacific Ocean, 1846–1849. Charles W. Gelett, captain. Pencil sketch of unidentified ship.

L56. UNION, ship of Salem. Salem–Mediterranean–New York–Salem, 1803. George Hodges, captain; Francis Boardman, journal keeper. Five ink sketches of vessels (sample illustrated).

L56

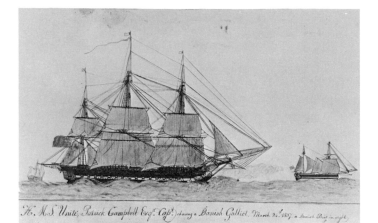

L57

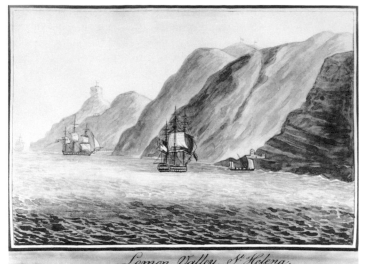

Lemon Valley St Helena.

L58

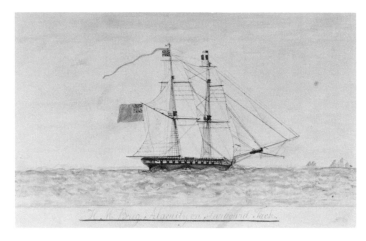

L57

L58

L57. UNITE, HMS. Spithead–Mediterranean, 1805–1809. Charles Ogle and Patrick Campbell, captains; Robert Mercer Wilson, journal keeper. This journal has been published by the Navy Records Society in *Five Naval Journals, 1789–1817* (London, 1951), pp. 121–276. Watercolors of anchors, signal flags, compass rose, *Unite* chasing a Danish galliot (illustrated), *Unite* in chase of suspicious vessel, town of Margo, Piran, *Unite* engaging flotilla of gunboats off Grado, Venetian squadron in chase of *Unite*, four vessels, *Unite* in chase of Venetians, thirty-eight different rigs at anchor and under sail, four plans of frigate's decks, *Unite* at anchor, frigate under all sail on the starboard tack, description of a frigate's sails, quartering view of a frigate, bow view of a frigate, view of the Castle and northeast part of the island of Ischia, HM brig *Alacrity* (illustrated).

L58. WARREN HASTINGS, East India Company ship. London–India–China–London, 1819–1821. Thomas Larkins, captain; George Mason, journal keeper. Ink and wash sketches of eclipse on 15 March 1820; the tip of Africa; "George Town, Penang, from the Shipping"; three sketches illustrating a journey by palanquin up a mountain; chart of Malay Peninsula; Malacca from the sea; Macao from the heights to the south; Whampoa and shipping; Boca Tigris from the south; front view of the Canton factories; Macao from the Roads; track chart of *Warren Hastings*; Table Bay and Cape Town; St. Helena with shipping; and Lemon Valley, St. Helena (illustrated). Watercolor of the "Hon^ble Comp^ny's Ships *Warren Hastings* and *Lady Campbell* off Lantoa" (illustrated).

L59. WASHINGTON, USS. Boston–Mediterranean. Isaac Chauncey, Commodore; John Orde Creighton, captain; Jacob Crowninshield (midshipman), journal keeper. Nineteen pages with pen and ink shore profiles and towns in the Mediterranean and drawings of the U.S. frigate *United States* (illustrated) and the U.S. frigate *Congress*.

L59

PART III

Corrigenda to
Marine Paintings and Drawings in the Peabody Museum
by M. V. and Dorothy Brewington, 1968

During more than a decade of intensive use, the Brewingtons' original volume, Marine Paintings and Drawings in the Peabody Museum, *has been subjected to much scrutiny. Inevitably, errors, omissions, and reattributions push their way to the surface like stones after a winter's frost. What is remarkable is that more stones have not heaved themselves up, because the Brewingtons' undertaking was a massive and logistically complex one.*

The following, then, are the principal amendments to the original work discovered by personnel at the Peabody Museum or brought to their attention. The numbers given at the beginning of each are the entry numbers from the 1968 published volume.

31. Change *Arctic* to *Atlantic*
32. Change *Baltic* to *Atlantic*
41. Add "s" after "Painter"
51. Change "Egg Rock, Nahant Bay" to "Halfway Rock, off Marblehead"
75. Change *La Glorie* to *La Gloire*
94. Add date of accession (1957)
110. Add date of accession (circa 1898)
118. Add date of accession (circa 1930)
180. Wrong illustration for entry (same as 182, which is correct)
181. Add "Gift of A. W. Longfellow, 1920"
183. After "Squadron" add "in the English Channel"
185. Shown in the Bay of Naples
188. Shown in the Bay of Naples
190. Add "fishing" before "sloop"
234. Add "Gift of Capt. James C. Ballard"
243. Add date of accession (1899)
244. Change "attributed to" to "signed by"
246. (M3870-25) Change "Silk Culture" to "Tea Culture"
249. Add "Praya Grande from the South"
252. Possibly by Sunqua
255. Possibly by Namcheong
257. Attributed to Sunqua
264. Change "In the" to "At"
270. Change dimensions to 27 × 36 inches
271. Attributed to Namcheong
272. *Levant* built 1801, Charlestown, Massachusetts
275. Attributed to Sunqua

278. Add date of accession (1925)
279. Add date of accession (circa 1943)
283. Possibly by Namcheong
284. Entry number skipped
290. Add date of accession (1959)
297. Add date of accession (circa 1918)
317. Should read "American steamer"
322. Attributed to Tinqua
323. Correct to read "Gift of Charles H. Taylor, 1932"
324. Illustration is a detail of the whole painting.
330. Add "circa 1820"
331. Change "Tigre" to "Tigris"
335. Add date of accession (circa 1905)
342. Add date of accession (circa 1919)
345. Attributed to Namcheong. Correct to read "Flags from left: American, English, Danish"
349. Add "Blockade by Commissioner Lin on 24 March 1839"
350. Correct to read "Flags from left: French, American, British, Dutch
353. Attributed to Sunqua
361. Correct to read "China, Pearl River, Boca Tigris"
362. Correct to read "China, Pearl River, Boca Tigris"
363. Attributed to Sunqua
364. Attributed to Tinqua
368. Attributed to Youqua
370. Add after Macao, "Praya Grande looking north"
372. Attributed to Sunqua. Add "Praya Grande from the east"
373. Attributed to Tinquá. Add "Praya Grande looking south"

374. Add "Macao looking north." Inner harbor at left; Praya Grande at right

375. After "Macao" add "from Bomparts Fort looking north"

377. Praya Grande from the east

378. Add "Penha" before "Monastery"

379. Praya Grande looking north before 1850. "Monastery" is Monte Fort

380. Attributed to Youqua. Praya Grande from the east.

381. Attributed to Tinqua. Praya Grande from the east.

382. Add "looking south"

385. Add "looking north from Penha Monastery at extreme right. Inner harbor at left. Praya Grande at right."

386. Attributed to Sunqua

388. Correct to read "unidentified landscape"

389. Correct to read "unidentified landscape"

390. Correct to read "unidentified landscape"

401. Location of painting is Shameen

404. Possibly by Chow Kwa

409. Attributed to Youqua

411. Attributed to Sunqua, after 1847

413. Attributed to Youqua

415. Attributed to Sunqua

422. Possibly by Sunqua

424. Attributed to Namcheong

425. Attributed to Namcheong

428. Attributed to Tinqua

431. Attributed to Tinqua

432. Change location from the Philippines to Lahaina, Maui

554. Returned to lender

574. Correct to read "574a" and "574b"

589. Returned to lender

652. Add after "Pencil," "with color notes"

659. Change to "M12631"

660. Change to "M12632"

727. Change "American steamer" to "British steamer"

731. Reattributed to Fred Pansing

755. *Britannia* built 1840, Port Glasgow

857. Schooner identified as *Nina*, built in 1928 for Paul Hammond. Steamer represents *Ile de France*

984. Add date of accession (1936)

1014. Correct to read "China, Macao, Makok Temple, etc."

1035. Add "Black Ball Line"

1070. Vessel shown off Elsinore Castle

1073. Vessel shown off Elsinore Castle

1075. Vessel shown off Elsinore Castle

1077. Vessel shown off Elsinore Castle

1078. Vessel shown off Elsinore Castle

1134. Returned to lender

1156. Reattributed to Michele Felice Cornè

1188. Reattributed to unidentified artist. Not by Ange-Joseph Antoine Roux.

1190. Change 14 sketchbooks to 20

1200. Reattributed to unidentified artist. Not by Mathieu-Antoine Roux.

1201. Reattributed to François Joseph Frédéric Roux

1202. Reattributed to François Joseph Frédéric Roux

1203. Reattributed to François Joseph Frédéric Roux

1204. Reattributed to François Joseph Frédéric Roux

1205. Reattributed to François Joseph Frédéric Roux

1208. Add date of accession (1955)

1214. Change "Json" to "Ason" (Addison). Change date to 1838.

1215. Illustration incorrect

1241. Reattributed to François Geoffroi Roux

1242. Reattributed to François Geoffroi Roux

1248. Reattributed to François Joseph Frédéric Roux. Not by Louis Roux.

1269. Add "whale" between "Dutch" and "ship"

1273. Returned to lender

1274. Add "partially completed oil sketch"

1276. Returned to lender

1277. Returned to lender

1279. Change dimensions to $15^{1/2} \times 23$ inches

1280. Reattributed to unidentified artist. Not by Robert Salmon.

1282. Returned to lender

1287. Revise to read "A. Coming off the beach. B. Anchored at the island. C. Whaling along the breakers. D. Orcas or Killers. E. Eskimo whaling"

1298. Add "Pencil and" before "wash"

1311. Delete "Two"

1314. Add "off Naples"

1317. Add "off Naples"

1318. Add "off Naples"

1344. For "U.S.S. *Chattanooga* [American monitor]" read "U.S.S. *Chattanooga* [American ship] in background"

1399. Attributed to Honoré Pellegrin

1410. Attributed to William Marsh

1419. Attributed to William Marsh

1420. Possibly by William Marsh

1427. Possibly by William Marsh

1434. Change date of 1805 to 1815

1438. Probably by a Chinese artist

1444. Attributed to Giuseppi Fedi

1454. Add "ship" before "*Monk*"

1458. Attributed to Montardier

1468. Attributed to Fibberti

1470. Entry number skipped

1471. Attributed to William Marsh

1472. By a Chinese artist

1473. Building date should read "1837"

1480. After "East India Marine Society" add "prior to 1867"

1491. Add "off Palermo"

1494. Add "entering the Bay of Naples"

1496. Attributed to Honoré Pellegrin

1503. Attributed to Michele Funno

1511. Attributed to Fibberti

1516. Attributed to William Marsh

1522. Attributed to Fibberti

1525. Attributed to Giuseppi Fedi

1526. Attributed to Giuseppi Fedi

1531. Attributed to Fibberti

1538. Attributed to Fibberti

1539. Attributed to Giuseppe Fedi

1541. Change "Deposit" to "Gift"

1546. Returned to lender

1599. Change "Deposit" to "Gift"

1612. Misidentified as *Clarion*

1671. Should read "United States 28-gun sloop of war"

1674. Should read "United States 66-gun ship"

1680. Change "vessel" to "schooner"

1690. Change "Pacific and Orient Steamship Co." to "Peninsular and Oriental Steam Navigation Company"

1709. Returned to lender

1715. Returned to lender

1716. Returned to lender

1746. Signed, l.r., "J. Webber 1779"

1777. Change "bark *Julian*" to "ship *Julian*"

1824. Illustration is incorrect

1847. Change "Deposit" to "Gift"

1869. Reattributed to Ashley Bowen

1882. Add "Dutch origin"

1915. Add "whaleship *Russel* also shown"

1917. Add "unidentified" before "native village"

1934. Attributed to Skillet. After "Isle of Dogs" add "Thames River"

1957. Change *Arizona* to *Alaska*

CHANGES IN ARTISTS' NAMES OR DATES

Arnold, Edward — add dates (1824–1866)

Cabral, Joao — add the initial "J"

D'Etroyat, A. — date should read "1857", not "1817"

Dewitt — add Christian names "Richard Varick"

Fedeler, Carl — correct dates should be (1837–1897)

Fedi, Guiseppi — correct spelling is "Giuseppi"

Freitag, David Carll — add working years (1874–1883)

Garnain, Louis — correct to "Louis Honoré Frédéric Gamain" (1803–1871)

Hardy, B. — should read "T. B. Hardy"

Leavitt, John Faunce — add date of decease (1974)

Monasteri, Guiseppi — correct spelling is "Giuseppi"

Petersen, H. — probably "Hans Ritter von Petersen" (1850–1914) or "Heinrich Andreas Sophus Petersen" (1834–1916)

Petersen, Lorenz — add dates (1803–1870)

Robertson, William A. — add dates (1911–1968)

Ropes, George — add "Jr."

Roux, Joseph-Ange Antoine — change to "Ange-Joseph Antoine Roux"

Roux, François Geoffroy — change to "François Geoffroi Roux"

Roux, Frédéric — change to "François Joseph Frédéric Roux"

Roux, Ursula — change to "Ursule-Joséphine Roux"

Smartly — add Christian name "Henry". Add working years (circa 1839 – circa 1848)

Truelsen, Mathias Jacob Theodor — add dates (1836–1900)

Yam Qua — change to "Youqua"

Index

Three thousand copies of *More Marine Paintings and Drawings in the Peabody Museum* by Philip Chadwick Foster Smith were printed at The Meriden Gravure Company, Meriden, Connecticut, from Baskerville type filmset at The Stinehour Press, Lunenburg, Vermont. The designer was Freeman Keith. The book was bound by Robert Burlen and Sons, Hingham, Massachusetts.